Entry Points

The Vera List Center
Field Guide on Art
and Social Justice
No. 1

This book is published on the occasion of the inaugural Vera List Center Prize for Art and Politics, awarded to Theaster Gates. It is the first in a series of biennial publications that probe the relationship between art and social justice, each one an international survey of the most pertinent examples in this emerging field at the time of publication.

Library of Congress Cataloging-in-Publication data Entry Points. The Vera List Center Field Guide on Art and Social Justice, No. 1 / edited by Carin Kuoni and Chelsea Haines Pages cm Includes bibliographical references and index.
ISBN: 978-0-8223-6200-5

1. Art 2. Human rights 3. Social justice 4. Urbanism 5. Aesthetics
I Vera List Center for Art and Politics
II Entry Points. The Vera List Center Field Guide on Art and Social Justice, No. 1
III Kuoni, Carin
IV Haines, Chelsea

Copy editor: Stephen Hoban
Editorial assistant: Zoe Carey
Design: Project Projects
Printed in Belgium by die Keure.

Printed on Munken Lynx Rough 120 gsm. Typeset in Founders Grotesk, Genath, and Lacrima.

Distributed worldwide by Duke University Press.
Published by the Vera List Center.

Vera List Center for Art and Politics
The New School
66 West 12th Street, Room 604
New York, NY 10011
www.veralistcenter.org

Duke University Press
905 West Main Street
Durham, NC 27701
www.dukeupress.edu

The publication of this book is made possible in part through the generous support of Vera List Center Prize for Art and Politics Founding Supporters James-Keith Brown and Eric Diefenbach, Elizabeth Hilpman and Byron Tucker, Jane Lombard, Joshua Mack, and The New School. Additional support has been provided by Lambent Foundation and The Malka Fund.

Cover: Theaster Gates, *Dorchester Projects*, 2013, photo by James W. Toftness

Entry Points

Edited by Carin Kuoni and Chelsea Haines

The Vera List Center Field Guide on Art and Social Justice

No. 1

Vera List Center for Art and Politics
The New School

The Field

Dorchester Projects

Entry Points: The Vera List Center Field Guide on Art and Social Justice, No. 1

Carin Kuoni

Lately, as a matter of course, art and aesthetic practices are called on in contemporary campaigns to advance social justice. This book captures some of the most significant examples worldwide and introduces an interested audience of artists, policy makers, scholars, students, curators, and writers to new ways of thinking about social justice: how it is represented, defined, and practiced through the arts. It assembles and analyzes some of the latest scholarship at the intersection of art and social justice in order to investigate the underlying motivations and strategies that constitute this increasingly robust discourse.

On the fault line between individual ethics and institutionalized protocols for justice, where many current political debates erupt, complicated terrains appear that are often the site of provocative artist projects. These projects share with (social) justice that they correspond to continuously evolving systems of values. The need for unceasing articulation renders them infinitely demanding (to paraphrase philosopher Simon Critchley) and elusive but also primarily visible in practice. Thus, in a number of ways this book marks the temporary nature of this discourse, acknowledging—even embracing—the fact that vocabularies are not set, standards not established, and that the way we learn, communicate, and teach this field is continuously evolving. Hence *Entry Points* is only the first in a series of future biennial publications. Hence also the frame of an almanac or chronicle, a gauge of what is happening right now coupled with both the risk of speculation and the exuberance of original exploration.

Entry Points accompanies the biennial Vera List Center Prize for Art and Politics, launched at The New School to celebrate the twentieth anniversary of the center's founding in 1992. The prize honors an artist who has taken risks to advance social justice in profound and visionary ways and is awarded for a particular project's long-term impact, boldness, and artistic excellence. Following an extensive research and evaluation process that enlisted a stellar jury as well as the exemplary Nominators Council of leading artists, art historians, and curators worldwide, American artist Theaster Gates was named the inaugural recipient of the prize for *Dorchester Projects* in Chicago. The paradox of any award—that is, to select the best among the best—is incorporated in this publication, where the winning project is seen as part of a diverse and international field of equally significant projects, the finalists to the prize.

* * *

Part One, "The Field," is testimony to this range of visions, providing a lively snapshot into the state of art and social justice on a global level with reflections on key concepts and a survey of the field at large. Here, twenty-two distinct projects are introduced—through photographic documentation chosen by the artists, their statements, as well as the voices of the curators, writers, and scholars who advocate for their projects and who constituted the original Nominators Council for the prize. The flavor of a campaign, with its translation into a passionate language, is maintained in these contributions in order to keep the arguments open and flowing. What we arrive at is not a list of "the best of" but a curated, carefully considered map of artists and projects suggested by a number of leading international curators and art historians that identifies key moments in the growing field of art and social justice.

The project pages are introduced by three keynote essays by leading thinkers, including literary theorist Thomas Keenan with a conversation on

notions of the political as they arise from the projects; curator João Ribas with an examination of ideas around dirt as material and metaphor; and media and legal scholar Sharon Sliwinski with a contribution on visual approaches to social justice.

Part Two of the book offers an in-depth analysis of *Dorchester Projects* by Theaster Gates. Here, four keynote essays look at *Dorchester Projects* from the distinct angles of performance art, urbanism, and the history of race relations in the United States. Providing these perspectives, respectively, is scholar of rhetoric and performance studies Shannon Jackson; Romi N. Crawford, a scholar of critical visual studies; Horace D. Ballard, Jr., an art historian and American studies scholar; and architectural historian and scholar of urbanism Mabel O. Wilson. An interview with Gates on *Dorchester Projects* is followed by eight distinct takes by faculty members of The New School who address the project through a variety of interdisciplinary perspectives, including curatorial practice, design, urban policy, religious studies, music, economics, and biology, speaking to The New School's comprehensive engagement with Gates's work during the prize cycle of programs, which also included an exhibition and conference. Written in response to a faculty trip to *Dorchester Projects* in Chicago in 2013, these contributions operate in a productive space between academic discourse and personal reflection.

Gates began *Dorchester Projects* in 2008 by transforming two buildings on Chicago's South Side into community gathering spaces with a library, slide archive, performance space, and soul food kitchen. The ongoing piece examines urban renewal and social justice through the lens of art, spirituality, alternative economies, and community engagement. A bold American artist with a global vision, Gates and his work expand the discourse of political enfranchisement and social inclusion. Prize jury chair Okwui Enwezor pointed out that:

Theaster Gates's project of historical reclamation, interrogation of archival legacies, and social construction of memory and cultural agency has it all tied together. *Dorchester Projects* layers a meditation on the present African American experience by connecting it to the haunted remains of the past, making links with narratives of race

consciousnesses, the Civil Rights Movements, but ultimately probing how the African American experience is enlivened by ongoing processes of testimony. Entering that installation is like entering a haunted space.

* * *

Exceeding all expectations, this field guide has become something of a movement itself with numerous stakeholders contributing in various forms. The book features the works of twenty-three artists or art collectives in their own photographs and words. The editors commissioned twenty-six new texts from curators, critics, artists, and scholars, challenging us to understand the stakes when we posit that art advances social justice and lending a sense of urgency and purposefulness to the reader. And the entire project was supported by extraordinary companions along the way, whose trust has found expression on these pages: there is the Nominators Council (listed individually on p. 277), professionals whose work at the forefront of politically engaged art—often happening far beyond the traditional confines of the art world—has shaped the work of the Vera List Center for many years. A particular note of thanks is due to the resourceful jury for the inaugural prize: my New School colleague, curator Lydia Matthews; artist Susan Meiselas; social justice advocate Dorothy Q. Thomas; and especially our chair, Okwui Enwezor.

The Prize Founding Supporters did as their name implies, lay the foundation for this most important initiative. They are James-Keith Brown and Eric Diefenbach, Elizabeth R. Hilpman and Byron Tucker, Jane Lombard, and Joshua Mack. The New School has supported the prize initiative and the Vera List Center for many years, currently under the leadership of the school's Public Engagement executive dean Mary Watson. Among our most essential supporters is the Vera List Center Advisory Committee, chaired by James-Keith Brown. To him—and to them—my profound appreciation. I am also grateful to Norman Kleeblatt, a member of the committee, who facilitated the introduction to The Malka Fund.

For close to three years, I was fortunate to have curator and art historian Chelsea Haines on my side as we first developed the exhibition *Theaster*

Gates: A Way of Working, presented at the Sheila C. Johnson Design Center at Parsons School of Design in September 2013, and then conceived and organized this publication. Chelsea's dedication, astute perception, and insights have shaped every aspect of this extended project, and I am grateful to her for generously sharing her skills, including a healthy dose of patience and stamina. The various elements of the prize initiative—from initial conception to conference and engagement with various classes—also benefited greatly from Vera List Center program associate Johanna Taylor's crucial support. An early discussion with the ad-hoc publication subcommittee—Lydia Matthews and Sina Najafi, augmented by Radhika Subramaniam—was additionally most helpful.

I hasten to thank the following colleagues and friends: Tabor Banquer in the University Development and Alumni Relations Office; Emily Donnelly and Naomi Miller, currently and formerly at the Vera List Center; Jocelyn Edens; New School curators Silvia Rocciolo and Eric Stark; former New School for Public Engagement dean David Scobey; Radhika Subramaniam, director and chief curator of the Sheila C. Johnson Design Center; curator Chen Tamir; Kate Hadley Toftness and La Keisha Leek at Rebuild Foundation; and Alexandra Small at Theaster Gates's studio. The book design is testimony to Project Projects's extraordinary talents, this time enjoyed in a lovely collaboration with Adam Michaels and Grace Robinson-Leo. The copy editor was again the adept Stephen Hoban; editorial assistant was Zoe Carey. I am grateful for another delightful collaboration with Duke University Press, spearheaded by senior editor and editorial department manager Courtney Berger. And thank you to a particular friend of heart and mind, John G. H. Oakes.

Part 1

The Field

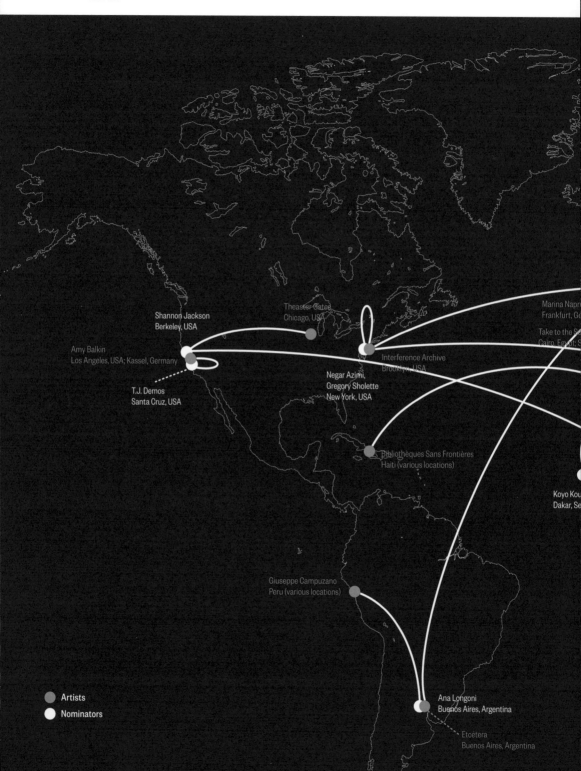

Shannon Jackson
Berkeley, USA

Theaster Gates
Chicago, USA

Marina Napr
Frankfurt, Ge

Take to the S
Cairo, Egypt; S

Amy Balkin
Los Ángeles, USA; Kassel, Germany

Interference Archive
Brooklyn, USA

Negar Azimi,
Gregory Sholette
New York, USA

T.J. Demos
Santa Cruz, USA

Bibliothèques Sans Frontières
Haïti (various locations)

Koyo Kou
Dakar, Se

Giuseppe Campuzano
Peru (various locations)

Ana Longoni
Buenos Aires, Argentina

Etcétera
Buenos Aires, Argentina

● Artists
○ Nominators

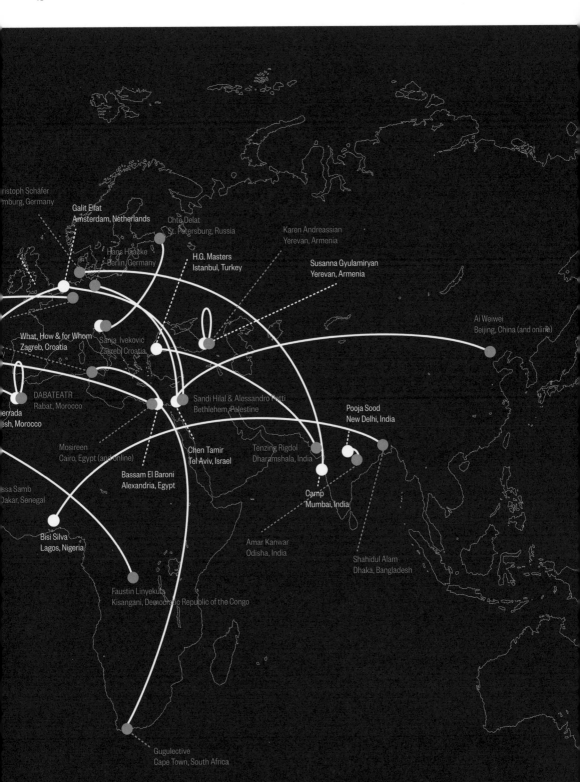

ristoph Schäfer
mburg, Germany

Galit Eilat
Amsterdam, Netherlands

Chto Delat
St. Petersburg, Russia

Karen Andreassian
Yerevan, Armenia

Hans Haacke
Berlin, Germany

H.G. Masters
Istanbul, Turkey

Susanna Gyulamiryan
Yerevan, Armenia

Ai Weiwei
Beijing, China (and online)

What, How & for Whom
Zagreb, Croatia

Sanja Iveković
Zagreb, Croatia

DABATEATR
Rabat, Morocco

errada
esh, Morocco

Sandi Hilal & Alessandro Petti
Bethlehem, Palestine

Pooja Sood
New Delhi, India

Mosireen
Cairo, Egypt (and online)

Chen Tamir
Tel Aviv, Israel

Tenzing Rigdol
Dharamshala, India

Bassam El Baroni
Alexandria, Egypt

ssa Samb
Dakar, Senegal

Camp
Mumbai, India

Bisi Silva
Lagos, Nigeria

Amar Kanwar
Odisha, India

Shahidul Alam
Dhaka, Bangladesh

Faustin Linyekula
Kisangani, Democratic Republic of the Congo

Gugulective
Cape Town, South Africa

That Incorrigible Disturber of the Peace

Sharon Sliwinski

"And what is the use of a book," thought Alice, "without pictures
or conversations?"
—Lewis Carroll, *Alice's Adventures in Wonderland*

When I was still a child, my maternal grandmother died of cancer. I
remember the event chiefly because it meant my mother went away for a
few weeks, "to take care of things," as she put it. I was young enough that
her absence was difficult. She brought some of her mother's possessions
back with her when she returned, and in one of the boxes I found a slen-
der picture book called *Creative America*. I remember stealing away to lose
myself in the book's photographs—mind-voyaging in the way children
do with picture books. I didn't really understand what was being por-
trayed, but I remember that I loved the book. Over the years, it eventually
migrated onto my own shelves, though I rarely opened it as an adult.

Creative America was published in 1962 by an organization called the
National Cultural Center. It was designed to celebrate the arts and
featured short essays by well-known American writers and pictures by
Magnum photographers. In an introductory essay, John F. Kennedy
praises the arts as incarnating social freedom. He distinguishes the United
States's artistic community from that of "totalitarian society" and wel-
comed "the free and unconfirmed search for new ways of expressing the
experience of the present."[1] Kennedy's words seem haunting on a number
of levels. Reading the book now is a rather disquieting exercise. To the
adult's eyes, this once beloved and familiar object seems like an unrecog-
nizable relic of statecraft issued at the end of some distant, gilded age.

 Despite its unseasonable air, parts of *Creative America* still have
the power to startle. In a short essay titled "The Creative Process," for
instance, James Baldwin offers a pithy account of the artist's primary
distinction. According to Baldwin, the artist is charged with cultivating
something that most people tend to avoid: the state of being alone. Most
of us are not compelled nor inclined to linger with the state of aloneness.

1 John F. Kennedy, *Creative America*
(New York: National Cultural Center/
Ridge Press, 1962), p. 4.

Fifty years later, in the midst of our own so-called age of connectivity, the insight seems remarkably prescient. In Baldwin's mind, our aversion to aloneness has to do with the way the condition can paralyze action:

> There are, forever, swamps to be drained, cities to be created, mines to be exploited, children to be fed. None of these things can be done alone. But the conquest of the physical world is not man's only duty. He is also enjoined to conquer the great wilderness of himself. The precise role of the artist, then, is to illuminate that darkness, blaze roads through that vast forest, so that we will not, in all our doing, lose sight of its purpose, which is, after all, to make the world a more human dwelling place.[2]

For Baldwin, the artist is a figure to be distinguished from all other responsible actors in society, an "incorrigible disturber of the peace," who trades chiefly in intimate knowledge of the human condition, which is to say, knowledge that most of us would rather not know. His essay presses uncomfortably on this point, on the fact that there is a great deal that we do not wish to know, and that the chief matter that we wish to remain ignorant of is knowledge of ourselves. He writes: "the barrier between oneself and one's knowledge of oneself is high indeed." Baldwin's argument here is that society itself creates a bulwark against this most intimate information. We are social creatures because facing the strangeness inside ourselves is simply too frightening. The artist, on the other hand, dares to tarry with these interior forces that menace our precarious security.

Baldwin's essay could be read as an old-fashioned grandiloquent portrait of the artist as a melancholy figure who is perpetually at odds with society. Contemporary readers might be suspicious of such a vision, in part, because we have rightly become skeptical of the *mythos* of individuality. Baldwin is not defending this particular *mythos*. But on

2 James Baldwin, "The Creative Process," originally printed in *Creative America* and reprinted in Baldwin, *Collected Essays*, ed. Toni Morrison (New York: The Library of America, 1998), p. 669. Contemporary readers who are attuned to the debates about the "Anthropocene epoch" might find Baldwin's phrasing naïve. Rather than transform the world into a more "human dwelling place," we have, in fact, created a global climate crisis. As Claire Colebrook puts it: "the human species is now recognizable as a being that for all its seeming diversity is nevertheless bound into a unity of destructive power." *Death of the Posthuman: Essays on Extinction, Vol. 1* (Ann Arbor, Mich.: Open Humanities Press, 2014).

the face of it, even his definition of aloneness seems like a condition
that falls outside the purview of politics proper. As Hannah Arendt often
insisted, politics is based on the fact of human plurality. It arises in what
lies *between* people, in the web of human relationships. Dwelling with the
state of aloneness seems like the very opposite of the idea of the *demos,*
the inverse of what Arendt described as the "the common public world."[3]

But let's linger with Baldwin's argument for a moment longer.
What if, as a fundamental fact of human subjectivity, each one of us
was inhabited by a strange otherness? And what if the ability to tolerate
this uncomfortable condition was a kind of necessary prerequisite upon
which the common public world depended? And further, what if, in our
current political epoch, so thoroughly dominated by neoliberal forms
of rationality that find this incalculable otherness indigestible, the
capacity for aloneness was more significant than ever before? However
counterintuitive it might seem, Baldwin is proposing exactly this: tarry-
ing with the state of being alone—and by extension, with those aspects
of being human that most of us would rather not face—is what makes
the artist among the most potent of political actors.

To cast this slightly differently, Baldwin is defining and defending
something we might call *political interiority.* In another age, we might
have simply called it the soul of the citizen. This is not a particularly
fashionable topic today, but it is worth remembering that, once upon
a time, every major political theory sought to address both aspects of
human life: the external and the internal. Aristotle claimed, for instance,
that in order for the *polis* to survive and thrive, it required that mem-
bers of the city-state have adequate material goods, but also that it
nurture the *psychē.* For a more recent example, consider Steve Biko,
one of the leading political voices in South Africa during the apartheid
years. Under the magnificent pseudonym Frank Talk, Biko articulated
an "inward looking process" he called Black Consciousness. Its "first
truth" was "to make black man come to himself; to pump life back into

3 Hannah Arendt uses the phrase
frequently, including in her long
essay, "Introduction *into* Politics,"
in *The Promise of Politics,* ed. Jerome
Kohn (New York: Schocken Books,
2005), p. 122.

his empty shell; to infuse him with pride and dignity; to remind him of his complicity in the crime of allowing himself to be misused."[4]

Civil resistance movements can be distinguished by this characteristic address to political interiority. Such appeals have the effect of exposing the gap between justice and the law. In his pivotal essay "On Civil Disobedience," for instance, Henry David Thoreau reflects on "the foolishness of that institution which treated me as if I were mere flesh and blood and bones."[5] The State, as Thoreau called it, may have an exquisite repertoire of techniques to assault and discipline the body, but it always fails to address the human being's inner "sense."

Thoreau drew his reflections from a night spent in prison, and perhaps it is worth noting just how much of this tradition of political thought overlaps with the genre of prison literature. If the experience does not destroy the mind, the solitude that prison imposes can induce a dialogue with the self. Or in Baldwin's terms, the imposition of aloneness can necessitate a tarrying with the great wilderness inside.[6] Consider that other incorrigible disturber of the peace, Dr. Martin Luther King, Jr., and the singular defense of human dignity that he managed to fashion in his "Letter from Birmingham City Jail." As King himself concedes, the letter would have been much shorter had he been writing from a comfortable desk: "what else is there to do when you are alone for days in the dull monotony of a narrow jail cell other than write long letters, think strange thoughts, and pray long prayers?"[7] There is a notable kinship between artists and the great political leaders on this point: both are able to wander in the great wilderness of the self, to eke out sustenance from the state of being alone.

4 Steve Biko, "We Blacks," in *I Write What I Like: Selected Writings* (Chicago: University of Chicago Press, 2002), p. 29.

5 Henry David Thoreau, "On Civil Disobedience," in *On Civil Disobedience and Other Essays* (New York: Dover, 1993), p. 12.

6 It bears pointing out that Baldwin wrote scathingly about the prison system in his "Open Letter To My Sister, Miss Angela Davis"

(printed in the *New York Review of Books*, January 7, 1971). It also bears pointing out that the mass incarceration of people in the United States has increased by 500 percent in the past forty years. Some 2.2 million people are behind bars, many for nonviolent offenses such as drug possession. And over 840,000 of these prisoners–40% of the prison population–are African American men. Echoing Baldwin's appeal, Jed S. Rakoff has recently called for more of us to speak out about this evil of

our time. See "Mass Incarceration: The Silence of the Judges," *New York Review of Books*, May 21, 2015. See also Angela Y. Davis, *Are Prisons Obsolete?* (New York: Seven Stories Press/Open Media, 2003).

7 Martin Luther King, Jr., "Letter from Birmingham City Jail," in *A Testament of Hope: The Essential Writings and Speeches of Martin Luther King Jr.*, ed. James M. Washington (New York: Harper, 1986), p. 302.

As you probably have surmised, I am making a case for the way Baldwin's essay offers a fresh set of entry points into the intersection of art and social justice. There is a more familiar set of philosophical debates about this particular crossroads (dominated by the Frankfurt School on the one hand and by a variety of interpretations of Kant's *Critique of Judgement* on the other).[8] But these entrenched arguments have a way of predetermining the route that one takes through this particular terrain. Baldwin's nimble lead takes us to other, less-traveled paths, alternate routes that nevertheless have their own beacons blazing in the dark.

Let's call one of these routes "The Path of Two Worlds." In Baldwin's mind, a great part of the artist's responsibility is to never cease fighting with the society of which he or she is a part. Later he frames this as a lover's quarrel, but he initially suggests that the battle has to do with the fact that society, by its nature, can only acknowledge the manifest world: "Society must accept some things as real," he writes. "One cannot possibly build a school, teach a child, or drive a car without taking some things for granted." But the artist's primary responsibility lies elsewhere. He or she must nurture the belief that "visible reality hides a deeper one, and that all our action and achievement rest on things unseen."[9] The artist is charged with this duty—for her own sake, but also for the sake of society—to tend this deeper reality, to nurture a vision of another world, a world that is sustained only by the imagination, one which the artist often cannot stop herself from creating.

The enclosed space of the studio often serves as the primary stage for this imaginary exercise. The studio is, of course, an enduring *topos* in the history of art. In her recent series *100 Days of Solitude*, the Palestinian

8 The Frankfurt School debates have several strands, one of which turns on the merits of politically committed art versus autonomous art. Several of the key texts are included in a volume called *Aesthetics and Politics*, ed. Fredric Jameson (London: Verso, 1980). A short list of the thinkers who returned to Kant's Third Critique include: Hannah Arendt, *Lectures on Kant's Political Philosophy*, ed. Ronald Beiner (Chicago: University of Chicago Press, 1982); Jean-François Lyotard, *Lessons on the Analytic of the Sublime*, trans. Elizabeth Rottenberg (Stanford: Stanford University Press, 1994); Jacques Rancière, *The Politics of Aesthetics*, trans. Gabriel Rockhill (New York: Continuum, 2006).

9 Baldwin, "The Creative Process," p. 670.

artist Nidaa Badwan probed the extreme edges of the genre.[10] Badwan
has barely left her studio in Gaza in two years. It is a self-imposed isola-
tion, but one that draws into sharp relief the devastating situation of
the larger territory. Badwan's room is less than one hundred square
feet; she has just one window and one light bulb. In this tiny space, she
creates strikingly colorful photographic portraits that effectively screen
out the grey desolation outside: the vast tracks of urban ruin caused by
the ongoing air wars with Israel, the poverty and suffering imposed
by the blockade, and the increasingly militant religious environment
demanded by Hamas. As Badwan puts it: "I feel I'm not living here.
The project made new windows for me."[11] The intimate photographic
interiors have been compared to the Renaissance masters, but they are
perhaps more reminiscent of Yinka Shonibare's playful engagements
with character and identity—the way they hint at (if they don't quite
provide) a narrative. Badwan's willingness to tarry with solitude epito-
mizes Baldwin's insight that blazing a trail through the wilderness of the
self can, at times, be the only means to retain a vision of the world as a
human dwelling place.

The staunchest of critics might dismiss such efforts as a consolatory
retreat from a devastating reality. What effect does nurturing imaginary
worlds have on the ordinary conditions of human existence? At its best, isn't
this just a species of heroic optimism, and at its worst, wishful thinking?

The same charge could be levelled at social justice movements.
Thoreau's aforementioned essay—a staple in political science curric-
ula—ends with this unforgettable exercise in imagining:

> I please myself with imagining a State at least which can afford to be
> just to all men, and to treat the individual with respect as a neighbor;
> which even would not think it inconsistent with its own repose if a
> few were to live aloof from it, not meddling with it, nor embraced by
> it, who fulfill all the duties of neighbors and fellow men. A State of

10 See Badwan's website for
the complete series: http://www.
nidaabadwan.com.

11 Jodi Rudoren, "A Gaza Artist
Creates 100 Square Feet of
Beauty and She's Not Budging,"

New York Times, February 27,
2015, http://www.nytimes
.com/2015/02/28/world/middleeast/
finding-gaza-unbearable-artist-
creates-her-own-world-in-one-
room.html.

which bore this kind of fruit, and suffered it to drop off as fast as it ripened, would prepare the way for a still more perfect and glorious State, which I also have imagined, but not yet anywhere seen.[12]

Eve Arnold, *Non-Violence (USA. Virginia. Petersburg. Civil strike, Core group. Training activist not to react when smoke is blown in her face)*, 1960

Thoreau is but one in a long list of thinkers whose political practice rests on nurturing a vision of an alternate reality. This is the principle that lies at the heart of civil resistance: a steely commitment to a deeper reality, an unshakable adherence to the idea that another, better world is possible.

This is one of the lessons that *Creative America* can still offer us, or at least this is the memory that the book retains for me: the idea that there is a delicate kinship between artistic and political practice, a kinship that rests on the quixotic fact that "the truth about us is always at variance with what we wish it to be," as Baldwin sagely observes. "The human effort is to bring these two realities into a relationship resembling reconciliation."[13]

Let me conclude with a series of images that epitomize, for me, the nature of this "human effort." The photographs were made by Eve Arnold in 1960. The sequence did not make it into *Creative America,* although I am tempted, now, to make the case that they should have been included. The great majority of the images in the book are

12 Thoreau, "On Civil Disobedience,"
p. 18.

13 Baldwin, "The Creative Process,"
p. 671.

Eve Arnold, *Non-Violence (USA. Virginia. Petersburg. Civil strike, Core group. Training activist not to react to provocation)*, 1960

attributed to Arnold, who joined Magnum in the 1950s. She frequently blurred the genres of documentary and portraiture, and she is perhaps best known for her unparalleled portraits of Marilyn Monroe (a body of work that puts pressure on the idea that the authorship of images belongs to their maker rather than their subject). But in 1960, she was in Petersburg, Virginia, covering civil resistance training. The young woman at the center of this series is Priscilla Washington, a twenty-year-old biology major who was attending Virginia State College at the time. For Arnold, the training sessions must have seemed uncannily similar to the more familiar form of stagecraft that she often photographed. Here protestors act out a scene from a lunch-counter sit-in, complete with mock harassment from patrons.

There is so much to say about this remarkable sequence of photographs, but to my eyes, they stand as vivid reminders of the human effort—the sheer force of creativity—that is required to bring two realities into a relationship resembling reconciliation. The political actors are all too aware of the strange way in which their "very presence is said to be bad," according to Jim Wood, Chairman of the Political Action Committee, who was the speaker at that meeting in Virginia in 1960. "The fact that you can't eat at the lunch counter is a device, a reminder that you're inferior," he points out. "We have to find a device that will change these things."

For Jim Wood, Priscilla Washington, and scores of others, the device of change is a form of political stagecraft known as civil resistance. Its lessons are worth remembering in our own troubled times. For Eve Arnold, Nidaa Badwan, and for many other artists, the device is photography. But whatever the tool, these incorrigible disturbers of the peace teach us, over and over, that our common public world is a manufactured one, that nothing under the sun is stable, least of all ourselves. Their courage to tarry with this disquieting fact makes for a more human dwelling place.

On Dirt

João Ribas

Dirt, as material and metaphor, grounds our notions of the civic and of social justice.

As a raw material of urban planning, dirt can transform landfills into public parks, abandoned city lots into community gardens. Dirt grows, and as an entropic and formless material, is built upon.[1] Yet as garbage, waste, or filth, dirt is also what is pushed out of the social space of the city, and in doing so, marks territory and exclusion. Massive piles of refuse wait to decay into dirt; as pollution, dirt claims and appropriates by soiling.[2] Dirt *dirties*: as contagion or filth, it invokes disgust, and with it, normative conceptions of moral desert and legislative demand.

Is what is dirty what most calls out for justice, even as the civic becomes increasingly shaped by waste?

1. Ground

On the edge of an estuary in the borough of Staten Island sit over fifty years of garbage, piled up in four massive and sprawling mounds.[3] Known as the Fresh Kills Landfill, this dumping ground was established in 1948 by Robert Moses, New York City Parks Commissioner, on a site then consisting of low-lying marshes and tidal creeks about fifteen miles from Lower Manhattan. The initial plan for the new landfill used the problem of efficiently disposing of "municipal solid waste" to provide a foundation for new development projects.[4] As a landfill, it was only to be in operation for a five-year period. By the mid-1950s, however, Fresh Kills was already the largest garbage dump in the world, and the

1 Antonio Furgiuele, in conversation with the author. I am indeed grateful to Prof. Furgiuele for his suggestion of "the entropic nature of dirt," and for his indispensable criticisms during the writing of this text.

2 See Michel Serres, *Malfeasance: Appropriation Through Pollution?* (Stanford: Stanford University Press, 2010).

3 "Freshkills Park: NYC Parks," New York City Department of Parks and Recreation, http://www.nycgovparks .org/park-features/freshkills-park/ about-the-site#history; Daniel Irving and Ian J. Vincent, "The Ethics of Place-Making: How Landscapes Lie," *xsection* (November 2013), http://xsection-placemaking. blogspot.co.at/p/blog-page_23.html.

4 John May, *Bringing Back a Fresh Kill: Notes on a Dream of Territorial Resuscitation*, http://issuu.com/ millionsofmovingparts/docs/ johnmay-freshkill.

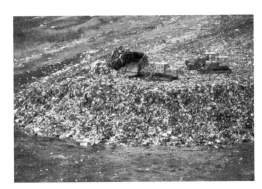

Chester Higgins, *Dumping area of New York City's Sanitation Department at Fresh Kills, Staten Island,* 1973

main disposal site for household refuse collected throughout the boroughs of the city of New York.[5] The eventual growth and development of the city, and the closing of its other landfills over the ensuing decades, meant Fresh Kills became a "3000-acre topography of trash without anyone quite intending it," as John May explains.[6]

This mass of solid waste became formed as the displaced volume of the city's postwar consumption—much in its raw, quantified state—sent off to decompose at the variable rates of organic and inorganic detritus. The very existence of Fresh Kills afforded New Yorkers the ability to live for several decades with little alteration to habits of consumption, and in doing so, avoid confronting the fact that the unseen place where the resulting waste was being sent to "is always a real place," as Robin Nagle explains.[7] The landfill received nearly 29,000 tons of solid waste every single day during its operational peak between 1986 and 1987.[8] By the time the last barge of trash was dumped on the site on March 22, 2001, the four mounds packed nearly 150 million tons of garbage, from slow-degrading plastic to decaying gray slime sitting twenty-five feet below the surface.[9]

5 "Freshkills Park: NYC Parks." A T-shirt bearing the slogan "World's Largest Landfill" was given to employees in the early 1990s. See "Online Collections Database of Historic Richmond Town and Staten Island Historical Society," http://statenisland.pastperfect-online.com/00039cgi/mweb.exe?request=record;id=9422DDA0-8F50-447B-8EAF-472394782284;type=101.

6 May, *Bringing Back a Fresh Kill.*

7 Robin Nagle, "The History and Future of Fresh Kills," in *How to Love a Landfill: Dirt and the Environment,* http://discardstudies.files.wordpress.com/2011/03/tolovealandfill-wellcome.pdf.

8 Ibid., and "Freshkills Park: NYC Parks."

9 "Freshkills Park: NYC Parks," and J. Raloff, "'Big Dig' Unearths Clues to Garbage Decay," *Science News* 138, no. 21 (Nov. 24, 1990), p. 324.

Following the closing of the landfill, the City of New York initiated what it called "a master planning process," whose goal was to transform the Fresh Kills Landfill "into a world class park." Known as "The Fresh Kills Draft Master Plan" it was to serve as a "blueprint for reclaiming the largest landfill in the country," then off-gassing 30 million cubic feet of methane gas daily.[10] The Fresh Kills Landfill was to be reconceived as Freshkills Park (the name itself suggests a linguistic clean up), a project to be developed over the next thirty years:[11]

> At 2,200 acres, Freshkills Park will be almost three times the size of Central Park and the largest park developed in New York City in over 100 years. The transformation of what was formerly the world's largest landfill into a productive and beautiful cultural destination will make the park a symbol of renewal and an expression of how our society can restore balance to its landscape.[12]

As a park, Freshkills proposes a new kind of civic space, built precisely on waste. That is, the park is to be formed on what had been *excluded and pushed out of* social, civic, and domestic space in the first place. Dirt, as Mary Douglas argued in her landmark study *Purity and Danger*, is "matter out of place."[13] While the soil in a garden nourishes the growth of life, when tread on a carpet, this same soil is dirt, a blemish, or stain.[14] This denotation of exclusion is both material and spatial in the case of the landfill as urban blight: in the first sense, defined as garbage, commodities now deemed used and expended are

10 May, *Bringing Back A Fresh Kill*, and "Fresh Kills: Department of City Planning," http://www.nyc.gov/html/dcp/html/fkl/fkl_index.shtml.

11 "Freshkills Park: NYC Parks." Nagle explains that an earlier planning report from 1968 had proposed converting the site to a ski resort. Nagle, "The History and Future of Fresh Kills."

12 Freshkills Park Blog, http://freshkillspark.wordpress.com.

13 Mary Douglas, *Purity and Danger* (London: Routledge, 2003), p. 41. As Douglas writes, "Uncleanness or dirt is that which must not be included if a pattern is to be maintained."

14 Terence McLaughlin, *Dirt: A Social History as Seen Through the Uses and Abuses of Dirt* (New York: Stein and Day, 1971), p. 1. "There is no such material as *absolute* dirt," McLaughlin explains, but "it is only in our judgments that things are dirty."

sent off as trash; no longer part of the consumption patterns of daily
urban experience, this refuse is then relegated to a site just *outside*
that very same urban space in which such patterns are enacted and
enforced daily.[15]

The Fresh Kills site, not quite marginal yet not within view, was
located precisely at the liminal border between conurbation and natural
habitat. One of the touted features of the new park, for instance, will be
"spectacular vistas of the New York City region," offered, one supposes,
by standing on its own refuse.[16] Garbage, as landfill, helps to establish
just such a geographical and ideological terrain, functioning as the
necessary constitutive site that allows the social space of the city to exist
and to appear to remain operational.[17] As Michel Serres writes, "what
we throw away is a new way to mark our territories," and in doing so,
"[a]ppropriation takes places through dirt."[18] As if to perversely further
emphasize the point, the planned reclamation of the landfill, turning the
outside of social space into a public space, also includes the harvesting
of methane from the decomposing garbage to provide energy for the city:

> This methane, enough to heat approximately 22,000 homes, is sold
> to National Grid and the city generates approximately $12 million in
> annual revenue from the sale of that gas.[19]

With a variety of "public spaces and facilities for social, cultural
and physical activity," the landfill-as-park will be built on a complex
layer of materials both "dirty" and reclaimed by dirt. It is the entropic

15 Nagle, "The History and Future
of Fresh Kills." As Nagle writes,
"Since landfills are usually sited
far from crowded population
centers they allow the illusion that
there is a distant, disconnected
place to 'throw away' rejectamenta."
David Pike writes, "The landfill,
like the sewer, has been closely
associated with the definition and
division of the urban population
between what is pure and what is
filthy, what is useful and what is to
be discarded." David L. Pike, "The
Cinematic Sewer," in *Dirt: New
Geographies of Cleanliness and*

Contamination (London: Taurus & Co.,
2007), p.138.

16 "Freshkills Park: NYC Parks."

17 As Nagle writes, "Without a
functioning landfill or some other
way of ridding itself of debris,
no metropolis can survive." May
asserts that "the closure and
imagined reclamation of Fresh Kills
is an attempt to redraw exceeded
limits; the hopeful projection of
techniques to fetter an accidental
urbanism." Nagle, "The History and
Future of Fresh Kills."

18 Serres, p. 3.

19 "Freshkills Park: NYC Parks."

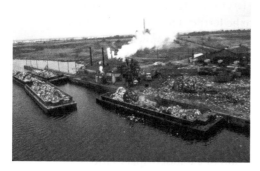

Chester Higgins, *Garbage scows bring solid waste, for use as landfill, to Fresh Kills on Staten Island, 1973*

nature of dirt—as both garbage and soil—that makes the transformation of such excluded space to civic space possible.[20] This is to be achieved by a complex engineering process of covering the garbage mounds "with a thick, impermeable cap," that is meant to "provide for hydraulic performance, slope stability and long-term integrity or durability of the landfill and its systems."[21] Constructed in suggestive stages, this cover is meant to minimize water infiltration from the surface, prevent erosion, promote drainage, and to separate "the waste layer from the environment to protect public health," while also capturing and preventing "the emission of air polluting gases."[22]

To cover or cap the mounds, a soil barrier layer is first placed over the waste. This layer is followed by a gas venting layer and then an impermeable liner, made from clay or plastic material; a further drainage layer reduces "the pressure of water on the barrier layer and increases friction, thus reducing the risk of sliding"; a following barrier protection layer is made of soil with "a minimum thickness of 24 inches, and more where trees are to be planted"; finally, a planting soil layer is placed on top:

20 It is interesting to note the often interchangeable use of "dirt" and "soil," as materials, an example of a semantic form of "distancing," as well as in using the word for the material to denote uncleanliness.

21 "Freshkills Park: NYC Parks." Two of the mounds had already been capped in the late 1990s; the process of capping the remaining two began in 2007, and will take more than a decade to complete. For a critique of this method, see May, *Bringing Back a Fresh Kill.*

22 "Freshkills Park Project," Department of City Planning, http:// www.nyc.gov/html/dcp/html/fkl/ fk13c.shtml.

The planting soil layer or top soil layer must have a minimum thickness of six inches. It is specified to be fertile. The soil used is a sandy loam, selected for its potential to prevent soil erosion and to provide a good growing medium for the vegetation layer. The primary objective of the vegetation layer is to protect the integrity of the final cover through erosion control. A network of plant roots hold onto the soil, providing stability.[23]

Dirt *grows*, and as a formless material, can be built on. Dirt is thus a central component of the transformation of excluded spaces into part of the commons of the city. Yet the soil that can convert a landfill to a park or commons is not a homogeneous substance, but rather a varied mixture of minerals, compounds, and inorganic and organic matter. Dirt is "the most complicated biomaterial on the planet."[24] Along with harnessing multiple social and environmental imaginaries, the process of converting garbage into landscape through layers of soil entails a variety of agents and actors, all mobilized to mitigate the significant anthropogenic change that a landfill-into-park implies, throughout the various steps of its complex life.

As Charles Darwin proposed in *The Formation of Vegetable Mould through the Action of Worms, with Observations on their Habits*, it is the earthworm that has worked tirelessly to sustain the fertility of the earth for millennia, turning dirt into soil. Darwin estimated that 53,767 worms could be found in a single acre.[25] "A weight of more than ten tons (10,516 kilograms) of dry earth annually passes through their bodies," he wrote,

23 Ibid.

24 I. M. Young and J. W. Crawford, "Interactions and Self-Organization in the Soil-Microbe Complex," *Science* 304, no. 5677 (June 11, 2004), pp. 1634–37, doi: 10.1126/science.1097394.

25 Charles Darwin, *The Formation of Vegetable Mould through the Action of Worms, with Observations on their Habits* (London: John Murray, 1881).

"and is brought to the surface on each acre of land; so that the whole superficial bed of vegetable mould passes through their bodies in the course of every few years."[26] The effects of this process are historically and geologically extraordinary:

> It has been shown that a layer of earth, .2 of an inch in thickness, is in many places annually brought to the surface per acre ... It is known from the amount of sediment annually delivered into the sea by the Mississippi, that its enormous drainage-area must on an average be lowered .00263 of an inch each year; and this would suffice in four and half million years to lower the whole drainage-area to the level of the sea-shore. So that, if a small fraction of the layer of fine earth, .2 of an inch in thickness, which is annually brought to the surface by worms, is carried away, a great result cannot fail to be produced within a period which no geologist considers extremely long.[27]

2. Figure

> *Then, churls, their thoughts (although their eyes were kind)*
> *To thy fair flower add the rank smell of weeds;*
> *But why thy odor matcheth not thy show,*
> *The soil is this, that thou dost common grow.*[28]

Dirt also *dirties*: proximity or contact with whatever is perceived to be dirty has the potential to pollute or contaminate.[29] If dirt is "matter out

26 Ibid.

27 Ibid.

28 William Shakespeare, "Sonnet 69," in G. Blakemore Evans, ed., *The Sonnets* (Cambridge: New Cambridge Shakespeare, 2013), p. 69.

29 William Ian Miller, *The Anatomy of Disgust* (Cambridge, Mass.: Harvard University Press, 1997), pp. 2, 5, 8; Martha C. Nussbaum, *Hiding from Humanity: Disgust, Shame, and the Law* (Princeton: Princeton University Press, 2004), p. 93;

Antonio Olivera La Rosa and Jaume Rossello Mir, "On the relationship between disgust and morality: A critical review," *Psicothema* 25, no. 2 (2013), pp. 222–26, doi: 10.7334/ psicothema 2012. 223.

of place," then contact with what is dirty sets someone, or something, as out of place itself. Waste, dirt, or filth can defile whatever it touches, be it a space, an object, or a body.[30] This fear of contamination by something unclean is set down plainly in the abiding injunctions in *Leviticus*:

> [I]f a soul touch any unclean thing, whether it be a carcase of an unclean beast, or a carcase of unclean cattle, or the carcase of unclean creeping things, and if it be hidden from him; he also shall be unclean, and guilty.[31]

The perceived contamination by dirt, in threatening to corrupt whatever it comes into contact with, is moral and social, as well as visceral and affective. The actual or perceived danger of pollution or defilement by something unclean elicits a complex set of emotions, as a result. Perhaps principal among them is the feeling of disgust. Disgust is "a strongly aversive emotion," closely intertwined with the senses of touch, smell, sight, and taste.[32] Should an objectionable or offensive thing touch perfectly edible food, for example, it immediately renders it unpalatable, spoiled, revolting.[33] "Whoever spits in the soup keeps it," as Michel Serres writes.[34] The feeling of disgust involves "cognitive content" that is focused on the potential incorporation of such contaminants into one's body, into one's very own self.[35] Dirt elicits powerful affects that are regulatory and seemingly instinctive, strongly felt and so not easily argued.

In its complex phenomenology, disgust then implies a social and moral order, not just a sensorial one; it constructs hierarchies and

30 McLaughlin, *Dirt*, p. 2.

31 Leviticus 5:2.

32 Miller, p. 25. Miller's brilliant study reflects the complex political, moral, and cultural aspects of disgust. As Miller writes, disgust is "lexically marked in English by expressions declaring things or actions to be repulsive, revolting, or giving rise to reactions described as revulsion and abhorrence as well as disgust." Miller, p. 2. The close semantic relationship between dirt, filth, and the obscene, noted even

by the Supreme Court in hearings on obscenity, reflects this. See Nussbaum, *Hiding from Humanity*, p. 73.

33 Nussbaum, *Hiding from Humanity*, pp. 87–88.

34 Serres, p. 2.

35 Nussbaum, *Hiding from Humanity*, pp. 87–88.

exclusions by ranking things and people, as William Ian Miller argues.[36] As a "moral and social sentiment," the feeling of "disgust evaluates (negatively) what it touches," he explains. By proclaiming "inferiority of its object," disgust "locates the bounds of the other," often as "something to be avoided, repelled, or attacked."[37] The emotion of disgust has a regulative and evaluative function: it mobilizes our reactive attitudes toward various types of moral or social behavior, implying all sorts of naturalistic fallacies used to justify, or excuse, forms of rejection and exclusion.

There is the disgust elicited by moral behavior,[38] for example, such that the disgust toward an act—as in the often-cited example of sodomy—is deemed as sufficient grounds to criminalize it.[39] Merely, it seems, if such an act offends the morals of Lord Devlin's famed "man on the Clapham omnibus," and his equally prosaic equivalent, "the man on the street."[40] The history of legal biases against gays and lesbians bares shameful witness to this.[41] Take the example of the role of disgust in mitigating legal punishment in the two cases recounted by Martha Nussbaum and Dan M. Kahan:

> Stephen Carr, a drifter lurking in the woods near the Appalachian Trail, saw two lesbian women making love in their campsite. He shot them, killing one and seriously wounding the other. At trial, charged with first-degree murder, he argued for mitigation to manslaughter on the grounds that his disgust at their lesbian lovemaking had produced a reaction of overwhelming disgust and revulsion that led to the crime.[42]

36 Miller, pp. 2, 8–9, 25, 36.

37 Ibid, pp. 8, 50.

38 Andrew Jones and Julie Fitness, "Moral hypervigilance: The influence of disgust sensitivity in the moral domain," *Emotion* 8, no. 5 (October 2008), pp. 613–27, http://psycnet.apa.org/journals/emo/8/5/613/. As Antonio Olivera La Rosa and Jaume Rossello Mir write, "[V]arious studies suggest that there is an interdependent causal nexus between disgust and moral judgments. For instance, there is evidence supporting that people use their feelings of disgust as embodied information about social events. Thus some studies suggest that incidental disgust can lead to more negative attitudes toward an entire social group." La Rosa & Rossello, "On the relationship between disgust and morality," p. 224.

39 Dan M. Kahan, "The Anatomy of Disgust in Criminal Law," *Michigan Law Review* 96, no. 1621 (May 1998), p. 1623. See also Nussbaum, pp. 2, 4, 72.

40 Patrick Devlin, *Morals and the Criminal Law*, http://faculty.berea.edu/butlerj/Devlin.pdf, quoted in Nussbaum, p. 4.

41 For a detailed study of this relation, see Martha C. Nussbaum's landmark *From Disgust to Humanity: Sexual Orientation and Constitutional Law* (New York: Oxford University Press, 2010).

42 Nussbaum, *Hiding from Humanity* 2, 73. As Nussbaum recounts, Carr was not successful in wining the reduction in sentence. Kahan also discusses the Carr case. Kahan, p. 1622.

Richard Lee Bernardski was convicted of a double murder. Evidence
at trial demonstrated that the eighteen-year-old Bernardski and
his friends had set out one evening to "pester the homosexuals..."
[The] judge who presided over Bernardski's trial expressed sym-
pathy for Bernardski's revulsion. "I put prostitutes and gays at
about the same level," the judge explained, "and I'd be hard put
to give somebody life for killing a prostitute." After all, he said,
Bernardski's victims would not have been killed "if they hadn't
been cruising the streets picking up teen-age boys.... I've got a
teen-age boy."[43]

The implication here is that those who perpetrate such crimes
have some right in being disgusted by their victims.[44] Moreover, disgust
solicits apparent condemnation of the very victims of revulsion for their
"failings," suggesting they are themselves responsible for, and intend,
their own disgustingness.[45] Disgust is therefore a deeply politicized
sentiment that unites ethics with the senses. Such sentiments mark
the dirty as excluded, both lesser and less deserving. An aesthetic
response to the dirty and defilement is thus transformed into an ethical
judgment concerning the source of the dirtying. This question of repre-
sentation, of what and how something, or someone, appears in the social,
is grounded by a connection or distance with polluting, filthying, dis-
gusting, or repugnant effects. With dirt, aesthetics is ethics. As a result,
aesthetic practices readily engage these representational ethics of dirt,
the affects through which the dirtying or dirty is marked for exclusion.

43 Kahan, p.1622.

44 Ibid, p. 1636.

45 Miller, quoted in Kahan, p. 1629.

The forms of exclusion elicited in this way, of those deemed to be polluting or contaminated, is demonstrated particularly strikingly in the case of arguably the longest standing social group to whom repulsion is still attached: the Dalits, or "untouchables," of Indian society.[46] Accounting for "nearly one quarter of India's 1.2 billion society, with population estimates of 250 million people," the Dalits make up the very lowest and most "objectionable" part of India's complex caste (*varnas*) system. Their status is such that contact with what the Dalits touch becomes itself a source of abject revulsion, enforcing a strict avoidance of contact to avoid contagion:

> In 70% of India's villages, for example: non-Dalits will not eat or drink with Dalits. Traditionally, when Dalits enter a teashop and request a cup of tea, they are served in a clay cup rather than a glass or metal cup that others receive. After drinking their tea, they are expected to crush the cup on the ground so that no other person risks being polluted by the cup the Dalit touched.[47]

The Dalits' perceived "dirtiness" is closely attached to the labor they perform in society. As "manual scavengers," they are assigned the cleaning of dry latrines, and so the disposal of human feces.[48] Their lot is also cast by proximity to other waste and garbage, with Dalit residences often located near landfills, cemeteries, toilets, slaughterhouses, or sewage—locations that themselves are sites of revulsion.[49]

46 "Who are the Dalits?," Dalit Freedom Network, 2014, http://www.dalitnetwork.org/go?/dfn/who_are_the_dalit/C64.

47 Ibid.

48 Susie Sell, "India's human-waste gatherers seek a better life," *The Guardian*, November 22, 2013, http://www.theguardian.com/global-development-professionals-network/2013/nov/22/indias-human-waste-gatherers-seek-better-life.

49 Gopal Guru, "Dalits from Margin to Margin," in "Marginalised," special issue, *India International Centre Quarterly* 27, no. 2 (Summer 2000), and "Citizenship in Exile: A Dalit case," in *Civil Society, Public Sphere and Citizenship: Dialogues and Perceptions*, ed. Rajeev Bhargava and Helmut Reifeld (London: Sage Publications, 2005), p. 271.

Yet the Dalits are merely a part of the growing mass of "waste pickers" found worldwide. These are the millions of people that survive by "collecting, sorting, recycling, and selling materials that someone else has thrown away."[50] Increasingly, many of the world's poor have come to rely on such labor, and on the collection of waste, as both a source of food and income.[51] "Hundreds of thousands of the world's poorest citizens live and work on landfills," according to one NGO, "surviving precisely on what the rest of the world's population throws away."[52] Along with being deprived access to social services or education, such people are invariably victims of violence, extreme discrimination, and serious health and environmental hazards, with living standards well below the population whose garbage sustains them.[53] Some are buried alive by the collapsing mounds of refuse.[54] Such people are out of place in every possible sense, their exclusion affirmed precisely by the relation between affect, ethics, and dirt.

50 "Waste Pickers," Women in Informal Employment: Globalizing and Organizing (WIEGO), http:// wiego.org/informal-economy/ occupational-groups/waste-pickers.

51 Katie Bandera, "Dangerous Life for Those Living on Landfills," The Borgen Project, June 28, 2013, http:// borgenproject.org/dangerous-life-for-those-living-on-landfills/.

52 "About Us," The Borgen Project, http://borgenproject.org/about-us/.

53 "Waste Pickers."

54 Stella Paul, "The uncounted people: waste-pickers of India," *Panos*, March 21, 2012, http://panos. org.uk/features/the-uncounted-people-waste-pickers-of-india/.

The Political in and of Art

Thomas Keenan
in conversation with
Carin Kuoni

CARIN KUONI Looking over the projects that map this field, three
sets of questions arise. The first concerns changing notions
of political space and political organizing. The second looks at
ideas around human rights and the relationship between aes-
thetic and judicial or ethical languages or conventions. A third
line of inquiry examines the possibilities of understanding a
situation that is not ours at all. This is a question of communi-
cation, global exchange, but also teaching: how and what can we
learn from any one of these projects?

Let's start with topic number one. The projects featured
in this publication advance social justice through aesthetic inter-
ventions or projects, and were selected for three reasons:
they show long-term impact, boldness (meaning fierce innova-
tion), and they show artistic excellence. Each one interacts
with a community—real, virtual, or imaginary—and in so
doing implies a certain understanding of politics or the political.
Could you comment on some of these implied definitions of
"the political"?

THOMAS KEENAN Before we talk about specifics, it's important to
pay attention to the overall enterprise you've been engaged
in here. I found the artists and projects collected here remark-
ably diverse and plural and incredibly invigorating. Even
inspiring, which is not a word I use very often. It represents an
amazing range of different ways in which people and collectives
are mobilizing artistic strategies to think about political ques-
tions. Such a good sign at a moment when it seems like political
space is shrinking and the forces of order are winning more than
their fair share.

Your gesture in gathering these projects together itself
facilitates a pluralizing and opening up of what counts in and as
politics. And maybe art, too! Both of those categories do not
emerge from this undertaking unscathed. That itself is an essen-
tial political and artistic move, to explode and fragment and
diversify these categories. You've captured, and effectively
endorsed, a real moment of multiplicity in the ways political
activity or engagement or identity can be imagined and prac-
ticed through the arts.

More specifically, I think we can identify a number of approaches to the political that are in play across many of the projects here. One significant group of them takes existing social or political institutions more or less as givens and then imagines—and puts into practice—challenges to and new claims on them that will make them more responsive. A number of projects deal with citizenship, for instance, citizenship understood in a relatively conventional way, which is fine, and they carry along with them a host of related terms: civil rights, access to information, democratic participation, the ability to protest, and so on. Senegalese artist Issa Samb's *Laboratoire Agit'art* (pp. 164–69) or Rabat's DABATEATR (pp. 92–97), with its insistence on theatrical *citoyenneté*, stands out, and likewise Bibliothèques Sans Frontières (pp. 72–77). There is no fundamental challenge to institutions posed by their projects, even in a place that is as fundamentally challenged itself as Haiti after the earthquake of 2010. They simply ask what it means to be a Haitian citizen at a moment when many of the possibilities for civic life in Haiti have, both for political and environmental reasons, collapsed. The basic building blocks of institutional citizenship need to be repaired, rebuilt, and rethought. So the powerful work conducted here consists of renovating these institutions.

> CK Then let me ask, Tom, how artistic interventions contribute to these existing institutions and go beyond simply empowering them or reaffirming their importance? How does the library or Pathshala, Shahidul Alam's photography school in Bangladesh (pp. 54–59), advance our understanding of these institutions in ways that a straightforward support by an NGO initiative does not or cannot?

TK In many of these cases, artists are able to mobilize resources or invent strategies and interventions that NGOs are not sufficiently empowered or imaginative enough to come up with. Libraries Without Borders mimics an NGO strategy and has an NGO name (maybe *the* NGO name!), but it has access to resources, entry points, and modes of organizing its audience that many NGOs could only dream of. Similarly, there are a

number of projects—Sandi Hilal and Alessandro Petti's *Campus in Camps* (pp. 118–23), Pathshala, or Chto Delat (pp. 86–91)—that do what they call teaching, in what they often call schools, but do it in a way that is simultaneously re-imagining what education might be, sometimes in quite unusual forms. Etcétera (pp. 98–105), for instance, speaks of "de-education." By and large, these projects accept a certain notion of what a school is, a place for the transfer or collaborative production of knowledge. *Campus in Camps* involves lots of experienced teachers, and yet the students don't imagine themselves as passive recipients of knowledge but rather as full-fledged "participants," as they call themselves. And they are participants who do things, make spaces, intervene in concrete ways in their communities—and in so doing take active charge of re-imagining what it is to be a refugee and to live in a camp. Maybe that's one of the differences that approaching these questions in terms of art can make.

> **CK** Mobilizing resources through the imaginative or the imaginary is of course also the essence of Theaster Gates's *Dorchester Projects* (p. 182ff). It, too, shows an ability to connect systems that are not necessarily logically or traditionally aligned and ties them together, so that their constituents act as leverage on each other.

TK That's exactly right. And while I'm not an art historian, this seems like a relatively novel phenomenon, namely that in many cases artists have access to transformative resources and ideas that might previously have been the monopoly of either governments or more conventionally defined civic activists.

So some of the projects intervene in or create civic institutions, like schools and libraries, in the name of expanding access to, and the meanings of, citizenship. Sanja Iveković's *Women's House* (pp. 130–35), for instance, not only makes claims on behalf of a marginalized or excluded community but builds an entire institution around them, opens up a space for taking action rather than just receiving help. (And the model—the practice—seems to have spread far from its origins in Croatia.) Cape Town's Gugulective (pp. 106–11) and Mosireen's book

room (pp. 148–53) does something like this, too. Others look toward the margins of citizenship, to those in exile or living as refugees—and *Campus in Camps*, given the unusual status of Palestinian refugees, does some of both—and to the pathways and displacements of people on the move. Migration, especially across the Mediterranean, is not exactly an institution, but it is a highly regulated and codified set of practices.

> **CK** Is this how you would read a project such as Take to the Sea (pp. 176–81)?

TK Yes, and I would also add *Our Land, Our People* (pp. 160–63), which shows such an insane daring, in terms of the size and scope of the project…

> **CK** … and a real commitment to the physical or material.

TK Then there are some difficult projects that refuse easy categorization, because we've never really been there before. For instance, when the artistic intervention has the power of pulling an issue or a category or an identity out of a certain kind of political invisibility and demanding recognition for it. Amy Balkin's *Public Smog* (pp. 66–71) does this: making a claim on behalf of something which might not have been thought of as a political entity or political unit, or which wasn't recognized as such.

> **CK** Amar Kanwar's *The Sovereign Forest* (pp. 136–41) falls into that category as well, no? His proposition to introduce poetics as evidence in legal proceedings is revolutionary.

TK Yes and no. Here we are halfway between the first and second categories we discussed. His series of questions is remarkably eloquent, with its focus on situations in which evidence could be useful but goes completely unrecognized. On the one hand, it is a classic legal, political, institutional question that has been around for as long as courts themselves: how can I introduce evidence or persuade a tribunal that a crime has been

committed? And that has often given rise to a related question: how can I tinker, even just slightly, with the boundaries of what's admissible, so that other things can appear and perform differently? Kanwar is documenting, producing, presenting, and looking for evidence, even while he protests against the institutional restrictions that render the evidence—and the crimes it chronicles—(almost) invisible. Here the artistic endeavor can speak in different ways from conventional legal practices and can make new sorts of claims on judges and audiences—first of all, the claim to make claims.

CK Here, then, a transition is made between the hypothetical "what if" and the actual action, from the symbol or gesture to the specific application.

TK Exactly. Kanwar's forest really takes us to the limits of the political, or at least the juridical—it forces us to confront those limits, which are themselves a matter of politics. In a very different way, Karen Andreassian's *Ontological Walkscapes* (pp. 60–65) does something similar. Going for a walk becomes a political activity—sort of. When the police can't tell the difference between political and ordinary walkers, we have a chance to learn something about politics, and to do something new. I was reminded of Asef Bayat's great book *Life as Politics* (2013), in which he uncovers the political dimensions of some basic attempts at survival or what he calls "quiet encroachment"— building a house or a shanty, appearing in a park, speaking out loud in public—even while he reminds us that it's somehow not exactly right to call them political because they testify to an almost complete collapse of political possibilities. They are practices in which agency is rebuilt from the ground up through what he calls, in a nice formulation for our purposes, "the art of presence."

CK Giuseppe Campuzano's *Museo Travesti del Perú* (pp. 78–85) reminds me of this approach, the only museum of transvestite culture in Peru, which Campuzano would carry on his own body. The insides of his coat were lined with pockets and folds, each

bearing artifacts about transvestite life in Peru, and he could
choose or not choose to open the coat, whenever a moment
arose that he felt was safe or appropriate or necessary. This idea
of an intimate personal space is not necessarily associated with
definitions of a public museum, not unlike the quotidian nature
of Andreassian's everyday walks that don't get read as "political."

TK That's correct, a very delicate project. To define the agents
there, I believe he used the phrase "subjects which refuse classi-
fication," which is very different from the typical claim of identity
that points to and tries to compensate for exclusion (the gay
marriage struggle in the U.S. and elsewhere would be more typi-
cal). Campuzano's project is about holding on to a certain kind of
refusal of identification or recognition, for good political reasons.
The damage he does, in the piece *DNI (De Natura Incertus)*, to his
own identity document would exemplify this practice of what he
calls "transformative post-identity" or "travesty."

 CK Tom, would you comment on these systems of citizen classi-
 fication and how language gets either adapted or subverted? I'm
 thinking of Ai Weiwei's blog (pp. 48–53) as well as the *Office for
 Anti-Propaganda* by Marina Naprushkina (pp. 154–59), and Hans
 Haacke's *To the Population* (pp. 112–17). Interference Archive
 (pp. 124–29) also focuses on the rhetorics of political discourse,
 albeit in a less cynical, ironic way. Mosireen, too, adapts a certain
 language of media newscast and dissemination that speaks to the
 aesthetics or forms of political dialogue.

TK That is possibly one hallmark of the artistic interventions
assembled here, a certain confidence about their capacity to
do new kinds of work with existing political languages. There are
not a whole lot of artists inventing brand new languages here.
Almost everyone here works with a set of terminological and
stylistic givens. The question then is, how much or how little do
I need to, or can I, modify or reshape those discourses to enable
them to do something that they aren't currently doing? And
sometimes, this becomes an immediate intervention.

CK Exactly, when it becomes a performance or a theater or a
play, for instance.

TK Right. So, for instance, you know that there are certain
things that you have to do if you want to show up in the media,
and there are negotiations and compromises that come from
participating in and making use of that language. How far can
I take it and still get away with it? How much do I have to give
before I sacrifice the gesture that I want to make? This conflict
or trade-off becomes clear in the projects based around evidence
or documentation or archiving, such as *more more more . . . future*
by Faustin Linyekula (pp. 142–47) or *Park Fiction* by Christoph
Schäfer (pp. 170–75). These are cases of testing the limits of
what such a discourse can sustain, how to work it or bend it to
get something said.

CK I'd like to probe more deeply the relationship between
strategies of NGOs and human rights organizations versus
what artists do. Social justice, human rights, and similar ethical
standards find legal expressions and a legal framework in con-
stitutions, best-practices documents, or declarations endorsed
by NGOs or other national or international conventions. In your
opinion, how can legal vocabularies and relations intersect with
artistic approaches to ethical notions of human rights? Where
are the crossing points that are mutually beneficial, appropriate,
and productive?

TK The first thing to say is that the intersection between
these fields, to which many of these projects point, is in itself
a noteworthy fact. Why should there be a necessary affinity or
resemblance between the work of artists and the work of NGOs?
There are two factors at work. On the one hand, the form of
the NGO is becoming more and more inescapable for a certain
kind of activist work. Michel Feher and others documented this
nicely in *Nongovernmental Politics* (2007) a few years ago. The NGO
functions either as a citizen movement that offers an alternative
to engagement with the state, or as a device for putting pressure
on the state to fulfill its responsibilities. Either way, the NGO

does seem to be an increasingly common denominator of a great
deal of political and ethical action, including artistic projects.
On the other hand, it seems as though NGOs are themselves
increasingly open to working with, or copying from, artistic
interventions. The American Civil Liberties Union recently had
an "artist-in-residence." Whoever thought that artists would be
embedded at the heart of civil rights organizations, artists as
such, not just as bearers of useful toolkits?

So it's an interesting sign of the times, for better and for
worse, the cross-pollination between the arts and NGOs. To
some extent, these artistic strategies, vocabularies, or rhetorics
are being instrumentalized by NGOs for more or less traditional
purposes, such as storytelling, documentation, visualization,
and the presentation of evidence. But it's significant that we
see, more and more, that NGOs are willing to embrace more
experimental alternative aesthetic strategies. A relevant exam-
ple here would be *Dear Obama*, Marcus Bleasdale's short film
about Joseph Kony and Lord's Resistance Army commissioned
by Human Rights Watch. Survivors of Lord's Resistance Army
attacks address the camera, and the president, directly (it might
remind you of a Spike Lee film) in order to make a claim about
human rights. Aesthetic strategies are increasingly playing a role
in NGO work, just as NGO structures are increasingly evident
in aesthetic projects. The work coming out of the Forensic
Architecture teams at Goldsmiths in London makes this power-
fully clear as well.

> CK Recently, the notion of post-democracy has emerged
> to describe Western democracies that are fully functional in
> all intents and purposes—they have free elections and free
> speech, provide for systems of representation, have independent
> media—and yet, the citizenry does not recognize itself in the
> state anymore and therefore engages increasingly in interest-
> focused actions, locally or globally. Is an NGO actually a political
> space? Can we differentiate more precisely between the state—
> which I, as a person of a certain age and experience, associate
> with democracy—and an NGO, or do we need to begin thinking
> of NGOs as the primary spaces for political representation?

TK I would be wary of a blanket answer here. It seems to me that sometimes NGOs can make up for political vacuums, that they can provide an alternative when people feel insufficiently or simply not represented by political institutions. NGOs can sometimes function as a perfectly fine substitute for states or governments. When the state is not going to build a school, an NGO will, and the kids will go to school. Emergency humanitarian relief, especially of the *Sans Frontières* variety, would be another obvious example. At the same time, though, this supplement can let the state off the hook, or displace it altogether. In that way, NGOs can serve as a form of privatization and sometimes de-politicization. Sometimes, however, those turns to an alternative can have the effect of widening the sphere of politics, so that other spheres of political debate or engagement can open up that do not belong to the state. That doesn't make them any less political. In those cases, NGOs pose a challenge to the state's monopoly on politics, often with interesting effects. The phrase post-democracy captures something of that ambiguity: at once the expansion of democratic potential and discourses, but also the shrinking or displacement of democracy by something else.

CK You've mentioned above your reluctance to make "blanket" or very general statements. I would now like to move onto the third section about understanding, teaching, and learning from projects that are removed from us in different ways— geographically, culturally, politically. How can we as educators overcome these obstacles of distance? What is the potential of true understanding through the means of communications available to us, whether it is this book, online communication, or teaching? Many of the projects in the book are very difficult to describe to those who have not experienced them firsthand. We have included at least two perspectives for each project, the artist and the individual who selected the work, in order to give a richer sense of the work. What other tools can we use as teachers or educators to introduce people to a work and a context that they are not familiar with? How can ethical standards be shared globally, and in fact, can they?

TK None of the actors or agents or artists in the book seem to have any interest in remaining purely local. Almost everybody wants to be talking to a broader audience, claiming a stage bigger than the one that they are physically occupying.

 CK Very interesting indeed.

TK Everybody seems to have a multiple audiences in mind, and none of the projects are shy or absent or pensively local.

 CK So they are not only presented to, but already conceived for, both a local and global context?

TK Yes, I think most of these projects, even when they have a clear set of local goals, imagine that they are unfolding in a situation where the local cannot stay just local. Even if somebody's political causes are local ones and have local solutions, others see them as resources in their own local struggles. The possibility of dissemination, replication, translation, and alliance seems built into pretty much everything here. Here you see people who have very precise targets of intervention and a lot of tactical thinking, and a desire to relate those targets and tactics to other ones.

This familiarity or a feeling of relative ease with operating at the global level does not lead to projects calling for world revolution (although I'm sure that that dream is not entirely absent here). There is a kind of modesty and specificity about many of the projects, but also a compelling public or civic orientation. The art wants to be seen, heard, and responded to. Almost everyone is focused on a public address, oriented toward an audience, and more precisely toward a transformative engagement with an audience. DABATEATR speaks of "an audience that thinks and reacts, and does not leave the representation without carrying its marks." That phrase, which is so rich, serves for me as pretty much the best summary of the most powerful aspirations in this collection.

In 2012, the Vera List Center began a search for the most exemplary projects at the intersection of art and politics by asking an advisory council consisting of curators, scholars, activists, and artists living and working across the globe for nominations. The results span a range of diverse artistic practices that are both aesthetically innovative and politically timely. They are presented here through visual documentation and in the words of the artists and artist collectives themselves, further accompanied by brief essays by those individuals who nominated the projects.

Ai Weiwei
weiweicam.com

What were you feeling when the Sina blog was closed?
AI WEIWEI It's very difficult to explain my feelings when the Sina blog was shut down. Even though it was a blog, after all, I had spent more than three years on it. I had more than 2,700 posts, and included a great number of images and texts. Even if I was on the road, I posted every day, or had my assistant post for me, and thus I had a high traffic volume, and it became an energetic blog. Even outside of China, I'm sure that few places have such active blogs; every day I would write from two to seven entries. Ever since the Sina blog was closed, I've had a feeling of weightlessness.

The goals of your blog seem to have evolved; do you feel that your personal status has undergone any change?
AWW When I was writing my blog, I never had writing experience, until I started to write. Of course this was a blog concerned with politics and current affairs, because art doesn't need too much written commentary. My status never changed, and politics have always interfered with my life. I think that an artist's, or person's, concern with attitudes of existence is always related to politics. The blog provided me with a more dynamic tool, and a place to take full advantage of my expressive potential.

What was your original intent in filming Laoma tihua*? The events that transpired over the course of that film changed your life. How can people overseas understand the actions of the local governments, and do you have any regrets?*
AWW I brought photo and video-recording devices when I went to Sichuan to testify for Tan Zuoren, because that's how I've done things for a long time; it wasn't with the intention of making a film. Moreover, we often carry cameras to do various kinds of documentation, something I started doing even before Fairytale. It was around 2003 that I started filming and documenting.

When we returned from Sichuan it became very difficult to clarify the unexpected events that happened there, and I had the idea of using the recordings to make a film. The

events there influenced the course of my life, and it threat-
ened me with a crisis, and it was something that had never
occurred to me, something that had a definite influence on
my personal and surrounding circumstances.

I think the actions of the local officials—including a lot
of things that happen in China—are not necessarily compre-
hensible to all Westerners. That is because these things lie
outside of the parameters of things that can be understood.
You're either inside a situation, or you're outside it, under-
standing is just one part of your surrounding circumstances,
and thus there will always be incomprehensible character-
istics. Nearly five months have passed since the Tan Zuoren
affair—I went to testify for this hard-working intellectual
who has always worked for public interest, and I don't regret
my actions. I think that every person must do something for
others; that is the only way this world will see change.

Are you filming any new films or documentaries lately? Are Beijing, China
you looking to develop in that direction?
AWW We've always been recording, editing, and making doc-
umentaries. We've already completed four documentaries;
they are all available online. I have no goal or direction, I'm
ever moving forward.

You haven't written any longer essays lately. Are we to
understand that this is related to the
incident in Sichuan?
AWW The Sichuan incident caused a
decrease in my ability to concentrate,
and my brain is still recovering. The
fortunate thing is that I've learned
how to use Twitter, and the events
in Sichuan and my surgery in Munich
were all posted on the Web via my cell
phone and Twitter. All of this natu-
rally allowed me the possibility to
use a new documentation method to
narrate my circumstances and expound

Ai Weiwei with rockstar Zuoxiao Zuzhou
in the elevator with two police officers in
Chengdu's Anyi Hotel, 2009

on events. A new means of expression presented itself, and
I discovered that it expresses a dynamic and energetic layer
that is easily accepted by the media and the public. At the
same time, and most importantly, it surmounts old power
structures and outdated possibilities for discourse.

*The number of your Twitter followers has already reached
twenty thousand. What is it that attracts you most to
Twitter? How has it changed your lifestyle? Compared to the
blog, which platform suits you most?*
AWW The distinctive nature of Twitter is its promptness
and instantaneous turnaround; it's the opposite of the ped-
antry and deep contemplation involved in literature. I'm
often thinking of something Allen Ginsberg told me: "The
first thought is the best thought," that kind of thing. I
think about how he never had an opportunity to use Twitter.
I believe that it will ultimately change the way humans
communicate, and will change that way we transmit text and
information. Twitter is most suitable for me. In the Chinese
language, 140 characters is a novella, it's enough space.
Twitter gives people the chance to interact more closely.

*Can you speak a bit on the future of human connectivity,
or relationships, as facilitated by the digital age?*
AWW We are located in an extremely new era, whose most
distinguishing characteristics are manifested in changes to
individual expression and influences that change the way
we receive information. When the characteristics of individ-
uals undergo change, the very concept of humankind itself
changes. The significance of the effects that the Internet
age will have on humankind still hasn't shown itself, but
it will become the tool that develops humankind to the great-
est degree.

*What are the unique effects the Internet has on Chinese soci-
ety and on Chinese netizens?*
AWW It's difficult to imagine the effects that the Internet
has had on Chinese society; this is because China has made

its very foundation on the blockading of information, sur-
veillance, and the limiting of free expression. The surveil-
lance and limitations are endlessly being augmented. But
at the same time, the technical prowess of the netizens and
their demands for freedom of expression are growing in
resistance to each blockade. The kind of stalemate over the
Chinese Internet has cultivated a great new power inter-
ested in expressive methods and potential technologies.

*In your opinion, what would be the most ideal outcome of an
Internet or digital society? Or what kind of social change do
you think it will bring about?*
AWW The most ideal outcome of an Internet society would
be that people are given the opportunity to make the best
choice, which is usually eliminated because of an inequality
of knowledge and opportunities or disproportionate infor-
mation. A real citizen society could potentially emerge. The
social changes that the Internet is giving rise to are moving
China even faster toward a liberalized and communalized
state of freedom.

*Do you have any other thoughts on the digital age or Internet
freedom? Is this a cyber Cold War? Will you continue to blog
in the future?*
AWW Freedom of speech on the Internet is a new concept,
and Hillary Clinton's remarks were a new evaluation of the
values of freedom and democracy, and new definitions of
these concepts. Everyone could benefit from the protection
of these new technologies; upholding these concepts will put
authoritarian politicians in a very difficult situation.

 I will continue using the Internet, and as an artist, I
think that this platform holds incredible potential and
expressive features; it's also bestowed on me some quite
unimaginable memories.

Published in *Ai Weiwei's Blog:
Writings, Interviews, and Digital
Rants,* ed. Lee Ambrozy (Cambridge,
Mass.: MIT Press, 2011).

Chen Tamir on
weiweicam.com

Ai Weiwei is a prolific artist whose career spans over three decades and includes sculpture, installation, architecture, curating, photography, film, and new media. His most noteworthy projects include *Sunflower Seeds* (2010), for which he filled Tate Modern's Turbine Hall in London with one hundred million porcelain seeds, individually hand-painted by 1,600 Chinese artisans, and *Fairytale*, presented at documenta 12 in 2007, for which he brought 1,001 Chinese people to Kassel, Germany, throughout the run of the exhibition to wander around the city in specially designed clothes, towing custom-made luggage. His exhibition *So Sorry* (2009–10) at the Haus der Kunst in Munich included reproductions of thousands of "too little, too late"–style apologies expressed by governments, industries, and corporations worldwide, as well as a giant banner covering the museum's façade made of 9,000 children's backpacks that spelled in Chinese the phrase "She lived happily for seven years in this world," a reference to the 2008 Sichuan earthquake, in which poorly built schools collapsed and killed thousands of children. A photographic series Ai has produced features him "giving the finger" to a series of national monuments, while another documents his destruction of ancient Chinese pottery by dropping them defiantly on the floor.

In addition to his personal practice, Ai has worked throughout his career to support other artists. He has been involved with several groups, such as the avant-garde Stars group in the late 1970s and early 1980s and the Beijing East Village community in the 1990s, and in 1997 founded the China Art Archives and Warehouse, which functions both as an archive and gallery for experimental art. He published a series of books on the Beijing East Village artists and co-curated *Fuck Off* (2000), a controversial group show that ran parallel to the Third Shanghai Biennial.

Aided by his creative practice, Ai is a dissident who openly and consistently criticizes the Chinese government, especially through social media, and inspires audiences worldwide to do the same. One of Asia's highest-selling artists, Ai enjoys a celebrity status that affords him an immunity most activists would relish. The mechanisms of the art world (specifically the art market) focus on individual authorship and can create personas that seem to "too big to jail." This notoriety, coupled with creative freedom, has helped Ai produce some of the boldest statements in the fight for democracy and human rights in China. For example, when the Chinese government would not release any figures tallying the victims of the 2008 Sichuan earthquake, Ai used his blog as a platform to gather volunteers to count and name each child (resulting in *So Sorry*).[1] This was in direct defiance of government policy, and his blog was immediately shut down.[2]

In addition, Ai immediately began to be surveilled and tracked by the Chinese authorities, who continue to hinder his freedom of movement and attempt to limit his freedom of speech. In April 2011, Ai was arrested and detained under harsh conditions for eighty-one days. A massive global appeal went underway to free him, including large-scale initiatives by museums and arts organizations worldwide. Hundreds of artists created graphics and street art in support of his release. After his release, Ai was barred from traveling abroad or engaging in public speech and continued to be watched heavily. On April 3, 2012, marking the one-year anniversary of his arrest, Ai installed four live-feed video cameras throughout his house and studio. He claims that he launched his self-surveillance

project as a way for loved ones around the world to see that he was okay, and also to aid the government in their severe monitoring of his activities—so that they could see he has nothing to hide. Forty-six hours after weiweicam.com went live, having received 5.2 million views, Ai was forced to shut it down. Similar to other artists using self-surveillance—such as Hasan Elahi's *Tracking Transience*, for which Elahi has been documenting his location and activities since 2002—Ai garnered much media attention for his online project. However, Ai's impact seems more marked. Tweets from around the world attest to the project's global reach and Ai's ability to blur the boundaries of art and politics using new technologies. Unlike Elahi's project, Ai's self-surveillance was less about his personal identity or marginality and more about a corrupt system, which is why it struck a nerve with the authorities who continue to track and hinder him.

Despite his website being taken down and other impediments to his freedom, Ai has recently debuted two music videos online, one reconstructing his prison experience, and the other, *Laoma Tihua* (2013), featuring footage of his self-surveillance, shot while being questioned or tracked by the police. The footage, from what began as an ambiguous prank that straddled the line between new media performance and activism, has been reconstituted into an established art form and is piggybacking on the popular music video to disseminate around the world.

1 Ai also made a documentary about the earthquake called *Hua Lian Ba'er*, as well as several other short documentaries about transparency and human and civil rights in China.

2 MIT Press has recently translated Ai's blog entries and compiled them into a book, *Ai Weiwei's Blog: Writings, Interviews, and Digital Rants, 2006–2009* (Cambridge, Mass.: MIT Press, 2011).

Shahidul Alam
My Journey As a Witness

Like so many others, I too believed I was going to change the
world through my images. It took a while for reality to set
in. A while to know that taking good pictures wasn't enough.
There were gatekeepers who decided, and they generally
didn't share my ideology or my passion.

We were trying to remove an autocratic general. With
the adrenaline flowing as we marched through the tear gas,
my camera learned to love the smell of the streets. But
international media wasn't interested, they only knew us as
icons of poverty, and they had ultimate control. This pow-
erful tool suddenly felt blunt in the face of corruption and
indifference. In order to fight, one needed an army. As
a photo activist, I built a school, set up a festival and a
global agency dedicated to promoting local storytellers. As
an artist, I found different ways of storytelling. I also had
a message for the gatekeepers.

"I don't want to be your icon of poverty, or a sponge for
your guilt. My identity is for me to build, in my own image.
You're welcome to walk beside me, but don't stand in front
to give me a helping hand. You're blocking the sun."

Dhaka, Bangladesh

Shahidul Alam, *Abahani Wedding,* from
A Struggle for Democracy, 1988

Top:
Shahidul Alam, *Bishsho Estemah*, from
A Struggle for Democracy, 1988

Bottom:
Alam, *Woman in Ballot Booth*, from
A Struggle for Democracy, 1991

Opposite page:
Alam, *Woman Wading in Flood*, from
When the Waters Came, 1988

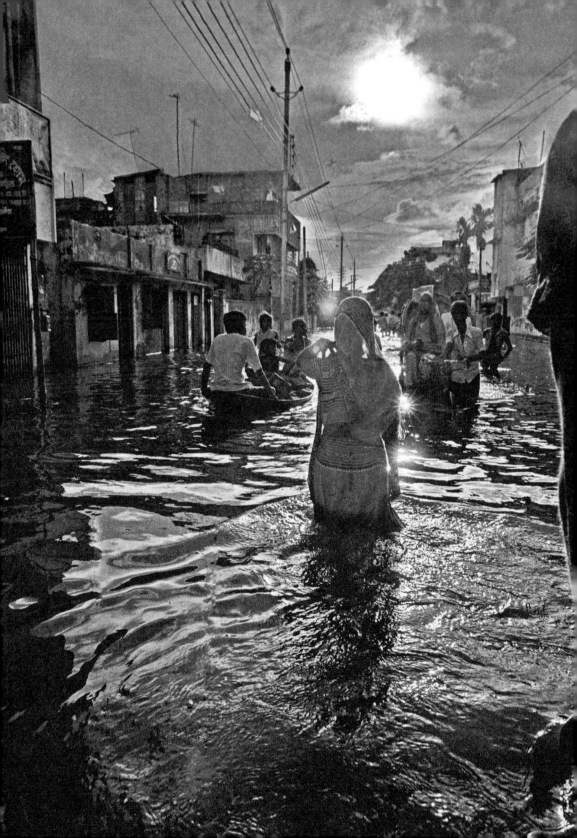

Bisi Silva on
My Journey As a Witness

Shahidul Alam is a man with a mission and a man of many projects. His mission is to use photography to counter the negative images of the "majority world," a term he coined in the 1990s to describe the global South. He also wants to make photography accessible to all levels of society so that they can tell their own stories. Alam is also a man of many firsts: he set up the first South Asian photo agency, Drik, in 1989; the region's first photography school, Pathshala: South Asian Media Institute, in 1998; and the region's first photography biennial, Chobi Mela, in 2001, among other achievements. As a documentary photographer, he is the first Asian to win the prestigious Mother Jones Award for documentary photography as well as the first non-Caucasian to chair the international jury in the World Press Photo Contest's fifty-year history. As a photographer he has exhibited his work internationally in institutions such as Tate Modern and Royal Albert Hall, London; Tehran Museum of Contemporary Arts; Museum of Modern Art and Queens Museum, New York; Powerhouse Museum, Brisbane; National Art Gallery, Kuala Lumpur; and at the Kochi-Muziris Biennale in India.

Alam's journey into photography—once considered a lowly profession in Bangladesh—began when he was an activist during the struggle for democracy and the efforts to bring down the autocratic rule of General Hussain Muhammad Ershad. Ershad was the chief of staff of the Bangladesh army and has been blamed for the assassination of the previous president, Ziaur Rahman. He went on to appoint himself president from 1983 to 1990, and he staged rigged elections to validate his claim. He was jailed after his fall, but is currently back in politics as a smaller but still significant politician. The resistance to Ershad was led by artists with the support of the wider student body.

Eventually the military refused to back the general, leading to his fall. With blanket censorship on all media information, Alam decided to use the evidential power of the camera. He took photographs that were critical of the regime, such as documenting the lavish public wedding of a politician's daughter while the rest of the nation was suffering the consequences of a devastating flood. Military repression against indigenous people and the use of religion as a political tool were also taboo areas highlighted in Alam's work, which led to death threats. Shortly after the downfall of the regime, the images he had taken during the struggle were exhibited in the same gallery that had refused him earlier. The three-day show (December 13–15, 1990) was attended by almost 400,000 people, confirming belief in the power of photography as a tool for social change. There were near riots and lines over a mile long to see this hastily put-up exhibition.

Shahidul Alam's publication *My Journey As a Witness* (2011) traces his artistic career, his activism, and his creation of the appropriate infrastructure for the development of photography in South Asia. The book highlights his journey from photojournalism to social justice and shows the ways in which his work deals with real facts and stories, government policies, corruption, economic development, and social issues in Bangladesh. The book looks not only at the bigger political struggles, but more personal class issues in his parent's home. Alam's 1998 publication *Family Lives* is very much about the personal being political. It was the first time photography was used to unravel the social fabric of Bangladesh, specifically looking at issues of class, gender, and corporatization.

His work has put him in danger: he was once stabbed eight times, and has faced conflict several times with the government. In 2009, he was detained

by the Indian border security forces while working on a project based on the river Brahmaputra and was released only after an international campaign was taken up.

His project *Crossfire* (2010) is an allegorical work in which staged photographs use elements of real case-studies to evoke stories which the government continues to deny. *Crossfire* is a euphemism for extrajudicial killings used by the RAB (an elite force with unlimited powers) to explain deaths in custody by claiming that the victims supposedly died during gunfire exchange. The work in *Crossfire* consists of large images evocative of the places where the victims were murdered. The exhibition quickly drew the attention of the authorities, who had it closed down, leading to a nationwide protest. The decision was challenged and overruled by the court, and the exhibition reopened. When questioned about this deviation from his documentary images, Alam responds that "protests, media reports, even attempts by the court to hold the government accountable have failed, so a new strategy had to be developed." The *Crossfire* show led to an ongoing series called *No More*, where Alam highlights social ills that in his opinion cannot be tolerated. Subsequent works have included shows on the garment industry in Bangladesh (orchestrated by Pathshala and photographed largely by its alumni) and the recent work in 2013 *In Search of Kalpana Chakma*, which provides a photo forensic analysis of the disappearance of the indigenous activist by the Bangladeshi military seventeen years ago. The work of Alam and fellow activists has led to the first instance of an owner of a garment factory being jailed and to the reopening of the case of Kalpana Chakma's disappearance.

As a photographer, Alam is also concerned with the ways we see each other, the ways we interact, and the ways in which we engage with one another as human beings, societies, and nations. In a country where class values are carefully preserved through lifestyle, Alam typically continues to ride a bicycle (until recently, unheard of in middle-class Bangladesh) and live in rented accommodation, having donated his inherited multimillion-dollar property to the school. But, most importantly, in keeping with the idea of the "majority world" telling its own stories, he attempts to break an exclusivity in which the images and visual stories of economically poor countries such as his are reported almost exclusively by white Western reporters that perpetuate stereotypes. Through his publications and the organizations he has founded— the agency Drik, the festival Chobi Mela, the internet portal banglarights.net, the online magazine *Meghbarta* (started by Alam, but now operating independently), the Rural Visual Journalism Network (RVJN), and most importantly the enormously successful school of photography (now with a new department of broadcast and multimedia journalism)—Alam powerfully depicts a complicated nation by providing an intimate and in-depth alternative to the stereotypical images of a country known principally for poverty and disasters. While these form part of the Bangladeshi reality, he is also keen to portray the beauty, diversity, history, culture, and humanity of his compatriots. Alam ascertains that "While poverty cannot be ignored, majority world photographers have found intelligent and sensitive portrayals of poverty, that have dwelled not so much on the lack of material things, but the commonalities that people have across class and cultural barriers. They have ensured that the dignity of the people portrayed come through. Their images show trust and understanding and a degree of access impossible for visiting photographers to gain."

1 Shahidul Alam, "When the Lions Find their Storyteller," Encuentro International de Medelin MDE11, http://www.slideshare.net/museodeantioquia/when-the-lions-find-their-storytellers-shahidul-alam.

Karen Andreassian
Ontological Walkscapes

The 2008 political revolt in Armenia, in response to presi-
dential elections, gave rise to a specific way of opposition,
"political walks," an activity where everyday practice
became an effective tool for resistance, invisible and
non-violent. The police found it difficult to differentiate
between political walkers and ordinary walkers. The walk-
ing trajectory had neither direction nor destination.

 Despite their spontaneous character, political walks
were functionally determined by the context of a certain
political event, were related to a certain space, the city
center, and a certain circle of people. My participation in
political walks was an attempt to synthesize this phenome-
non with art, i.e., with an activity *of looking in a different
direction*, which in turn makes it possible to see the other,
other events, to decentralize the activity. Looking in a
different direction also implies talking about the now. Now
is viewed as an interval, an empty space, a suspend situa-
tion. In fact by doing so I emphasize the ontological status
of walking politically–simply walking plus expression of
disagreement.

 Newly evolved walking spaces had a specific connection
with Soviet modernistic architecture, producing a refer-
ence to the largely forgotten factography movement of the
Soviet Union of the 1920s (New LEF). The LEF method is on the
borderline between aesthetic impact and utilitarian life
practice. In factography's constructivist epistemology, the
construction of facts is inseparable from their interpreta-
tion. Factography is a mode of praxis, a vast archive coex-
tensive with reality itself, perennially "in search of the
present tense."

Karen Andreassian, *Ontological
Walkscapes* (Hrazdan, Armenia, with
Vardan Andreassian, Stephen Wright, and
Karen Andreassian), 2009

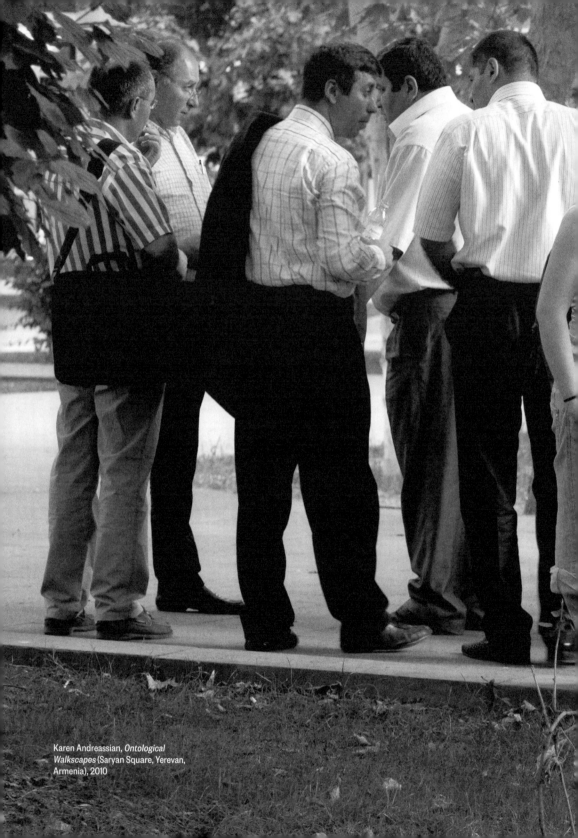

Karen Andreassian, *Ontological Walkscapes* (Saryan Square, Yerevan, Armenia), 2010

Susanna Gyulamiryan on
Ontological Walkscapes

The 2008 presidential elections in Armenia were conducted according to a well-rehearsed scenario: the representatives of the opposition were persecuted by the regime, voters were bribed or threatened, ballot boxes were stuffed, and in the end a coordinated and deceitful vote counting took place. Thus the chosen representative of the regime came to power.

Unprecedented public indignation was the result, which hastily grew into a massive movement, and Freedom Square in Yerevan, symbol of Soviet-era political struggle, became once again the main gathering site of a movement. The movement of 2008 was both social and civic—on the one hand, it was a struggle between two social strata: a wealthy class of political and economical elites and the regular people surviving in an uncontrollable market-oriented context. On the other hand, it was also a fight to protect the values of democracy. Starting on March 1, 2008, the movement was severely challenged by the ruling power and its subordinates, the national army and riot police: At least ten people were killed, a considerable number of activists were arrested, and public rallies were banned.

The protesting masses, however, did not vacate the streets. Instead they took what were labeled "political walks" in public spaces. Even though public areas were strictly controlled by the regime, and the authorities recognized that this wasn't just "innocent" walking but a form of resistance, a political action with the potential to evolve into explosive action, the law enforcement structures were unable to deal with this form of covert protest.

It was no coincidence that a considerable number of the participants were artists, among them conceptual artist Karen Andreassian. While the majority of artists depicted the political situation by placing new images (street art/graffiti, posters) in a normative context, thus reproducing the *unseeable* situation of covert resistance through visible means, Andreassian did the opposite: In his *Ontological Walkscapes* (2008–10), he placed existing situations, of strolling people, in art contexts, articulating the artistic position which to my mind is the only valid criterion for innovative contemporary art—a new criterion that differs from previous times when innovation was mainly defined by the production of new forms.

Political walks first took place on the Northern Avenue of Yerevan, a place symbolizing the processes of commercialization, reurbanization, and remodernization of the country that originated in early 2000s. In accordance with Andreassian's description of that phenomenon of *walking political* at a certain hour each day, politically active people merged with crowds of ordinary city-dwellers and took part in a specific *political walk*. People just walked and discussed about political currency. Given the space where this public "performance" was held and the reevaluation of that very space through the performance, the authorities were constantly tempted to issue banning orders. Which is what eventually happened. The Northern Avenue was in turn closed to the participants of *political walks*, and the walkers were moved into another place of the city, continuing this form of nonviolent resistance over the following few months until its final dispersion by authorities.

Andreassian has been employing a method of art production that he has labeled a "performative document."[1] Considering his photographs and video works as *factography*—a material fact—the artist freely applies to it the ideological angles of the Left Artistic Front (LEF).[2] The LEF, known to have emerged immediately after the Bolshevik revolution in Russia, encouraged the production of "expedient things" in art, which would

"not move people away from life," but would dynamize and organize them for a new life. The *raison d'être* of art, in their definition, was to influence and construct a new and a more expedient world—where things would cease being passive objects and would instead, being revolutionarily anthropomorphized, change the world—and the idea that new technologies such as photography and film should be utilized by the working class for the production of "factographic" works.

Such processes require endurance in a temporal sense. However, according to the artist, his works are always related to the *now*, a word which, coincidentally, was one of the most popular slogans of the movement. In order for the events of the present to be reproduced and rethought as artworks, they require the use of the future tense; thus the present transforms into the past as compared to the future, while the in-between of that past and the future is not the present per se (an equally spatial and stretching category), but the now, which pertains to attitude rather than time.

Andreassian's involvement, identification with, and adherence to the protest movement have made him and other activists visible to the regime, easy targets for its "control and liquidation" practices. In 2008, due to the organization of a communication network of student-correspondents as part of the *Ontological Walkscapes* project, Andreassian was forced to leave his position as a lecturer at the Department of Art History of the Yerevan State University. His students at the university had also turned into political walkers, documenting the bio-organization of various Armenian regions, places, and sites by means of factographic essays and bio-interviews.[3]

The majority of Armenian artists involved in the protest movement aligned themselves with the political interests of the leader of the opposition, thus equating the hope for change with the election of a new president. In reality, Armenia was absorbed in rampant corruption, and, since the power structures themselves were entrenched, it would be difficult, if not impossible, to change even with a change in leadership. The groups established by Andreassian at the university embarked on their task through active collaboration with each other, but their activities were severely curtailed by the university administration, which closed the course and declared any lecturer who was involved with this struggle *persona non grata*.

The struggle continues: since 2008 a wave of mass political, civil, social, and environmental disagreements has emerged in Armenia. That year constituted a pivotal moment in the history of Armenian contemporary art. It heralded a shift from the hitherto commonplace artistic practices confined to arbitrary, imaginary, and play-oriented works of art towards the advent of a political art, which peered into traumatic reality and resistance. This was a year when in Armenia the sovereign individual, the citizen, emerged capable of defiance. This same year also became the threshold when a myriad of other individuals—hundreds of thousands of citizens of Armenia—became far more courageous, far more uncompromising, and far more unflagging in their attitude for matters of civil rights and social justice. And as this story unfolded, it also provides a background to build on for the hope that the promise of continuity is the result of any civil struggle.

1 The "performative document" is a Russian term that Andreassian uses to follow the concepts of the Left Artistic Front.

2 LEF (Left Artistic Front), a widely ranging association of avant-garde writers, photographers, critics, and designers in the Soviet Union. It had two runs, one from 1923 to 1925 as LEF, and later from 1927 to 1929 as *Novy LEF* (New LEF).

3 The ideologists of the Left Artistic Front were sure that building a new social formation without social injustices was possible through exact description of human life. It doesn't need any literary approaches, as literary words are far away from the factographic fixation of human life and situations. The Left Artistic Front elaborated a new method of writing—factographing, or bio-interview.

Amy Balkin
Public Smog

Public Smog is a clean-air park created as a countermodel to the current expropriation of the atmospheric commons. It opens in the troposphere or stratosphere for public use whenever and wherever possible.

The park is a response to the production and effects of ground-level ozone, particle pollution, and rising green-house gas levels in the atmosphere, and the offloading of their associated risks onto those trapped by it—geopolitically, spatially, temporally, economically, bodily.

This production of risk can be seen in the siting of polluting infrastructures, flows of profit, "loss and damage" of embodied aftermaths offset onto the politically weak, and in political dissent and resistance.

The park is opened using tactics from investigative journalism, speculative fiction, structural land art, derivatives trading, diplomacy, and the environmental justice movement. When successful, it is intended to produce an atmospheric counterspace at the scale of the activities of nations and markets, mitigating their dangerous and obscene influence on the climate system.

Los Angeles, USA

It is an effort in solidarity with the climate justice movement and a missive to future people who will occupy the aftermath of our present climate politics.

In response to the known risks and hazards of state- and market-based activities on climate for both present and future people, *Public Smog* is a model for mitigation built on the precautionary principle; an equitable public park open for the pleasure and recreation of all.

Amy Balkin, *Public Smog*,
2004–present

As a citizen of _____, "The Nation," I urge you to act now to initiate an extraordinary nomination process to inscribe Earth's Atmosphere on the UNESCO World Heritage List on an emergency basis, consistent with the aims and goals of the World Heritage Convention, and lead a coalition effort to that end,

Recognizing the outstanding universal value of Earth's Atmosphere, and responding to the formidable threats and risks to its integrity from greenhouse gases, including a forecast global temperature rise of 3 to 6 degrees Celsius by 2100,

Finding it in the common interest to protect the Atmosphere for present and future generations, and acknowledging that its preservation is the duty of the international community,

Further recognizing the impacts of climate change on sites of tangible and intangible natural and cultural heritage currently inscribed on the World Heritage List,

The Nation should undertake and faithfully carry out a coalition-led effort for inscription of Earth's Atmosphere on the World Heritage List, consistent with the aims and goals of the World Heritage Convention.

Willing governments should 1) Immediately notify the World Heritage Committee and relevant Advisory Bodies of the decision to present a nomination with the request for processing on an emergency basis, and 2) Register at *d13.publicsmog.org/initiate* to announce the nomination plan publicly via dOCUMENTA (13), the German cultural initiative (Attn: Carolyn Christov-Bakargiev/Amy Balkin).

_____ _____
UNTERSCHRIFT / SIGNATURE DATUM/ DATE

PUBLIC SMOG IS A
SCHEME TO BUY BACK
YOUR RIGHTS ON
THE OPEN MARKET

PUBLIC SMOG IS A PARK
IN THE ATMOSPHERE
THAT FLUCTUATES IN
LOCATION AND SCALE

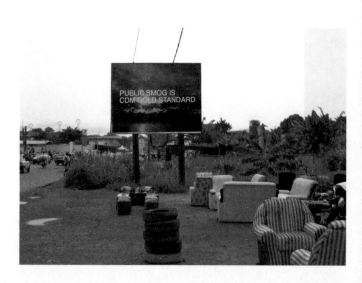

PUBLIC SMOG IS
CDM GOLD STANDARD

Amy Balkin, *Public Smog,*
2004–present

Permanent Delegation of the Republic of Estonia to UNESCO

Délégation Permanent de la République d'Estonie auprès de l'UNESCO

Carolyn Christov-Bakargiev
Artistic Director
Friedrichsplatz 18
341 1 7 Kassel

dOKUMENTA (13)
9/6-16/9-2012

Paris, 3rd March 2011, No 5.2/71-1

Dear Ms Carolyn Christov-Bakargiev,

Thank you for the letter about the contemporary art exhibition dOCUMENTA and its curatorial concept, which also concerns the innovative idea of nominating Earth's atmosphere for inscription on the UNESCO World Heritage List.

I would like to inform you, that The World Heritage Convention is a property or site-based convention, which means sites need to have clearly defined boundaries and meet certain criteria.

While we understand the importance of protecting the Earth's atmosphere and share the concerns of the global community about current ecological issues, we believe that the Earth's atmosphere might not eligible for inscription on the World Heritage List under current interpretation of the Convention.

With best regards,

Marten KOKK
Ambassador, Permanent Delegate

17, rue de la Baume 75008 Paris – tél (33-1) 56 62 22 00 – fax (33-1) 49 52 05 65 – www.est-emb.fr

T.J. Demos on
Public Smog

The San Francisco–based artist Amy Balkin draws together interdisciplinary research and sociopolitical critique in order to energize the cultural and civil spheres, doing so in relation to legal and political systems. A continuous point of focus of her projects is the natural environment and its relation to political, ecological, economic, and legal frameworks. Exemplary of an ethically and socially engaged practice, her work is noteworthy not only for its critical political investment—for instance, investigating social dislocation in relation to infrastructure development, highways, and toxic waste sites or examining the politics and economics of global warming and greenhouse gases. It is also significant for its creative imagining of alternative visions for how people might build an environment based on the shared commitments to equality, diversity, sustainability, and social justice.

Balkin's representative projects include *Invisible-5* (2006), for which she worked in collaboration with Kim Stringfellow, Tim Halbur, and the organizations Pond: Art, Activism, and Greenaction for Health and Environmental Justice. The work comprises a photographic display coupled with an audio commentary that addresses land use along the corridor between San Francisco and Los Angeles. The image-audio installation offers documentary accounts of the diverse areas concerned therein and stories told by individual stakeholders from the communities affected by the highway, who are struggling for environmental justice along Interstate 5. As such, the project exemplifies Balkin's commitment to collaborative production, and to working within and among the fields of contemporary art, political activism, environmentalism, and social justice.

Balkin's *Public Smog* (2004–present) builds on that engagement, defining a creative remodeling of the links between nature and finance. For the work, the artist has attempted to set up a clean-air "park" in the atmosphere, one whose dimensions and duration are contingent on the emission credits the artist purchases and on the length of their contracts. Having obtained a number of carbon offsets, Balkin proposes to subvert the dubious cap-and-trade system by withholding the credits from industrial usage. She opened the Lower Park above the coastal zone of California's South Coast Air Quality Management District during summer 2004; the Upper Park existed for a year beginning in December 2006 over the European Union, then again from April to August 2010 over the United States. In addition, as part of a residency organized at the Centre Culturel Français "Blaise Cendrars" in Douala, Cameroon, Balkin installed a series of thirty billboards across the city to announce the possible inauguration of a clean-air park over Africa.

A digital slide show on her *Public Smog* website reproduces the financial and legal documents from which these parks derive, including details of letters she wrote to traders to acquire offsets, as well as legal agreements concerning sales. Also included are snippets of conversations with various unidentified bureaucrats relating to the artist's attempt to register the earth's atmosphere as a UNESCO World Heritage site. Balkin's hope is not so much defined by the unrealistic expectation that her proposals will come to fruition; rather, by showing the unlikely dimension of such suggestions, she reveals the seriousness and inflexibility of entrenched ways of addressing the environmental problem and also provides evidence of their profit-driven motivations and ineffectiveness in addressing climate change.

The virtuality of the project—a "park" in the air can neither be seen nor exist in any stable

state—mirrors the invisibility and abstract quality
of atmospheric carbon dioxide and, indeed, the
complexity of its effects on climate change. This very
invisibility eases the deniability of global warming and
facilitates its economic manipulation, whose problem-
atic nature Balkin's project seeks to expose. As her
website states, "Ultimately, as the logic of privatization
points to the commodification of all common pool
resources, a reduction model based on trade is contra-
dictory to a socially just solution to global air pollution.
We need another model. In the meantime we have
Public Smog, a way for the global public to buy back
the sky on the open market."[1] Balkin's work thus mim-
ics the financial practice of offsetting as a response to
climate change only to reveal its specious logic. Yet in
declaring that "*Public Smog* is no substitute for direct
action," the artist acknowledges that merely drawing
attention to the problem is not enough. Rather, her
work contributes to the momentum of a multifaceted
ecological movement that is necessary to bring about
transformative structural change.

 Balkin's artistic project powerfully and compel-
lingly explores the politics and economics of climate
change and environmental destruction at the hands of
advanced capitalism, unchecked growth economics,
and increasing developmentalism, with its threats of
sea-level rise, increased atmospheric temperatures,
droughts, species extinction, environmental degrada-
tion, and resource scarcity—all of which are expected
to lead to increased human conflicts globally in the
near future. As such, Balkin's engagement doesn't
shirk from the complexities and difficulties of address-
ing this mounting crisis and its emergency conditions;
indeed, she approaches it head on, in ways that are at
once critically incisive, aesthetically provocative, and
politically creative.

1 See Amy Balkin's website, which
includes links to critical literature,
including Tamra Gilbertson and
Oscar Reyes, *Carbon Trading: How
It Works and Why It Fails* (Uppsala,
Sweden: Dag Hammarskjold Centre,
2009), http://publicsmog.org.

Bibliothèques Sans Frontières
The Haiti Project

Over the last seven years, BSF has implemented a great
variety of projects to promote access to information, edu-
cation, and culture close to the most vulnerable people
and communities, in developed and developing countries.
Beyond traditional, long-term library support projects, BSF
has considerably widened its scope of activity by engaging
in humanitarian action to promote a better account of the
intellectual needs of populations in urgent and post-urgent
situations (*Ideas Box*), as well as in the creation and dif-
fusion of digital knowledge and learning contents for the
French-speaking world (Khan Academy, Codecademy). This
diversification provides an accurate illustration of how pow-
erful libraries—be they physical or immaterial—can be today
to break ancient barriers and promote social justice around
the world.

Indeed, beyond culture diffusion and education support,
libraries now have a role to play in all public and devel-
opment policies. As collaborative spaces, they not only
can bring normalcy and safety even in the most desperate
situations, but also provide numerous tools to promote
citizenry, entrepreneurship, health policy, social cohe-
sion, inclusion, and dialogue, and to empower communities
for co-constructed and self-reliant futures. Furthermore,
ever-improving information and communication technolo-
gies provide new chances to reach those who were usually
marginalized and left unequal due to geographic, social, or
symbolic barriers. More than ever, twenty-first-century
libraries thus prove to be key instruments to extend the
set of capabilities of the most deprived and provide them an
equal freedom to achieve.

Bibliothèques Sans Frontières,
Ideas Box, Burundi, 2014

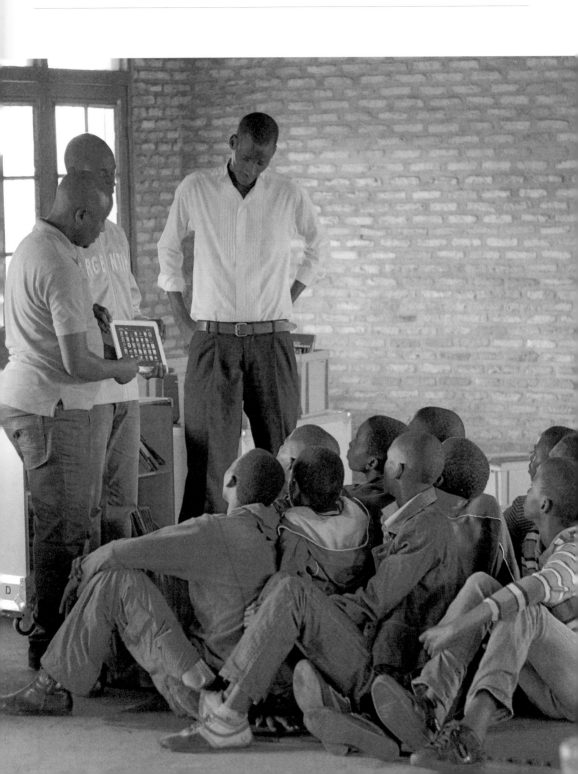

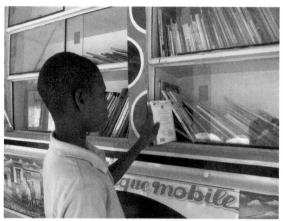

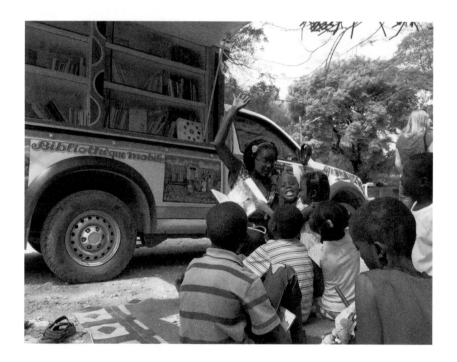

This page:
Bibliothèques Sans Frontières,
The Haiti Project, 2010

Opposite page:
Bibliothèques Sans Frontières,
Ideas Box, Burundi, 2014

Omar Berrada on
The Haiti Project

Bibliothèques Sans Frontières (BSF) aims at providing access to reading where such access is scarce or made difficult by circumstance. The premise is simple: that reading and access to books are a fundamental human right as well as an important factor in the struggle for democracy. The statistics are telling: in the world today 795 million adults are illiterate, while 72 million children don't go to school, and hundreds of millions don't have access to libraries or any reading material at all. The usefulness of such a reading-focused initiative seems unquestionable. Its effectiveness and relevance, though, depend on the many nuances of its implementation.

Book donating is no new concept, and many non-profit organizations are active in the field. But since it was founded in 2007, BSF has brought about a tremendous amount of both energy and ethical thinking. More often than not, in this age of Western abundance, economic crises notwithstanding, well-meaning generosity turns into cultural imperialism. Many organizations simply dump boxes of books on African villages as you would parachute bags of rice, without giving much thought to the relevance—or lack thereof—of the books in question,[1] or offering much help toward their appropriation. BSF, in contrast, has embraced an integrated approach that is attentive to local contexts, cultures, and economies.

At the origin of any BSF project is a request from a community, municipality, or organization on the ground. BSF then works with the local organization on their needs, in terms of book choices but also, crucially, in terms of infrastructure and training, in an effort to make the project sustainable. For instance, part of the budget is always reserved to purchase books from local publishers, in order to prevent that generous donations from France might stifle the often-fragile local publishing economy.

After a number of small projects in various villages and cities in Africa and elsewhere,[2] BSF have been carrying out an impressive project in Haiti, in the wake of the massive January 2010 earthquake, after being approached by Haiti's National Library, as well as by the State University of Haiti, both of whose shelves were all destroyed in the disaster.

One might ask, paraphrasing Hölderlin: What are books for in these destitute times? BSF have very pragmatic answers. Conditions on the ground required working across divergent scales, time frames, and geographies: Small neighborhood libraries on the one hand, and Haiti's National Library on the other; emergency relief on the one hand, and long-term reconstruction on the other; centralized infrastructure on the one hand, and dispersed communities of displaced people on the other.

After the earthquake, over one million people became refugees, scattered over countless camps across the country. BSF established provisional libraries under tents in seven refugee camps. These provided job opportunities to people from the camps themselves and, on top of books, offered book-based psychosocial workshops for children and youth several times a day. In addition, BSF devised a "story box," consisting of a selection of one hundred books in French and in Creole, as well as games and educational activities, along with a manual on how to use them. Such boxes were sent to many camps around the country. Another small-scale action was the conversion of TapTaps (collective taxis) into BiblioTapTaps, traveling libraries on wheels, meant to stop by a different community every day for a few hours of book lending, story telling, math instruction, and trauma relief.

Certain parts of the project proposed an articulation of emergency action and long-term planning. For

instance, the building of the Haitian ministry of foreign affairs collapsed, along with its extensive library and precious archives. As a first step, BSF helped salvage the books and documents and secured them in a neighboring building that was left intact. Afterwards, they strived to clean and restore the documents and organize them into a new international law library that would be open to students and researchers. They also provided opportunities for enlarging the collection and training the staff.

All the while, more projects were taking shape. Donations of large numbers of shelves were coordinated all over France, and over one hundred Haitian librarians were trained to take charge. Twenty of them were sent to France to complete their training and to choose the books to be donated to the National Library by various French institutions. For instance, the École normale supérieure in Paris gave as many as a hundred and fifty thousand volumes.

In addition, September 2011 brought the inauguration of the State University of Haiti's first digital library. BSF had convinced twenty international academic publishers and web portals to give access to their electronic resources for free. Millions of journal articles and e-books became available there for the first time, from sixty computers connected to high-speed Internet in a 1,000-square-foot facility in Port-au-Prince. The National Library reopened in new premises in spring 2011, only one year after the earthquake. Several other branch libraries have opened or are opening across the country.

Stemming from a belief in the importance of social justice and community building, a belief in the possibility of sharing with no prerequisites, the BSF project went far beyond merely rebuilding what used to be. It has made available resources that were unthinkable before the catastrophe, while at the same time taking into account and, as much as possible, acting upon the irremediable loss and psychological impact of the disaster. Though they center around books—that is, around the work of writers and artists—the projects of BSF do not aim or claim to be art projects. Ultimately, their aesthetic is an ethics of specificity, which stresses the importance of context and the importance of scale, and which trusts local partners in the formulation of their own needs. It rests on the recognition that while books are key to reconstruction and to solace, they can only be effective if they are wanted, carefully chosen, patiently accompanied, and well taken care of.

1 This sometimes happens on the massive scale of an entire nation. See the French government's gift to the Library of Alexandria in 2009: every single book or pamphlet published in France between 1996 and 2006, i.e., over half a million volumes. A way of flooding Alexandria with books in French conveniently relieved congestion in the reserves of the French National Library (which, until 2006, systematically collected four copies of every single French publication).

2 Burundi, Cameroon, India, Madagascar, Mali, Niger, Romania, Rwanda, and Tunisia, among others. In addition, Bibliothèques Sans Frontières gave much support to the library of the Dar al-Ma'mûn arts center in Marrakesh, Morocco, with which the author of this text is closely involved.

Giuseppe Campuzano
Museo Travesti del Perú

TRAVESTI MUSEUM OF PERU
(excerpt from Manifesto in Four Acts)

Pleasure versus knowledge. Not to enunciate the world but to wallow in it.

How to open an archive for that body where the spoils of its human condition can only outlive surveillance in the silence of its traces? Is it possible to impugn the identifying fabric that simultaneously sanctioned and erased it in the registration act?

How can someone who bodily belies the normative corporality of human beings be a subject of human rights?

Archives are traces that intend to retain the memory of the past.

But their selection criteria normally conform to the official historiography—colonialist superego. Thus the unarchived traces are still more numerous than the archived ones.

Problematic canon for a genealogy of the resistance strategies, and of the emergency and rupture moments inside the dominant discourse. Essential absence for the subordinate.

Let's renegotiate the archive from this Latin America that was once the initial moment of formation of modern-colonial capitalism and is now an alternative production center opposing coloniality. A Lima—South America's West—as an arena where collision is manifest.

Venereal archives and their in[ve]stigatresses. Journalistic fiction and *travesti* fiction. Frailty and resistance. Invented inventory. Daily journal of selling oneself. *Travesti* whose alien desire desubjectivates her from capitalism. Decolonial hooker. Postmodern whore.

No more dualism. Not an inside and an outside of language, the ritual, the nation, the museum, but transgender transnational bodies. Aesthetic gaps. No to evolutionism.

Museum, musex, mutext, mutant.

Opposite page:
Giuseppe Campuzano (with Germain Machuca), *The Two Fridas—Lifelines (Las Dos Fridas—Línea de Vida)*, 2013

Published in *Errata*, n° 6, Bogotá, December 2011.

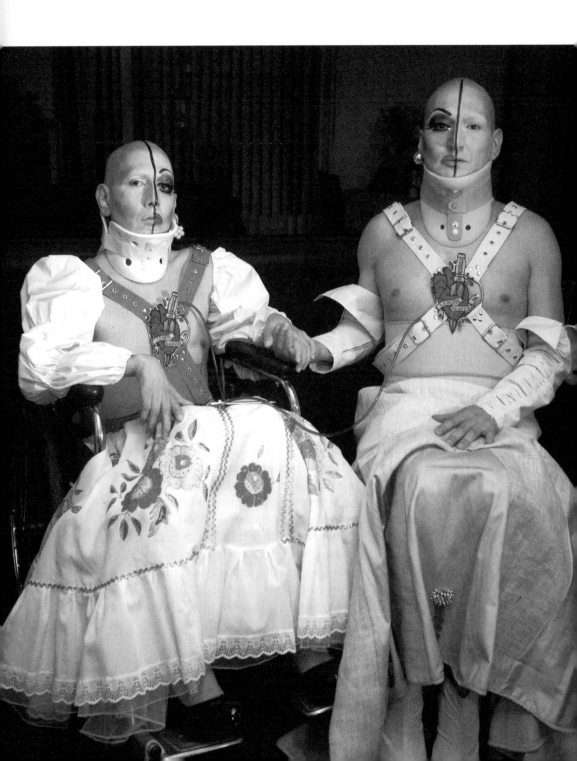

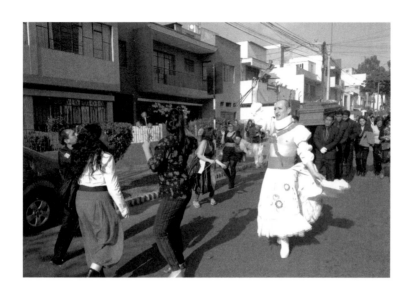

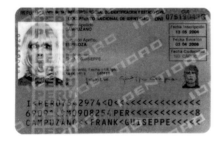

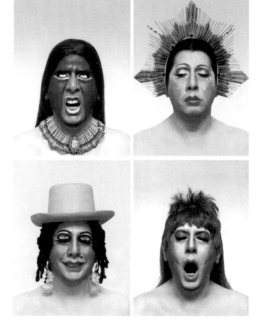

Clockwise from top left:
Giuseppe Campuzano, *Velorio*, 2013

Giuseppe Campuzano (with makeup by
Germain Machuca), *Photographs for
Identity Document (Fotografías para
documento de identidad)*, 2011

Giuseppe Campuzano, *DNI (De Natura
Incertus)*, 2009

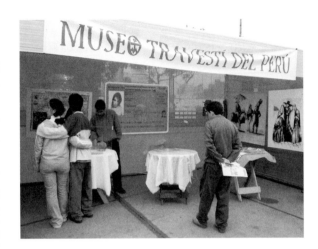

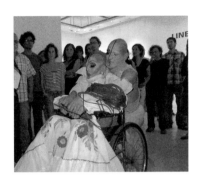

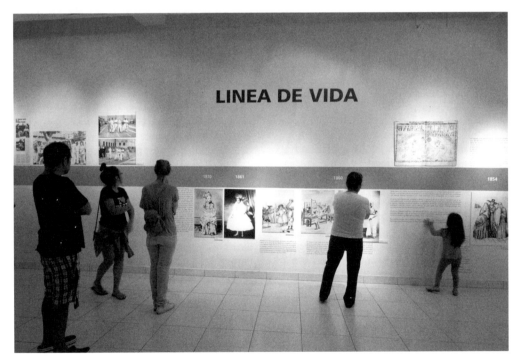

Clockwise from top left:
Giuseppe Campuzano, *Museo Travesti del Perú*, 2008

Giuseppe Campuzano, *Línea de vida–Museo Travesti del Perú*, 2013

Giuseppe Campuzano, *Línea de vida–Museo Travesti del Perú*, 2013

Ana Longoni on
Museo Travesti del Perú

Probably the best way of approaching the *Museo Travesti del Perú*, founded in 2004 by artist and philosopher Giuseppe Campuzano (Lima, 1969–Lima, 2013), is by tackling the very notion of *travesti*. No English word can convey the connotations the term carries in Latin America. As Campuzano himself pointed out, it is much more than a man who dresses like a woman, or a "person who assumes the characteristics of the 'opposite sex.'"[1] The *travesti* explicitly manifests the male and female characteristics we all have, thus denouncing the inadequacy of the binarism of gender norms.

Campuzano's interest in the *travesti* did not lie in the "production of one more identity for the long existing list" of Lesbians, Gays, Transexual, Bisexual, etc., but in its power as a "transformative post-identity,"[2] an *elusive* plurality of bodies.

Travesti manifestations shouldn't be understood as fixed identities, but rather as symptoms, as the signs of subjects who refuse classification. In this sense, a key work of the *Museo Travesti del Perú* is *DNI*, Campuzano's personal national identity document enlarged and successively altered. In his first version of the work (2004), made by means of a lenticular print, two superimposed portraits of himself appear: viewed from one angle, the card exhibits his "original" (normatively masculine) photo, but as we shift the angle, the document shows a deliberately blurry photo of the *travesti*. The document, usually green, now turns pink, and no date of expiration is indicated. In 2009, a new mobile mutation made it possible to consider successive metamorphoses, in "a commentary as much about the impossibility of containing identity within a fixed document, as about the very idea of a unity that cannot correspond to an identity always in process of formation."[3]

Another possible approach to Campuzano's work is to see it as a radical mechanism for critical or alternative perspectives on the museum as such,[4] intensely parodist insofar as it involves a portable itinerant institution. This is a museum where the material structure is literally the artist's own body. Its site is radically provisional and precarious, ephemeral and wall-less, as it occupies different spaces and takes on a range of formats that sometimes allow it to be a parasite on an existing context: the street, a plaza, a Sunday market, an electoral campaign, a museum, the university, a literary event, an academic conference, a mobilization of sex workers and *travestis*, the Internet, or an international context like the current book.

The *Museo Travesti* produces an enormous ongoing open archive of images and representations from different eras: the pre-Hispanic, Colonial, Republican, and contemporary, originating both in high culture and the popular imaginary. It also draws from the most diverse sources, from which he proposes a disrupting narrative of Peruvian history from the *travesti* viewpoint. These images, read through the negated and marginalized codes of androgyny, are key to the *Museo*'s mechanisms of intervention: the *Museo* resorts to appropriation (plunder) and montage (made through association, counterpoint, superimposition, and an infinite, ever-open and unfinished accumulation of the most diverse documents), and intervenes in publications ranging from catalog books to fold-out zines that Campuzano and his temporary allies distribute through individual or collective actions. Wherever the occasion arose, the archive was taken out to the streets, carried directly on Giuseppe's body or those of other *travestis*, in a demonstration with no apparent aim or precise claim, which the artist called "Identikit."

Many items coexist in its collection, from erudite references to colonial painting to works embodying a return to rituals, imagery, and festivals from the Quechua culture, alongside documentation from the mass media on the long history of persecution, violence, and discrimination against homosexuality in Peru, where the state—with deeply Catholic roots— still denies people a right to sexual diversity.

As pointed out by Miguel López: "The project, halfway between performance and historical research, proposes a critical reviewing of the so-called 'History of Peru' from the strategic perspective of a fictional figure he calls the 'androgynous indigenous/mixed-race transvestite.'"[5] Campuzano has related the situation of *travestis* in Peruvian culture to androgynous and bifront representations of a bipartite being (that can be one thing and another simultaneously), typical of indigenous cultures, which in official discourse tend to be reduced to spaces of marginalization or monstrosity. Through this lens, he addressed the interpretation and classification of a ceramic piece from the pre-Incan Moche culture, which belongs to the Museo Larco, Lima. The piece, depicting a ritual scene of coitus between an individual dressed in clothing pertaining to both sexes and a supernatural being, is classified by the museum logic in a series of "moralizing vessels," which would supposedly prescribe social prohibitions. The *Museo Travesti* proposes a different reading of the scene: a foundational *travesti* myth of Peruvian history.

The practices of the *Museo Travesti* challenge "the stratified spaces of traditional academic analysis around sexual oppression, taking as its locus of expression and rewriting of history the *travesti* body, which is an artificial, prosthetic, dressed-up and made-up body, the nature of which is uncertainty."[6] This uncertain and unstable choice puts the experience of the *Museo Travesti* in friction with the conventional forms and subjectivities of traditional activism and militancy, from those of the Left to those of the feminist and gay movements, "interposing a new anamorphic and elusive political subject that proposes other narratives and other ways of inhabiting the world." It is an unsettling and destabilizing opportunity to "imagine new communities."[7]

In April 2013, in what was to be his last art action, a few weeks before dying of a disease that had been quickly depriving him of his speech and motor functions, Campuzano made a significant re-edition of *Lifeline*. This is one of the activation modes of the *Museo Travesti del Perú* archive that he had been showing since 2008 in different exhibition contexts, following a chronological sequence in which the artist's biography and the history of Peru intersect. Alongside newspaper clips, press photographs, zines, and other documents that witness *travestis'* persistent presence in Peru since its precolonial past as well as the persecution to which they have been subjected, the montage included masks, portraits, pumps, and other costume pieces and objects that Giuseppe or his *travesti* friends had used at different times. "My body as a support for my artistic work and the *Museo Travesti* feed on each other," Campuzano explained. Both the artist's body and life are transformed into a museum device.

After exhibiting the archive for four days, Campuzano carried out a performance together with Germain Machuca, his lifelong sidekick, who took on himself the loving task of taking care of the artist and accompanying him through the process of his disease. The action started when, without previous notice, they silently entered the exhibition space and began to go around it. Giuseppe became a spectator of his own museum, of his lifeline, pushed slowly around in his wheelchair by Germain. They were both dressed alike, as complementary replicas of one and the same character: shaved head, thick make-up on one half of a face parted in two by a black line, and dressed in a costume composed of a superimposition of medical implements (orthopedic neck brace), BDSM belts, religious images (the sacred heart of Jesus on their chests), colorful Andean skirts, and high heels. Their bodies were connected through a long blood transfusion tube that at times seemed to shackle and restrain the patient. Finally, Giuseppe—too weak to move by himself and having to be helped, or rather embraced, by Germain—cut the tube that bound them with a pair of scissors, thus breaking the symbiosis of the conjoined twins. He lets go of him/he lets him go.

This action evokes in the spectator's mind a variety of intimations. First, the explicit allusion to *Las Dos Fridas*, not so much the famous painting by Frida Kahlo (also bedridden and paralyzed) but rather the

travesti appropriation of that iconic image of Latin American art made by the Chilean duo Las Yeguas del Apocalipsis, as they staged a live version of the painting in Santiago de Chile in 1990, in which they transfused each other's blood in the midst of the HIV/AIDS epidemic. The piece also keeps a direct dialogue with *Carrying*, the action that Spaniard artist Pepe Espaliú repeatedly performed during his last two years of life.[8]

If queer theory has contributed to undermine any fixed sex or gender determination, by conceiving these as a continuous, unstable, and unexpected transformation process, crip theory—posited, among others, by Robert McRuer[9]—also starts by appropriating a disparaging term and turning it into an affirmative statement of the difference and a legitimate place of enunciation. Queer and crip share circumstances of exclusion vis-à-vis the norm, and this parallelism can serve as a key to approaching the aforementioned actions: unclassifiable bodies that disturb the man/woman, heterosexual/homosexual, healthy/ill, beautiful/monstrous, able/disabled, normal/abnormal binarism. Bodies that do not hide, but expose themselves with pride and empowerment, unsettling the given order. Bodies that, like Giuseppe's, become maps-archives-museums, where continuous transformations, stories of repression and rebelliousness, remain inscribed as traces of subjection and transgression. Bodies that challenge sexual order as well as the medical establishment, by turning the disease process, rather than an experience of helplessness and prostration, into a political, ritual act of farewell. Mourning and grief in a raging celebration.[10]

Translated from Spanish by Jen Hofer
and Jorge Salvetti

1 Giuseppe Campuzano, *Museo Travesti del Perú* (Lima, 2008), p. 89.

2 Campuzano, "Andróginos, hombres vestidos de mujer, maricones...el Museo Travesti del Perú," *Bagoas*, no. 4 (2009), p. 79–93.

3 Campuzano, "Museo Travesti. Concepto, contexto y proceso" ("Museo Travesti: Concept, Context and Process"), presentation at La Culpable, Lima, July 2008.

4 Ana Longoni, "Ya no abolir museos sino reinventarlos. Algunos dispositivos museales críticos en América Latina" ("Not to Abolish Museums, but to Reinvent Them: Some Mechanisms for Critical Museography in Latin America"), unpublished talk presented at the international symposium Qué hacer con los museos (What To Do With Museums), Universidad Pública de Navarra. Part of the program on "Arte y cultura en las sociedades del siglo XXI" ("Art and Culture in 21st Century Societies"), Cátedra Jorge Oteiza, Pamplona, Spain, April 13, 2010.

5 Miguel López, "The Museo Travesti del Perú y the histories we deserve," *Visible Workbooks* no. 2 (2013), http://www.visibleproject.org/blog/.

6 Campuzano, "Museo Travesti. Concepto, contexto y proceso."

7 Miguel A. López, "Indígena-Antropofágica-Tropical-Mutante-Memoria-Sexual. El Museo Travesti del Perú y la lucha política por nuevos marcos historiográficos" ("Indigenous–Anthropophagic–Tropical–Mutant–Sexual–Memory: The Travesti Museum of Peru and the Political Struggle for New Historiographic Frames"), unpublished talk presented at the *Art Archive: Latin America and Beyond* symposium, University of Texas at Austin, October 15–17, 2010.

8 Already severely weakened by AIDS, Espaliú let himself be carried barefoot along the streets of Madrid by a human chain of people willing to carry him in their arms and care for him. Adrián Searle writes: "The *Carrying* action demands carefulness, trust, flexibility, strength, humor, coordination and solidarity from all the participants, both carriers and carried alike. Espaliú, the man being carried, was also a carrier–of the HIV virus, of his own fear and suffering. *Carrying* was (. . .) a public statement of love and solidarity, and also a demand–a demand that his audience engage itself not only with the ritual but with its implications." Adrián Searle, "La pérdida de Pepe Espaliú," in Acción Paralela no. 1 (1992) , http://www.accpar.org/numero1/searle.htm.

9 Robert McRuer, *Crip Theory: Cultural Signs of Queerness and Disability* (New York: NYU Press, 2006).

10 This can be clearly appreciated in the description of Campuzano's burial written by his friend Malú Machuca: "Last Sunday we buried his body letting him know that we'd always lend him ours for him to come back, just like he lent his to so many divas so many nights. (. . .) and once again, he stopped the traffic, because all his friends and family went out into the street to dance, throwing flowers and color petals, with a beautiful troupe dancing a passacaglia, Germain dressed as Giuseppe leading the coffin that carried his body. We all danced, we danced a lot, tap-danced a lot. We laughed, smiled, wept, laughed again, smiled again, because the neighbors looked out of the windows and came out of their houses to see what was happening. And what was happening was what had always happened: Giuseppe reigned. And his body, tired and in pain, left to take now ours." Malú Machuca Rose, "Mariconixima renace en cabrísimo ritual" in *La Mula*, Lima, at https://lamula.pe/2013/11/12/mariconixima-renace-en-cabrisimo-ritual/malulin/.

Chto Delat
Chto Delat/What is to be done?

The School of Engaged Art
A Project of Chto Delat and the Rosa Luxemburg Foundation

How does one become an artist?
Why should one become an artist?
What is art today, and what role does it play in society?
We aren't sure that we have ready answers for these
and other urgent questions, and this is why we started
the school—to meet the younger generation and work out
together what is happening with art and the subjectivity of
artists here and now, in contemporary Russia.
What do we want from an art school?
First of all, we have no illusions about the miserable situ-
ation in which contemporary art finds itself today. Least of all
are we inclined to indulge the free play of "differences" (of
little concern to anyone), which provides an excuse for with-
drawing from any kind of responsible position. We want to go
against the grain of things and insist that art remains essen-
tial for human becoming, that art is always a gesture of nega-
tion and a call for the world (and oneself) to become other.
This is what defines the active position of the artist in soci-
ety. Art, like philosophy, has always been and still remains a
special space in which debates about truth can occur.
But how can one defend this position today, when all talk
of truth is suspect, interesting only to the marginalized,
and the borders between art and life, art and media, art and
the social sciences, art and activism have been effaced to
such an extent that any desire or opportunity to redefine
the meaning of art is blocked?
What knowledge should an artist possess?
How should such knowledge be evaluated?
Who has the power to judge whether an artwork is good
or bad?
We are rather skeptical about the "academicization" of
art education taking place in Western institutions of higher
learning (perhaps because we—the artist-initiators of the
school—never went through the mill of an academic educa-
tion). And like all self-educated artists, we believe in the

axiom that art cannot be taught but only practiced. This is
why we humbly want to continue the good old tradition in
which artists of one generation try to share with the next
generation their faith in art and its power, their doubts and
hopes, their fears and passion.

The twentieth century produced many similar projects:
Unovis in Vitebsk in the 1920s, the Bauhaus, Black Mountain
College in America in the 1930s–50s, the unofficial circles that
formed around a number of dissident artists in the late Soviet
period, etc. Some of these projects left an indelible mark on
history; others, hardly anything at all. Even the most serious
educational projects often became a force for change among
only a very small circle of people, but their mere existence
served to preserve hope in the darkest of times.

*What kind of art education is necessary in the Russian
context today—in a situation where basic democratic free-
doms are crushed and the level of violence in society has
reached a critical level; in conditions that offer no support
whatsoever for an independent, critical culture, and
where there are no academic programs in contemporary art
at all?*

In our view, art can and must deal with all the painful
processes of our transforming society. Today it is essential
to practice art that does not hide in the safety of institu-
tional and pedagogical ghettos. We want an art that will tear
itself free of the formalist approach to political and social
questions; an art that can appeal to a broad viewership
(while still touching each viewer on an individual level), not
a narrow group of professionals immersed in discursive and
contextual nuances. To achieve this we need to accrue knowl-
edge from the widest range of disciplines and use it in the
most unorthodox ways.

*We need a hybrid of poetry and sociology, choreography
and street activism, political economy and the sublime,
art history and militant research, gender and queer experi-
mentation with dramaturgy, the struggle for the rights
of cultural workers with the "romantic" vision of art as
a mission.*

The distinguishing characteristic of our school is its open declaration of fidelity to the leftist tradition of modernist and avant-garde art and the simultaneous rejection of a dogmatic approach to politics. We want to experiment with collective egalitarian and emancipatory practices, which are still alive despite all the traps of the oppressive political situation. In order to do this, we have to demonstrate a viable alternative to the private interests of oligarchs and corporations and to the senseless machine of mass entertainment. Art, like authentic politics, is a common task—it is one of the key fronts to fight for social justice. The ten-year activity of Chto Delat and the position of the Rosa Luxemburg Foundation (the institution supporting our initiative) have always been based on these assumptions; the time has come to affirm them in education.

A central component of our school is the idea of collective practice. We want to develop a range of models for collective art production while of course continuing to discuss personal projects. We are convinced that a *community of learners* emerging in this way will have no place for neutral, unengaged abstractions. *And this is why we have called our project the School for Engaged Art.* Such a school requires all participants to take a position in this world, where fundamental battle lines are drawn by developing a particular ideological/aesthetic movement. And face this risk of taking positions together—with newly constructed constituencies.

In conclusion it is important to point out that our goal is not to teach students how to make a career as an artist. Instead, we practice art as a vocation. We are not going to provide students with all the right "connections"—we simply want to introduce them to interesting, wonderful people. We don't promise anyone that they will become rich and famous—we want them to share an experience of that fullness of being, freedom, and becoming, without which no self-realization is possible in the world.

**Chto Delat, Poster for *Study, Study, and Act
Again* (Moderna Galerija, Ljubljana), 2011**

What, How & for Whom on *Chto Delat/What is to be done?*

Chto Delat (What is to be done?) is a self-organized platform, founded in 2003 in Saint Petersburg by a group of artists, critics, philosophers, and writers from Saint Petersburg, Moscow, and Nizhny Novgorod, who work at the intersection of political theory, art, and political activism. The name of the collective derives from a novel by the nineteenth-century Russian author Nikolai Chernyshevsky, as well as Vladimir Lenin's 1902 political text. Its members today include Olga Egorova/Tsaplya (artist, Saint Petersburg), Artiom Magun (philosopher, Saint Petersburg), Nikolai Oleinikov (artist, Moscow), Natalia Pershina/Glucklya (artist, Saint Petersburg), Alexei Penzin (philosopher, Moscow), David Riff (art critic, Moscow), Alexander Skidan (poet, critic, Saint Petersburg), Kirill Shuvalov (artist, Saint Petersburg), Oxana Timofeeva (philosopher, Moscow), and Dmitry Vilensky (artist, Saint Petersburg). Apart from being engaged in artistic and theoretical production through video works, theater plays, and installations, as well as by issuing a Russian-English newspaper, *Chto Delat?*, the group supports mutual assistance networks through a number of other grassroots groups who share the principles of solidarity, internationalism, feminism, and equality.

The artistic, theoretical, and activist work of Chto Delat contributes to the reworking of the principles of self-organization, solidarity, and collectivism in art. Their working method stems from concrete and materialist analysis and critical employment of mimetic procedures in a process described by member David Riff as "collective reconsideration of critical realism." This notion of critical realism is consistently articulated politically and theoretically in the pages of their newspapers in relation to projects developed by different constellations of the members of the collective.

The main aim of Chto Delat is to initiate the process of repoliticization of Russian intellectual culture in its broader international context and to carry on the discussion over development of leftist thought that can serve as a counterweight to the prejudices created by the anti-communist sentiment and rampant nationalism of the last two decades. Since 2003, the collective has published almost forty issues of its newspaper, each featuring a particular topic such as states of emergency, self-education, and language at/of the border. They have included contributions by Russian and international artists, art theorists, philosophers, activists, and writers such as Peio Aguirre, Jodi Dean, Mladen Dolar, Jason Jones, Antonio Negri, Gene Ray, and Sergei Zemlyanoi.

Chto Delat's newspaper and video works are published on the web and distributed freely at conferences, exhibitions, and demonstrations. Their projects act as double agents: on the one hand, they deliver politicized content, appropriately based on the methodological principles of the Russian avant-garde and soviets, while on the other hand, they revive the capacity of speech in the public sphere through a focus on the crucial questions of political and intellectual Russian contemporary life in relation to an international context. Additionally, like in the video *Museum Songspiel: The Netherlands 20XX* (2011), filmed on location at the Van Abbemuseum, Eindhoven, their work questions ideological and geocultural constellations of art institutions and the institution of art as such.

Their installations, consisting of videos and in situ wall drawings, explore the potential of political projects to generate social emancipation and collectivism. For example, a series of collective video works, *Songspiel Triptych: Perestroika-Songspiel*

(2008); *The Victory over the Coup* (2008); *Partisan Songspiel: A Belgrade Story* (2009); and *The Tower: A Songspiel* (2010), revisit a form of *songspiel* developed by Bertolt Brecht in the late 1920s as a vehicle for social critique. The videos are structured like ancient tragedies that present key moments and topics of post-communist dynamics in Eastern Europe generated by vast political and economic transformation from socialism into the current neoliberal order. The dramatis personae are divided into a chorus and a group of protagonists, representing characters typical for particular historical constellations, such as a democrat, a businessman, a revolutionary, a nationalist, and a feminist in the *Perestroika-Songspiel*; or city official, war profiteer, business tycoon, factory worker, NGO activist, and disabled war veteran in *Partisan Songspiel*. They often address the viewer directly, exploring complex and contradictory social dynamics as well as the intellectual and material conditions of political changes after 1989.

 Chto Delat's work can be seen as both an artistic and theoretical effort that aims to actively politicize the field of art. Based on a concrete analysis of the social and political tensions and the ways in which these erupted through conflicts in recent history, their "socially engaged musicals" look into the functioning of the ideological apparatus, the production of new social symbols, and the way power alliances are formed and reshaped within society. Through deliberate mixes of different and contradictory elements, such as traditional form and radical political content, as well purposeful shifting between the comic and tragic elements, they employ a new approach to the Brechtian concept of estrangement that can be viewed as a model of radical and effective, yet sensual and educational, political art. By moving away from aesthetic illusions, Chto Delat's works lay bare the contradictions of social mechanisms and look into possible ways to shake up the political resignation that permits the loss of control over the direction of social transformation.

DABATEATR
DABATEATR Citoyen

DABATEATR is a theater company founded in 2004 by stage director Jaouad Essounani and a group of artists from different artistic disciplines to promote a "free cultural, citizenship, and artistic action" while maintaining the principle of a theater meant to be "elitist but for all," that is to say, a theater that does not demean the art, gives some room for the artist, and helps the public, through the creations, to think and react.

In 2008, the company DABATEATR was joined by the writer and playwright Driss Ksikes with the aim of creating the play *Il / Houwa*, which marks the first collaboration between Essounani and Ksikes. Since then, DABATEATR took a new turn, going beyond creation and providing the company with a new dynamic. Today DABATEATR has established a platform for hosting various art forms to create bridges between different artistic disciplines, cultures and society.

DABATEATR tends to refine its creations in order to bring in new contributions. In fact, DABATEATR does not consider that things should remain intact, but rather should be nourished and enriched by the process of sharing, exchange and discussion with the audience. Therefore, DABATEATR describes its work as a "laboratory" because the company's creations and performances operate in a dynamic of research, learning and constant evolution depending on the encounters, contemporary political, social and cultural trends, as well as the place of performance within national or international contexts.

Along the lines of this approach, the audience is accountable and takes part in the creation by enriching it with their reactions, comments and questions. Thus, the audience does not just have fun, and does not engage in an attitude of mere consumers. Instead, the audience thinks and reacts, and does not leave the representation without carrying its marks. DABATEATR tends to retain the public by generating their desire and consistency.

Since 2004, DABATEATR produced a dozen performances in Morocco and abroad. Starting with *La jeune fille et la mort* (2004), then *Crash Land / Une Nuit* (2005), *Chamaa*

(2006), *D'HOMMAGES* (2007), *Il / Houwa* (2008), and arriving to *180 degrés* (2010), DABATEATR has explored various themes, including human rights, cross-cultural cohesion, human nature, and the clashes and reconciliations between people and their cultural and social environments.

Being open to national and international collaboration, DABATEATR collaborated with theater, music, and choreography artists from different countries. Examples are *Crashland*, which gathered Moroccan, Jordanian, German, and French artists, and *Confidences* (2010), fruit of the collaboration between Moroccan and French theater companies.

DABATEATR remains best known for the play *Il / Houwa*, which won the Grand Prize of the National Festival of Theatre at Meknes, Morocco, and the Prize of Best Directing in 2009. Also in 2009, the play won the award of the Best Text in the Constantine Festival in Algeria. The company also organizes a series of theater and performance art events, including Dabatelier, a series of workshops to train theater amateurs, and *DABATEATR Citoyen*, a monthly event where actors, directors, writers, musicians, dancers, and artists of all disciplines come together to promote the idea of a multidisciplinary theater and exchange views and creations with the audience, confirming its concept of theater as a permanent "laboratory."

This year, DABATEATR launched the monthly event 9lil W Mdawem,[1] designed to gather theater artists and circus performers with the public. The audience, by choosing the themes as well as the art forms, becomes an essential component of the creative process.

Rabat, Morocco

1 In Moroccan Darija, 9lil W Mdawem can be translated as Small but Sustainable.

All images:
DABATEATR, *DABATEATR Citoyen*, 2010–13

Omar Berrada on
DABATEATR Citoyen

DABATEATR is a theater company based in Rabat, Morocco. Its name, a condensation of Moroccan Arabic and French, translates as "theater now," stressing both an imperious need for expression and an urge to be contemporary, to be in the present. DABATEATR was founded in 2004 by Jaouad Essounani and took its current collaborative and interdisciplinary form in 2008 with the inclusion of playright Driss Ksikes, along with associate artists Salima Moumni (choreography) and Imane Zerouali (directing).

In the words of Ksikes, the urgency implied in the *Daba* is an "urge to understand, to experience things, and to abolish factitious categories: high art and low art, literariness and orality." DABATEATR tries to keep alive a tradition that might be traced to the French TNP (Théâtre national populaire, or People's National Theater) or to what theater director Jean Vilar thought of as "elitism for all." The point here is not to bring high culture to the masses. The point is to bring as many people as possible into the explorations and uncertainties of the creative process. This is the raison d'être of the collective's long term project called *DABATEATR Citoyen* ("Citizen Theater Now") and, within it, *L'khbar F'lmasrah* ("The News on Stage").

DABATEATR Citoyen opens a stage in the space of the city through a weeklong festival over six nights every month. Each show is a different collaborative mix of theater, music, dance, and poetry. One of the six nights—one night a month—is *L'khbar F'lmasrah*. This is a performance where issues of current social and political concern in Morocco are acted out on stage. It proposes a radical performative alternative to TV news and a public fleshing out of issues that are hardly ever openly discussed in a society that is authoritatively policed.

For instance, following protests from prisoners' families, the then-head of the Moroccan penitentiary administration declared, in an interview, that if all Moroccans want human rights, they had better go to a different country. In the hands of DABATEATR, this gave rise to scenes mixing satire with a meditation on human rights, under the title *Wash bnadem huwa l-insan* (Are men human? or, Is man part of humanity?). On another occasion, in February 2011, Fadoua Laroui, a twenty-five-year-old Moroccan woman, immolated herself, much in the way of Tunisian revolutionary icon Mohamed Bouazizi. Soon after, and as the protest movement in Morocco was starting to gain momentum, DABATEATR staged a play imagining an encounter in purgatory between Laroui and Bouazizi.

What is most interesting, though, is the processual nature of what happens behind the scenes: the collective and collaborative writing of each month's play. This is done during an intensive weekend writing workshop led by Ksikes, ten days before each month's performance. The workshop is open to all. It has its regulars, but also new participants each time. Some of the members are writers or intellectuals, but many are not professionally engaged with writing—often people have registered for the workshop after attending a performance of *L'khbar F'lmasrah*. The workshop leader strives not to impose his own voice on the writing, so that the work is, in a way, quite literally produced by its spectators.

Typically, on Saturday morning the group would brainstorm possible themes relevant to the current social and political situation, then break into groups of four with initial ideas for scenes that each group would write over the next afternoon and morning. On Sunday afternoon the whole workshop comes together again to critique and polish the work done by each group,

and decide on a sequence before sharing the work with one of the troupe's directors. Ksikes again: "To be contemporary is to stake the humble claim of interpreting all the audible voices in order to invent the impossible."

As a project, *L'khbar F'lmasrah* developed out of the idea that theater is an ideal space for social polemic, while bearing in mind the necessity of not instrumentalizing art for the sake of foregrounding political opinion. Each time, the work being presented is an experiment. It is not conceived as spectacle, but as a suspension of everyday life to precisely look at everyday life in a different light. In the time-space of this suspension a (temporary) work of art takes shape, and a (fragile) public space of interaction is constructed. *L'khbar F'lmasrah* was a theater lab constantly experimenting with new forms (of writing, of staging, of collaborating) out of recurring materials appropriated from newspaper headlines. Over the months a singular community was built, uniting those on stage, those backstage, and those in the audience.

Today *L'khbar F'lmasrah* is no longer. But through theater production, training workshops, and experimental projects, DABATEATR still pursue their radical agenda: a grassroots dissemination of participatory art practices in a country where political participation, or indeed public gatherings of any sort, have not traditionally been encouraged.

The insurrections of what has come to be called the Arab Spring have relied heavily on social networks and the horizontal dissemination of information that they allow. DABATEATR proposes its own version of an artistic spring, where artists step out of a logic of stardom and spectacle in favor of a slow, long-term process of mutual transformation; they are stepping down from their pedestals in order to become elements of a collective intelligence in the making.

Etcétera

Etcétera was founded in 1997 in Buenos Aires as a multidisci-plinary collective composed of visual artists, poets, actors, and performers sharing the intention of bringing art to the site of immediate social conflict—the public spaces, the streets, the protests and demonstrations—and of bringing those social conflicts into arenas of cultural production, including the media and art institutions.

The relationship between art and social justice was the starting point since the beginning of our activities. Most of Etcétera's actions, interventions, and performances fight social injustice, institutional violence, and repression.

There are three key moments in the history of the collective: in 1998 we joined the human rights organization H.I.J.O.S. (Children for Identity and Justice Against Forgetting and Silence), developing and popularizing the "escraches,"[1] a method of denunciation created together by artists and activists, seeking for new forms of social justice not beholden to the state's legal and judicial institutions, which in several cases has kept impunity as a model even during the democracy.

The second moment started in December 2001, when we faced the biggest economic and social crisis in Argentina. Thanks to the crisis, we were able to understand how global capitalism works micro and macro scale, discovering at the same time the effects of the so-called "crisis of represen-tation" which appeared as a premonition for the future: the 2008 world financial crisis which is still ongoing.

Since then we used the concept of "social ready-made" as one important tool in our artistic practice. The "social ready-made" results from a contextual displacement and uses different artistic or semiotic strategies to signal and highlight situations, tensions, and conflicts in order to give them visibility.

During crisis times it was urgent to artistically support the main groups affected by the economic crash, the so-called new social protagonists: social movements, workers' unions, and movements of unemployed (UTD, MTD). Factories taken by the workers were transformed into cultural centers, and

the people's assemblies occupy every single park in Buenos
Aires. After the devaluation of the currency, the crisis of
representation grew incredibly, and people do not trust any
of the institutions, or rulers, or even banks.

Such anarchistic times were a panacea for Etcétera, and
the collective performed the most audacious and surrealist
actions—like "El Mierdazo," when hundreds of people threw
their excrement on banks and corporations responsible for
the economic crash.

After the drama of the crisis, the romantic process of
normalization started around 2004, when President Nestor
Kirchner won the elections after neoliberal former pres-
ident Carlos Menem abandoned the elections in the second
turn. The government implemented several reforms related
specifically to the human rights issues that society has been
demanding for more than thirty years.

Slowly the economy started to recover, thanks to the
old-new business of the exploitation of the soil, the imple-
mentation of genetically modified organisms (GMO)—mainly
transgenic soy and corn—and also multinational investments
in the extraction of oil for exportation. People returned to
consumerism, and in the streets protests decreased because
of the inclusion of a big part of the social movements into
the state apparatus.

This normalization was a turning point for the collec-
tive. Accustomed to work about the conflict, the apparent
calm of the return to capitalism also brought an internal
crisis within the group due to the change of context.

We did not know if Etcétera could continue to exist...
However, the miracle occurred: in November 2005 the
President of the United States, George W. Bush, came to visit
Argentina at the Summit of the Americas. Bush brought a
series of geopolitical and legal reforms for the countries of
the South: the creation of an area of free trade, deregulation
of regional exploitation of the lands in order to develop the
"extractivist"[2] model, and most controversially the inclu-
sion and application of anti-terrorist laws in Latin American
legislation.

We performed a series of actions questioning the ste-
reotypes created by the media to criminalize a portion of
non-Western society, accusing them of terrorism. In such a
context we participated in the formation of a movement and
the creation of a new -ism: errorism.

The founding myth of the movement happened that
afternoon, when by mistake we aimed the poetic-weapons
at a big aircraft crossing the sky, without knowing that
it was Air Force One, where Bush was traveling back to
Washington. Since then Etcétera has been an active cell of
the International Errorist Movement.

1 *Escraches* is a form of public
protest organized by HIJOS, sons and
daughters of people disappeared
during the last dictatorship
(1976–83). The word "escrachar" is an
Argentine slang term meaning "to
uncover." *Escraches* are campaigns
of public condemnation through
demonstrations that aim to expose
the identities of hundreds of
torturers and assassins benefiting
from amnesty laws sanctioned
during the democratic governments.
Marchers invade the neighborhoods
where torturers live, walking

around the streets performing
art interventions, signalizations,
carrying banners and singing
slogans.

2 Extractivism or neo-
extractivism is a term used
primarily to refer to the economic
policies of Latin American countries
that rely heavily on primary
product exports but have recently
increased the role of the state in
directing the economy and making
investments in the social sector.

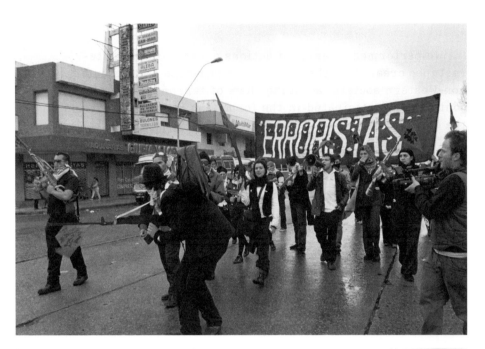

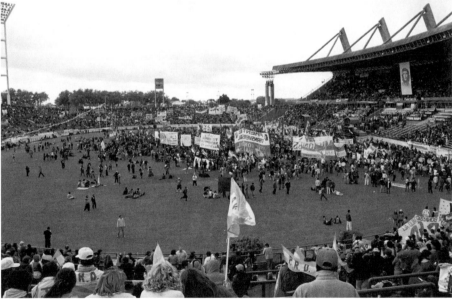

All images:
Etcétera, *La IV Cumbre de las
Américas*, 2005

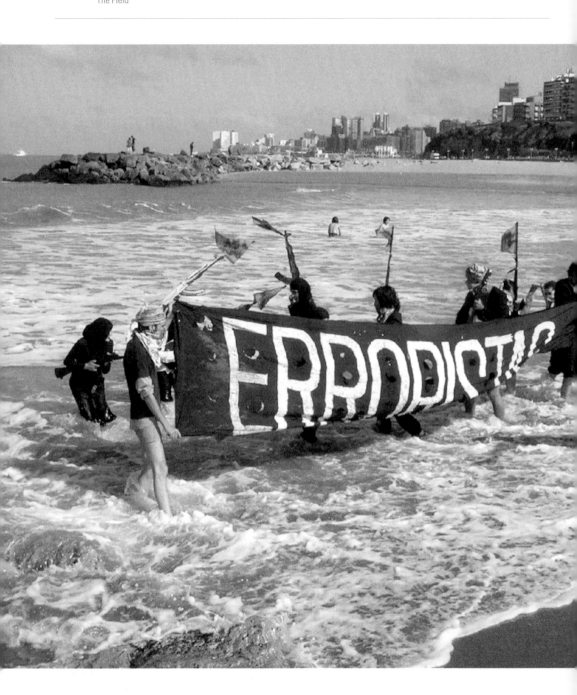

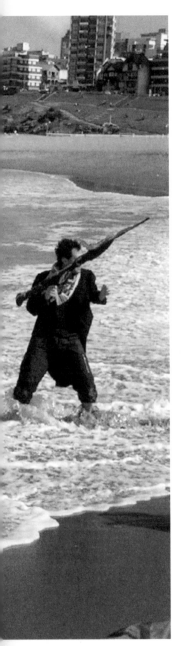

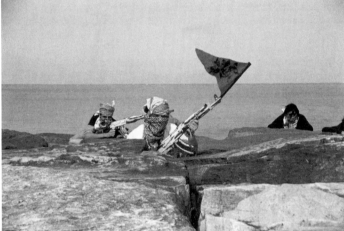

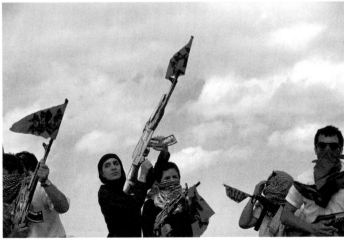

Galit Eilat on *Etcétera*

Etcétera is a collective founded in 1997 in Buenos Aires by artists, actors, poets, and puppeteers. It has had a prominent role in developing participatory art practices, actions, and public interventions, while exhibiting a profound, responsible social engagement in different contexts and communities, linked to activism and the human rights movements. Loreto Garín Guzmán (Chile) and Federico Zukerfeld (Argentina) are the cofounders of Etcétera and core members of the International Errorist Movement (IEM).

When the group was formed most of its members were under twenty. Living in Argentina, they were witnesses to the social and political consequences of the economic collapse of debt-driven capitalism in 2001. They shared the intentions of bringing art to sites of immediate social conflict—the streets—and of bringing the conflict into arenas of cultural production, including media channels and art institutions. They often work with street art that is by nature ephemeral and circumstantial. Their work often takes place in the everyday urban environment where it forms a statement of protest, denunciation, or a simple signaling of injustice. As a result, it pertains to a specific time and place. In their actions, Etcétera employ humor, theatrical display, and any tactics they can muster in order to forge an engaged art. In their works, there is often a surrealistic edge or a playful relationship with political correctness.

Perhaps the most notable of their recent activities is the conception of the IEM, an international movement that claims "error" as a life philosophy, carrying out manifestations, conferences, publications, workshops, and exhibitions in its name. The IEM was founded in November 2005 in Buenos Aires. It has members in Argentina, Austria, Bolivia, Brazil, Canada, Chile, Colombia, Croatia, France, Germany, Italy,

Japan, Mexico, Spain, Sweden, the United States, and Venezuela. They came together in the framework of actions to protest the presence of President George W. Bush at the Summit of the Americas, a meeting of the leaders of all the countries of the American continent in the town of Mar del Plata, Argentina.

In 2005, the International Errorist Movement took part in an international anti-summit, called the People's Summit, whose participants included social organizations, agricultural movements, leftist parties, NGOs, independent media, civil rights organizations, syndicates, and student committees. These groups together created various manifestations and cultural events in Mar del Plata. For the summit the city center had been closed and flooded by military and police in the name of security. It was there that the IEM made its manifesto, which begins with the declaration, "WE ARE ALL ERRORISTS." A series of errorist actions accompanied protest demonstrations on the streets. In this way, the resistance to Bush's war on terror was the basis for the creation of the Errorist Movement. The movement is based on the idea that error is the ordering principle of reality. The concept of error is considered more open than the capitalist notion of what is an error; error can be a philosophy of life. At the same time, the word errorist alludes to a wordplay with the word terrorism. This wordplay evidences not only the movement's fascination with humor but the possibilities of resisting by language alteration and ideological deconstruction.

Error is a negative affirmation, or a speculation about another possible outcome. Traditional education teaches by examples; it uses error as a variable to measure knowledge. In traditional education error would be eliminated, sanctioning, in a way, that which passes through the experience of error. Yet, while it

attempts to minimize the idea that error is something positive, the educational system also lives off the dialectic of trial and error that constitutes the very matrix of its methodology. In a society where "erring" is criminalized, one attempts to structure one's life under the martial law of the market and concentration camps of consumption. Yet it is this same society that periodically collapses in its search for the permanent application of "efficiency and optimization" to every relationship.

Errorism accepts the permanent presence of error in reality in order to liberate the individual from the "infallible" market. Using cultural tools, it drives a new vision of and participation in life. Error thus becomes a permanent source of inspiration.

Losing the fear of being wrong impels a surpassing of limits and releases a creative potential that was latent but inhibited by the moral structures determining social values and behaviors under our traditional educational system.

Errorists therefore affirm the urgent necessity of a general de-education. In its place, the group posits knowledge based on a sum of collective projects and of experiences in the transmission and exchange of practices. By doing so, errorism provides a capacity for the self-formation of individuals and collective subjects and takes life itself as their object of study. This is a crucial concept for any art that seeks to effect social change by providing its users or participants not only with critique but with a positive suggestion for how to combat the social rules of neoliberalism. As such, it serves as an exemplary artistic methodology for building collectivity and expressing political desires with cultural means.

Today, errorism and its actions enjoy the broad support of the international community. Its practices and its philosophy are spreading, creating new autonomous cells of the International Errorist Movement all over the world. The group continues to develop its activities collaboratively with other collectives and individuals, and also inside the educational field.

Gugulective

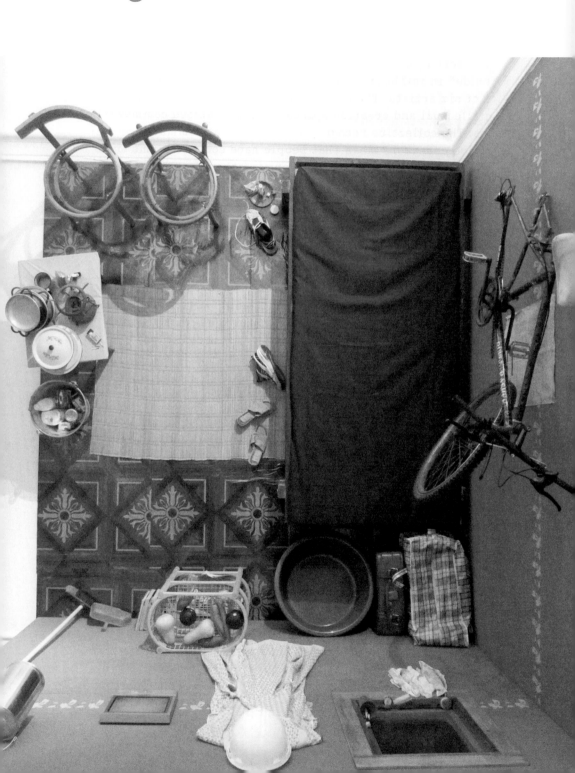

Gugulective, which derives from the word *gugu*, denoting
"pride" in isiXhosa, is a Cape Town-based collective made
up of six artists. The collective was born out of a need for
intellectual and creative spaces in disadvantaged communi-
ties. The collective recognizes the fact that communal or col-
lective endeavors mean that people have come to terms with
their conditions and are transforming them for the better.

We live in a time in South Africa when collective artistic
endeavors have acquired the status of significance, because of
the "significant" statements they make. At the core of this
mission is the issue of infrastructure, the availability and
access to resources. The collectivization of artistic practice
thus undermines the notions of individual outlook, solitary
work habits. Encouraging collectivism rather than individu-
alism, thereby promoting solidarity and positive social val-
ues through creative forms in disadvantaged communities.

Gugulective, through its creative intervention and the
soon-to-be-launched project space, proposes a complete
rethinking, if not necessarily the overhaul, of the forms,
strategies, and techniques of everyday existence as well as
the devices through which cultural production occurs and
in the places where it is grounded. Gugulective recognizes a
crisis that affects the effectiveness of traditional institu-
tions, their conditions of production, and the visibility and
quality of discursive formations; the position of the art-
ist and intellectual within the public sphere are subjects
that the collective constantly aim to call into question.
The Gugulective views its work as a socio-cultural activity
geared toward knowledge and discourse production, rather
than specifically as an object-based visual art activity. With
this in mind we aim to make individuals the authors of their
own history and the masters of their own destiny.

The collective has been mainly working and exhibiting
in a local shebeen in Gugulethu, Kwa Mlamli's Shebeen. We
have worked with a variety of groups from high schools both
locally and internationally, and through multidisciplinary
art exhibitions have also worked with local artists, poets,
filmmakers, musicians, dance groups, and art curators.

Cape Town, South Africa

To date the collective has self-initiated and curated
three exhibitions at Kwa Mlamli's Shebeen. Through these
exhibitions Gugulective has created a space for dialogue,
where creative interaction takes place between artists
(young and old), creative producers, and the immediate com-
munity. The Gugulective occasionally hosts film screenings
after which a space for dialogue about the issues and con-
cerns raised by the film are discussed, and as part of these
screenings a number of academics and scholars have spoken,
including Professor Ntongela Masilela (English and World lit-
erature at University of California), Abdulkadir Ahmed Said
(award-winning filmmaker) and land activist Ricardo Jacobs,
among many others.

Gugulective has also been open to collaborations and has
taken part in a number of exhibitions both outside of and
including the project space (Kwa Mlamli's Shebeen).

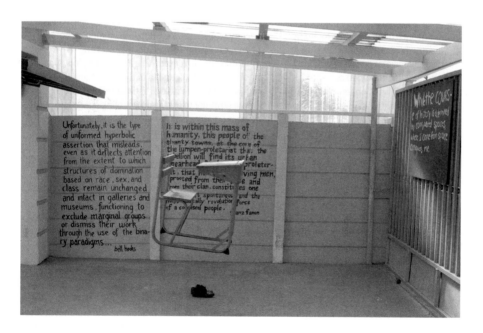

Previous page:
Gugulective, *The Building Is the
Man*, 2010

This page:
Gugulective, *Corporal Punishment*, 2008

Kathryn Smith
on *Gugulective*

*"One has to be an artist to survive as a poor person . . .
you have to imagine space where there is none"* [1]

A locked-off camera observes an interior scene where
seven people—Gugulective members Lonwabo Kilani,
Dathini Mzayiya, Khanyisile Mbongwa, Themba Tsotsi,
Ziphozenkosi Dayile, Kemang wa Lehulere, and Athi
Joja—sit around a dinner table. An informal meal is in
progress; wine is poured. The guests variously enter
and leave the frame, their movements sometimes leav-
ing spectral traces. These ghosts seem to point directly
to the conspicuous absence of charismatic founding
member Unathi Sigenu, whose premature death exactly
one year before this reconciliatory meal devastated
plans to regroup and tackle unfinished projects.

Premiered at Kwa Mlamli's Shebeen in Gugulethu[2]
in November 2014, Gugulective's film *The Last Supper*
communicates endings and beginnings. It was the
first indication in more than two years that the group
had not disbanded completely, the intervening period
marked by solo successes and collective losses. It is
edited with a light touch, the occasional cross-fade
implying the passing of time. It is presented without
audio, the silent conversation looping and cycling
between relaxed and animated. There is laughter but
also a keen sense of gravity, sliding into the poignantly
absurd when we notice Mzayiya wears an apartheid-era
police uniform and occasionally sweeps the floor.

As Dada is often incorrectly attributed with the
suffix *-ism*, so Gugulective does not require the defi-
nite article qualifier (*The*). Gugulective is both a proper
name and proper noun, an amalgam referencing both
isiXhosa and English to address the pride (*gugu*) and
dignity of community, context, and conditions of
being. They do not use the term collaboration in their
collective praxis, although they protect their individual
identities within the group. Whether for philosophical,
political, or practical reasons, they are frank about the
pitfalls and privileges that this approach offers.

Collective art practice in South Africa has roots
in the community art centers and parks that provided
both physical and mental spaces of perceived freedom
for artists to work together, albeit precariously, under
apartheid's subjugations. Here, creative collabora-
tion mapped onto political solidarity, mobilizing and
providing impetus for democratic change. Gugulective
self-identifies as "the creative intellectualism of a
society whose value system is grounded on notions
of community or the collective," asserting they have
inherited—not invented—this imperative, "cultivated
by the black intelligentsia of the 1930's and 1940's."[3]
In their view, collective artistic practice is the only
viable strategy to create an enabling space for their
greater creative community and peers, promoting
solidarity over solitary pursuits and struggles.

That Gugulective is about to mark a decade of
working together is an extraordinary feat, particularly
in a context where infrastructure and resources to
support anything filed under "contemporary art" are
sparse and precarious, if not wholly lacking. Their
major contribution has been to align critical discourse
with the vernacular. Since their formation in 2006,
their résumé lists numerous exhibitions in South
Africa and abroad, including two major exhibitions at
the Iziko South African National Gallery in Cape Town.[4]
Their approach seemed to answer a profound need
in the post-apartheid context; a group of young town-
ship-based artists, self-organizing and working across
visual and performing arts, poetry, and film, embodies
an ideal of the "new" South Africa.

That that they use a shebeen as their operational
base provides an immediate engagement with local

communities, but it is also a wry gesture. A social space points to the reality of where the "real work" within the art world is so often done, but stops short of becoming the work itself, as per the variously named relational, dialogical, and participatory forms of recent practice. But this common trait of using social spaces to test ideas takes on a slightly more urgent inflection here. Shebeens are historically contested spaces, performing multivalent functions. They are completely enfolded into the labor and leisure, politics, and cultures of the lives of their patrons, coalescing as they have so many moments of resistance, ingenuity, creativity, and indeed violence. The shebeen also encapsulates stereotypical Western fantasies of township life.[5]

Their installation *The Building Is the Man* (2010) directly confronts the legacy of apartheid's spatial violence, exploring the psychological effects of radical proximity enforced by apartheid architectures in hostels, townships, and informal settlements by presenting a faithful reconstruction of a single-room dwelling, flipped on its side, and balancing on a dais.[6] There is no surplus in this scene of bare life, other than the implicit self-respect and dignity that it projects, without extending to the romanticization of poverty.

Ityala Aliboli/Debt Don't Rot (2010) extends their interrogation of space to failed promises of economic opportunity (if not equality) for all in a post-apartheid democracy, pulling no punches with their collection of mousetraps and enlarged bank note montages depicting currency denominations and designs no longer in circulation. Stenciled images of people standing in line encircle the gallery walls' skirting, repeated and stacked so as to appear endless.

"Our acute collective eye spies a grave lack of change in these times of transformation . . . in spaces outside our community, even in institutions of higher learning," they write. "How do we learn and teach each other that the ideologies that divide us are not necessarily a basis for ostracism or prejudice?" Jean Fisher has observed that the closer art approaches the vernacular, the closer it is to the "*parole* of oral storytelling than most other visual or literary forms."[7] A tradition distinct from the coded conventions of Western historical narratives, it is "the 'no-place' where language falters, where it exposes its own indeterminacy,

and therefore a space of *trans-action* from which one can begin again . . . the collaborative work of aesthetic invention, play, and transformation."[8]

Gugulective is acutely aware that we lack a dynamic perspective of South African art histories that are sensitive to the particularities of context. Discourses concerning artistic production in South Africa have continued to be developed externally, and work is made for this market, often resembling the messy, risky, contingent, intellectually engaged positions that Gugulective itself embodies, but whose concerns lie elsewhere. As such, they remain an emergent force, working within and without conventional art world infrastructures; being co-opted into such structures and, in so doing, co-opting interests to advance their urgent work.

Gugulective was nominated by Bassam El Baroni.

1 See Mamphela Ramphele, *A Bed Called Home: Life in the Migrant Labour Hostels of Cape Town* (Cape Town: New Africa Books, 1993), p. 23, note 1.

2 Gugulethu is one of Cape Town's largest townships, situated off a major national highway on the periphery of the metropolitan center.

3 Gugulective, *Collective Practice as a Tactics of Action*. Unpublished transcription of a performance presentation at *Dada South?* symposium, February 18, 2010, Iziko Rust-en-Vreugd, Cape Town.

4 *Dada South? Exploring Dada Legacies in South African Art from 1960 to the Present*, curated by Roger van Wyk and Kathryn Smith, with Lerato Bereng (December 12, 2009–February 28, 2010) and *1910–2010: From Pierneef to Gugulective*, curated by Riason Naidoo (April 15–September 15, 2009). Their first international presentation was in Berlin as part of the *Performing South Africa* festival in September 2008.

5 Traditionally referring to an illegal drinking establishment, contemporary shebeens are (mostly) legal, some becoming popular features on "township tourism" routes. Shebeens emerged in response to a crude form of social control where the apartheid government attempted to regulate access to alcohol (consumption of which was illegal for black people) by making it available on its own terms, at legal beer halls, profitably administered by the state. See Charl Blignaut and Siyabonga Sithole, "Twisted tale of alcohol and apartheid," *City Press*, January 27, 2014, http://www.citypress.co.za/news/twisted-tale-alcohol-apartheid/.

6 This work has been presented in two iterations thus far, first on *Upstairs Downstairs* (Association for Visual Arts, Cape Town 2008, curated by Bettina Malcomess) and a second version was commissioned for *Dada South?* (2009).

7 Jean Fisher, "The Syncretic Turn: Cross-cultural Practices in the Age of Multiculturalism," in *Theory in Contemporary Art since 1985*, ed. Zoya Kocur and Simon Leung (London: Blackwell, 2005), p. 234.

8 Ibid., p. 241.

Hans Haacke
Der Bevölkerung/To the Population

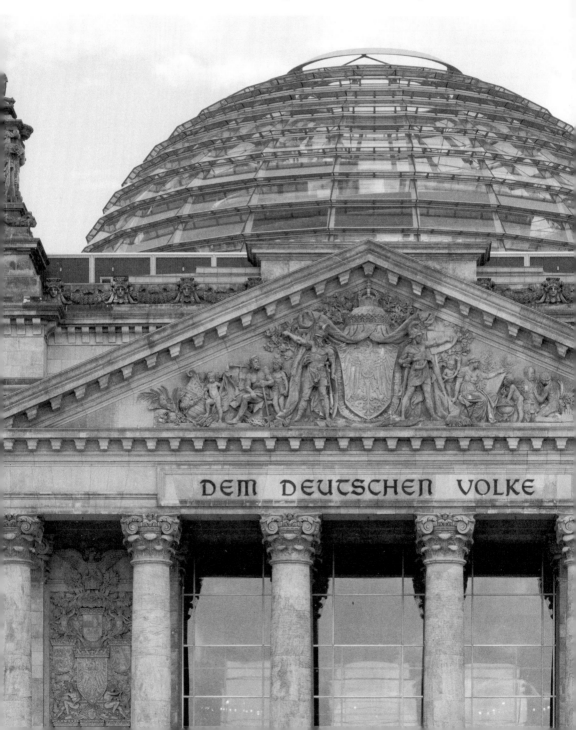

Looking back.

The letters for the exclusive and history-laden inscription DEM DEUTSCHEN VOLKE (To the German People) on the Reichstag portico were cast in a well-known Berlin bronze foundry. During the Nazi period, two sons of the owner were stripped of their German citizenship and killed—one in Auschwitz, the other in a prison in Berlin-Plötzensee. They were Jewish. One hundred thirteen members of the Reichstag were imprisoned. Seventy-five of them died in prison.

Concurrent with the deliberations over the proposal for *DER BEVÖLKERUNG (To the Population)* a debate raged on whether the law on German citizenship should continue to be based exclusively on a person's descent or to make her/his German birthplace a decisive factor as well, and open up other avenues. In 2000, approximately nine percent of the country's inhabitants were not of German origin. The majority had been recruited to work in Germany, or they were children of migrant workers born in Germany.

All but two members of the conservative CDU/CSU party, both women, voted against adding the proposed alternative dedication to the inscription on the portico and inviting MdBs (Members of Parliament) to deposit soil from their constituencies around it in an interior courtyard. One of the two was a former president of the Bundestag who had been arguing forcefully for a more inclusive citizenship law. The project was accepted by a majority of two votes.

In 1935, in his essay "Writing the Truth: Five Difficulties," Bertolt Brecht wrote: "In our times, anyone who says population in place of people...is by that simple act withdrawing his support from a great many lies."

Berlin, Germany

All images:
Hans Haacke, *Der Bevölkerung/To the Population*, 2000

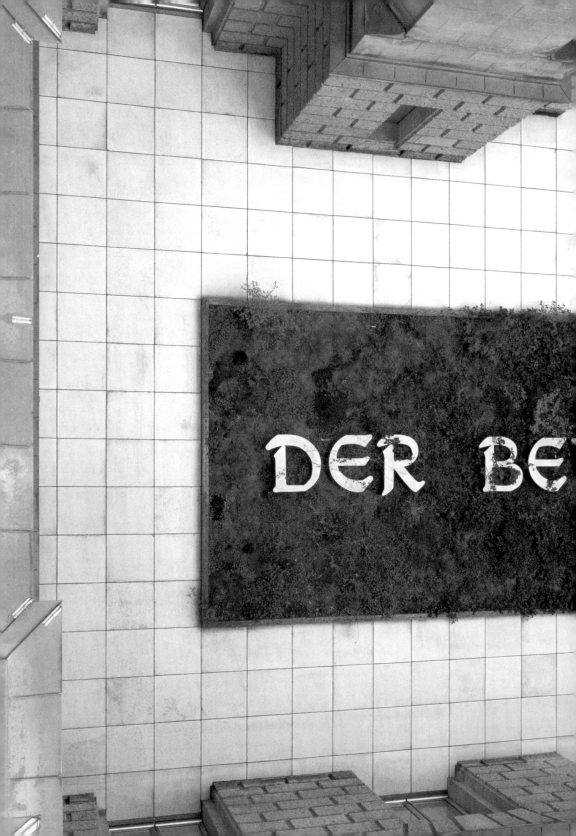

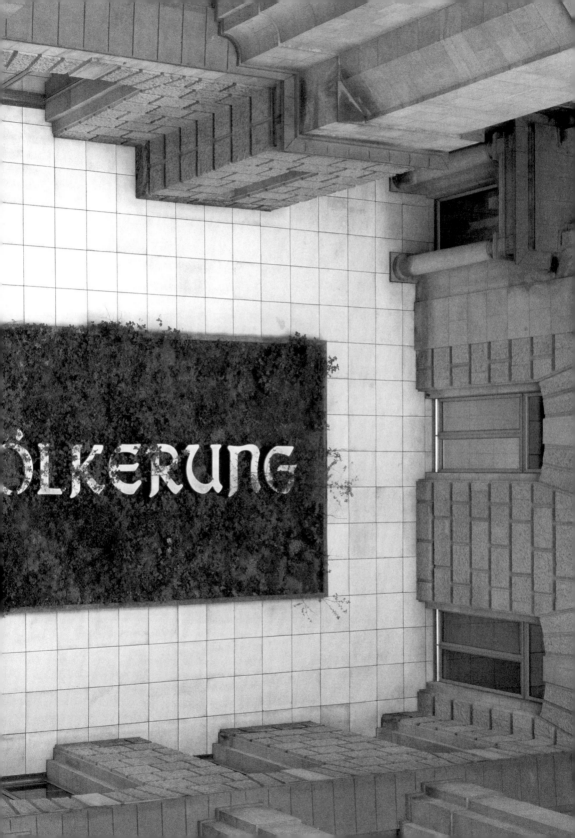

Chen Tamir on
Der Bevölkerung/To the Population

Hans Haacke emerged in the late 1960s as an import-ant voice of critique, especially of the relationship between museums and corporations. His 1970 piece at the Museum of Modern Art's *Information* exhibition was a site-specific work called *MoMA Poll*, for which visitors were asked whether or not they would vote for Nelson Rockefeller, one of MoMA's trustees, for governor of New York despite the fact that he had not denounced President Richard Nixon's Indochina policy. He followed this work by another, *Shapolsky et al. Manhattan Real Estate Holdings, A Real Time Social System, as of May 1, 1971,* which chronicled the shady dealings of one of New York's biggest slumlords. The piece was to be included in a solo show at the Solomon R. Guggenheim Museum, which was subse-quently canceled. Haacke continued to make biting and important works of Institutional Critique as well as work that used art to unveil corporate or govern-ment misconduct. Fearless and without consideration for any personal consequences, Haacke was one of the first to implicate the artist himself or herself in the ethics of the art institution. By articulating these connections, Haacke in effect empowers the artist to take an active role in shaping how—and if—he or she participates in exhibitions, and to which institutions they lend their voices. Not coincidentally, he is one of the key instigators behind the recent call for a boycott of the Guggenheim Abu Dhabi.

In 1998 an arts commission appointed by the Bundestag, the German parliament, and consisting of government deputies, Members of Parliament, and art experts, commissioned Haacke to develop a work of art for the northern wing open-air court-yard of the recently renovated parliament building, the Reichstag, in Berlin. Haacke proposed a large trench filled with earth in which lie the words *Der Bevölkerung* ("To (or 'of') the Population") in neon let-ters. The letter type and size mimic the main inscrip-tion above the main entrance of the Reichstag, *Dem Deutschen Volk* ("To the German People"), which dates to 1916. The phrase was arranged in a bed composed of earth brought by government representatives from each of their election districts. The soil carried with it seeds that have since sprouted, and this *hortus conclusus* continues to grow and change.

Haacke's proposed artwork sparked a lively debate at the Bundestag that was widely reported in the press and much discussed in Germany. The Bundestag voted 260 to 258 in favor of the installa-tion. The World Socialist website pointed out at the time: "Recent debates in the German parliament over issues involving spending cuts affecting tens of millions of people have often taken place in an almost deserted chamber. However, for the debate over Haacke's artwork, more deputies attended and voted than was the case for the parliamentary discussion and vote on the intervention of the German army in Kosovo."[1]

The political resistance against Haacke's work was expressed in particular by the Christian Democratic Union, interestingly also spearheaded by Antje Vollmer, a member of the Green party and vice-president of the Bundestag. Aside from questions of personal taste, arguments emerged that drew unfounded parallels between the work and Nazi spectacle, as well as anti-German immigrant sentiments. The crux of the matter was the distinction between the connotation of the word "population"—a demographic term that brings to mind non-Germans and people without citizenship status and also carries with it an undertone of passivity and subservi-ence—and the term "folk," which carries the weight

of nationalism and specifically Germany's Nazi past. Haacke's simple gesture is so successfully evocative precisely because it can be read in quite different yet striking ways. The work can also be seen as a self-contained ecosystem, a symbiosis of vulnerable life forms growing together under the protection of the Bundestag.

An essential part of the project is its website, which documents the evolving monument with a daily photograph. It captures the changing seasons, the evolving layers of soil, and developments in vegetation. In 2006 Haacke forbade the use of an image of *Der Bevölkerung* on a private website and sparked another debate, this time about the artist's rights in the reproduction and use of his or her works. The debate brought to public attention the power dynamics involved with intellectual property. Four decades after using his practice to instigate art as an agent in a questionable if not corrupt sociopolitical system, Haacke continues to bring to the fore the mechanisms of art, now embedded in an even more complex economic reality shaped by the Internet, digital culture, and international trade.

1 Stefan Steinberg, "The hue and cry in Germany over Hans Haacke's artwork *Der Bevölkerung (The People),*" www.wsws.org, April 14, 2000.

Sandi Hilal and Alessandro Petti
Campus in Camps

Campus in Camps is a two-year experimental educational
and project-based program, engaging the participants from
the West Bank's refugee camps in an attempt to explore
and produce new forms of representation of camps and
refugees beyond the static and traditional symbols of vic-
timization, passivity, and poverty. The program aims at
transgressing, without eliminating, the distinction between
camp and city, refugee and citizen, center and periphery,
theory and practice, teacher and student.

 This initiative stems from the recognition that refu-
gee camps in the West Bank are in a process of a histori-
cal, political, social, and spatial transformation. Despite
adverse political and social conditions Palestinian refugee
camps have developed a relatively autonomous and indepen-
dent social and political space: no longer a simple recipient
of humanitarian intervention but rather as an active politi-
cal subject. The camp becomes a site of social invention and
suggests new political and spatial configurations.

 In recent years the refugee camps have been trans-
formed from a marginalized urban area to a center of social
and political life. More notable is that such radical trans-
formations have not normalized the political condition
of being exiled. For decades, the effects of the political dis-
course around the right of return, such as the rise of
a resolute imperative to stagnate living circumstances
in refugee camps in order to reaffirm the temporariness of
the camps, forced many refugees to live in terrible con-
ditions. What emerges today is a reconsideration of this
imperative where refugees are re-inventing social and
political practices that improve their everyday life with-
out normalizing the political exceptional condition of
the camp itself. After more than sixty years of exile, the
camps are now viewed as the village of origin: a cultural
and social product to preserve and remember. What is
at stake in this program is the possibility for the partici-
pants to realize interventions in camps without normaliz-
ing their conditions or simply blending the camp with
the rest of the city.

Campus in Camps aims at providing a protected context in which to accompany and reinforce such complex and crucial changes in social practices and representations. We believe that the future of the refugee camps and their associated spatial, social and political regime force us to re-think the very idea of the city as a space of political representation through the consideration of the camp as a counter-laboratory for new spatial and social practices.

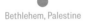

Bethlehem, Palestine

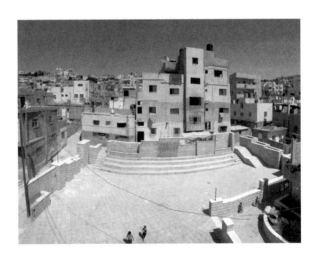

Vincenzo Castella, *Dheisheh Refugee Camp,* **2007**

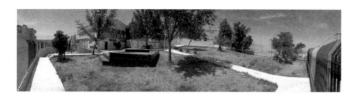

All images:
Campus in Camps, Bethlehem, Palestine,
2012–present

Galit Eilat on
Campus in Camps

Over the past few years Sandi Hilal and Alessandro Petti have developed an innovative and internationally significant artistic platform addressing questions of political representation and imagination. They challenge the artistic field to examine its own practices and at the same time lay claim to the Palestinian right for education and land in a complex way that avoids following any given political agenda. They struggle against different forces that keep Palestinian refugees in stagnation and underdevelopment, and they reflect on the way refugees become subject to different interests from the Israeli and Palestinian sides, as both try to gain political power. These strategies can be seen clearly in the educational platform *Campus in Camps*. Through *Campus in Camps*, Hilal and Petti enable communities of Palestinian refugees to produce new forms of representation of the camps and of themselves, overcoming the static, traditional images of victimization, passivity, and poverty by promoting new political and spatial configurations.

Campus in Camps is an experimental educational platform that started in January 2012 in Dheisheh refugee camp in Bethlehem. The initiative engages young participants in a two-year program dealing with new forms of visual and cultural representation of refugee camps after more than sixty years of displacement. The aim is to provide young, motivated Palestinian refugees who are interested in engaging in their community with the intellectual space and necessary infrastructure to facilitate these debates and translate them into practical community-driven projects that will enact representational practices and make them visible in the camps.

In 1948, approximately 750,000 Palestinians were displaced from their homes. They fled both to neighbouring countries such as Jordan, Syria, and Lebanon, and to the parts of Mandate Palestine that became the West Bank and the Gaza Strip. Today, there are 4.6 million refugees registered, according to the United Nations Relief and Works Agency for Palestine Refugees (UNRWA). The Palestinian refugee community constitutes one of the largest and longest-lasting refugee populations in the world. The plots of land on which the camps were set up are either state land or, in most cases, land leased by the host government from local landowners. This means that the refugees in camps do not own the land on which their shelters were built, but have the right to use the land for a residence. Socioeconomic conditions in the camps are generally poor, with high population density, cramped living conditions, and inadequate basic infrastructure such as roads and sewers.

What has emerged from *Campus in Camps* is the production of new forms of representation of camps and refugees. *Campus in Camps* provides a protected context in which to accompany and reinforce such complex and crucial changes in social practices and representations. After two years, the impact of this initiative has far exceeded the initial expectations and has had a deep influence on other refugee camps across the West Bank and beyond. Now, a camp is being built in Bahia, Brazil, together with the Brazilian artists group Contra Filé and in collaboration with the Quilombo community there. The aim is to explore the possibility of constructing the commons and transferring the experience of a *Mujawara* (Arabic for "neighborhood") to Bahia, where the experience of the first two years of the project in Palestine can be applied to develop an environment of libertarian, decolonizing education.

Like the project in Brazil, many other projects developed under the framework of *Campus in Camps*.

A collective dictionary was developed in a series of
publications containing definitions of key concepts.
The terms proposed are those considered funda-
mental for the understanding of the contemporary
condition of Palestinian refugee camps. These words
have emerged as a result of actions and active dia-
logues with the camp community. Written reflections
on personal experiences, interviews, excursions, and
photographic investigations constitute the starting
point for the formulation of more structured thoughts.
The collective dictionary is both the reference and
conceptual framework for all *Campus in Camps* proj-
ects and interventions.

 Campus in Camps extends Hilal and Petti's earlier
project, *Decolonizing Architecture Art Residency*
(DAAR), an art and architecture collective and a
residency program based in Beit Sahour, Palestine.
DAAR's work combines discourse, spatial intervention,
education, collective learning, public meetings, and
legal challenges. DAAR's practice is centered on one of
the most difficult dilemmas of political practice: how to
act both propositionally and critically within an envi-
ronment in which the political field is dramatically dis-
torted. It proposes the subversion, reuse, profanation,
and recycling of the existing infrastructure of a colonial
occupation in order to rebuild society in full recognition
of its contemporary condition, rather than forlornly
attempting to return to a pre-catastrophic past.

Campus in Camps is a program of Al Quds University
implemented with the academic support of Al-Quds
Bard, and hosted by the Phoenix Center.

Interference Archive

Interference Archive explores the relationship between cultural production and social movements. This work manifests in public exhibitions, a study and social center, talks, screenings, publications, workshops, and an online presence. The archive grew out of the personal collections of Dara Greenwald and Josh MacPhee, who amassed an extensive collection of materials through their involvement in social movements, DIY and punk, and political art projects over the past twenty-five years. It consists of many kinds of objects that are created as part of social movements by the participants themselves: posters, flyers, publications, photographs, books, T-shirts and buttons, moving images, audio recordings, and other materials. Interference provides open access to materials for the communities who created them and encourages archival work conducted by movement participants. Through our programming, we use this cultural ephemera and contextual work to animate histories of people mobilizing for social transformation. We consider the use of our collection to be a way of preserving and honoring histories and material culture that is often marginalized in mainstream institutions. As an archive from below, we are a collectively run space that is people powered, with open stacks and accessibility for all. We work in collaboration with like-minded projects and encourage critical as well as creative engagement with our own histories and current struggles. The archive is all volunteer and relies on the help of many people. We welcome all to get involved.

Brooklyn, USA

Interference Archive (donation of political buttons), 2013

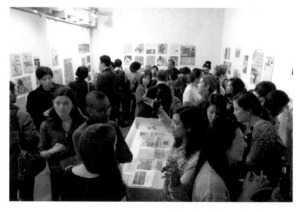

Top:
Interference Archive ("cataloging party" for
the collection), 2013

Bottom:
Interference Archive, *Serve the People: The
Asian American Movement in New York*
(exhibition opening), 2012

Clockwise from top left:
Interference Archive, *Strike Now!*
(exhibition poster), 2013

Interference Archive, *Serve the People:
The Asian American Movement in New York*
(exhibition poster), 2013

Interference Archive's One-Year Birthday
Party (installation view), 2013

Gregory Sholette on
Interference Archive

Josh MacPhee and the late Dara Greenwald's personal collections make up the bulk of Interference Archive's (IA) holdings, but since its founding in 2011, the project has become a volunteer-run institution, with over a dozen people regularly helping and a core organizing group that includes Kevin Caplicki, Molly Fair, Jen Hoyer, Greg Mihalko, and Blithe Riley, as well as MacPhee. There are two sides to Interference Archive—one scholarly, the other directly engaged in generating an activist art community. It houses a large collection of posters, flyers, publications, photographs, moving images, and audio recordings generated by grass-roots social movements, which can overlap with—but are just as often unique from—works made by artists in support of social and political causes. At the same time the archive is itself a site of production, insofar as the space offers exhibitions, public talks, film screenings, workshops, and publishing projects. This combination of research and engagement is augmented by an online presence that underscores IA's overarching mission: to animate the histories of people actively mobilizing for social transformation. Another feature that makes IA particularly engaging is its lack of major institutional support. Like other projects MacPhee has helped initiate, including Justseeds Artists' Cooperative and the Occuprint distribution network, IA's organizational model aims to achieve the highest level of political and economic autonomy possible given the less than ideal circumstances of contemporary life (including renting a space in the increasingly gentrified Brooklyn neighborhood adjacent to the Gowanus Canal).

All of this is in keeping with the work the core organizers, who are also artists, designers and writers, have engaged in for decades. Through both individual and collective projects they have created a range of video and graphic artworks, books and print publications, curatorial programs, street interventions, and research projects. These works have challenged not only the political status quo of the United States, but also the art world's tendency to isolate and elevate a few successful producers while suppressing the majority of its stakeholders, not to mention the many creative individuals who lie beyond its immediate purview. With IA this multilayered artistic "dark matter" reaches a new level of intensity, visibility, and convergence.

IA contains over ten thousand distinct collectibles, including recent acquisitions of more than one hundred posters from the anti-nuclear and anti-militarist movements throughout Europe and Latin America, donated by a member of the War Resisters League; hundreds of international anti-nuclear posters donated by a former organizer for the Mobilization for Survival; over two dozen original Bread and Puppet Theater pamphlets, magazines, show bills, and other publications from the 1960s and 1970s; a poster collection compiled over the last thirty years by the San Francisco anarchist book store Bound Together; and a major collection of 1990s and 2000s Latin American anarchist punk zines and newspapers. Meanwhile, IA's public events have included over a half-dozen exhibitions: *SQEK Library* in collaboration with Squatting Europe Kollective and the historian/activist Alan Moore's House Magic; *Radioactivity!*, an intersection of 1960s and '70s anti-nuclear materials with current post-Fukushima activist culture from Japan, organized in collaboration with Todos Somos Japon; *The Persistence of Dreams*, a retrospective of the graphic works of the Mexico City-based graphic producers Sublevarte Colectivo; and most recently *Serve the People: The Asian American Movement*

in New York, curated by Ryan Wong. However, IA's initial public project, titled *Riot to the Sound of Their Own Desire: Punk Feminisms*, was a presentation of over two hundred zines, newspapers, stickers, fliers, buttons, T-shirts, cassette tapes, vinyl records, and other ephemera organized by IA co-founder Dara Greenwald, who months after tragically succumbed to cancer at age forty.

Despite its shoestring budget IA continues to expand, thanks to a strong support network. The space has recently moved its events and exhibitions to a second, expanded space in their building, installed a semi-professional A/V system, with a high-quality projector, speakers, a soundboard, and continues its monthly film night, which is free and open to the public. While these screenings range in form and subject matter they remain linked to the intersection of art and politics, including videos from the massive and unprecedented student strike that began on May 22, 2012, in Quebec, or films made in the 1930s by the Workers Film and Photo League collectives. By focusing on alternative histories through a range of artistic media and communication technologies IA continues the type of work Political Art Documentation/Distribution initiated in the 1980s with its archive of socially engaged art. Unlike PAD/D—whose collection is now housed at the Museum of Modern Art—MacPhee and Greenwald's Interference Archive remains independent. Perhaps by dint of this autonomy it will come to fulfill PAD/D's vision of an archive that functions both as a toolbox for art activists who wish to study new models of cultural resistance, as well as a means of documenting these little known histories of artistic dissent.

Sanja Iveković
Women's House

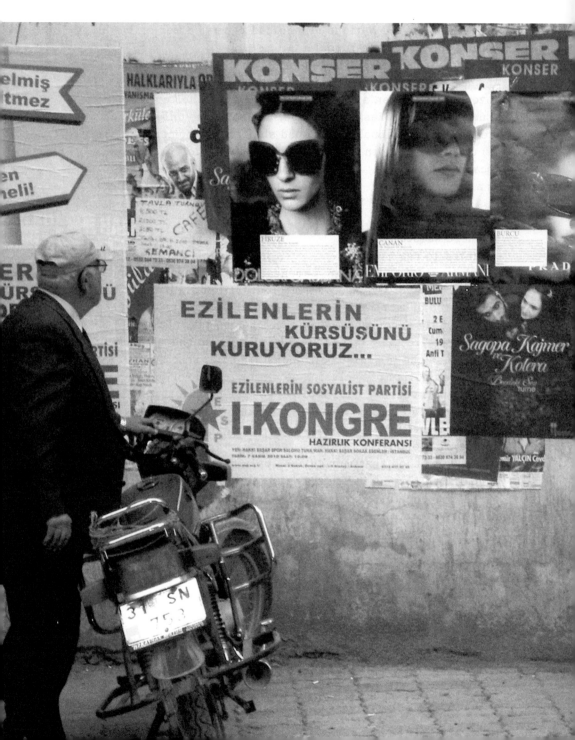

In 1998 the United Nations recognized rape as a war crime during the war in ex-Yugoslavia.

 In the same year I started the project *Women's House*. At the time in Croatia, a newly established state, Autonomous Women's House (AWHZ), the first shelter for abused women in Eastern Europe, was still the only specialized and professionally equipped shelter for women who survived violence in the country. Domestic violence had been escalating after the end of the war but was still regarded as a symptom of bad relations between partners, instead of as a serious crime. The government supported AWHZ with a minimal financial means (about 30% of the annual budget), so there existed a serious danger of closing the shelter. I wanted to react to the situation by making a statement which would raise public awareness for this burning issue. This subject not only became my content but influenced my method of working. My aim was to develop a project which would encourage the women who are taking refuge in the shelter to take an active role in creating the work. I believe, as the feminist bell hooks has said, that "we must focus on a policy of inclusion so as not to mirror oppressive structures." One form of participation was the series of workshops that I offered to conduct in the shelters. Collaboratively, we produced the personal testimonies of the residents along with the plaster casts of their faces using a simple method that women can apply themselves. I didn't conceive the *Women's House* as a single work of art; rather, I tried to use every possible media that would be effective in a given context. Although the project started as site-specific to the context of Croatia it has been developed internationally in collaboration with the number of shelters for abused women in Europe and in Thailand.

Zagreb,
Croatia

Sanja Iveković, *Women's House (Sunglasses),*
public display of a poster, Antakya, Turkey, 2009

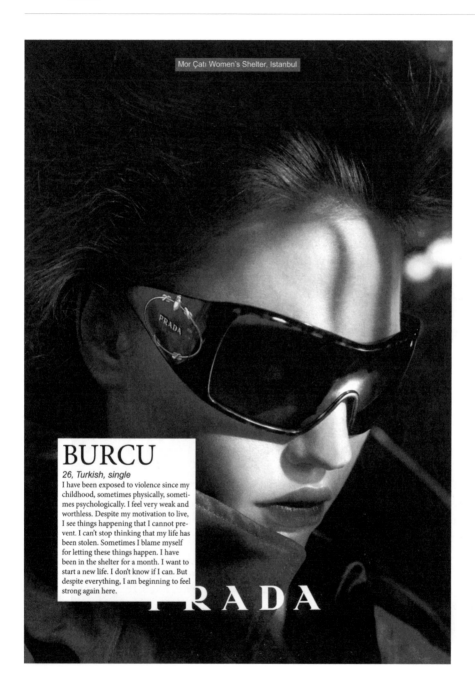

Mor Çatı Women's Shelter, Istanbul

BURCU

26, Turkish, single

I have been exposed to violence since my childhood, sometimes physically, sometimes psychologically. I feel very weak and worthless. Despite my motivation to live, I see things happening that I cannot prevent. I can't stop thinking that my life has been stolen. Sometimes I blame myself for letting these things happen. I have been in the shelter for a month. I want to start a new life. I don't know if I can. But despite everything, I am beginning to feel strong again here.

PRADA

Sanja Iveković, *Women's House
(Sunglasses)*, Antakya, Turkey, 2010

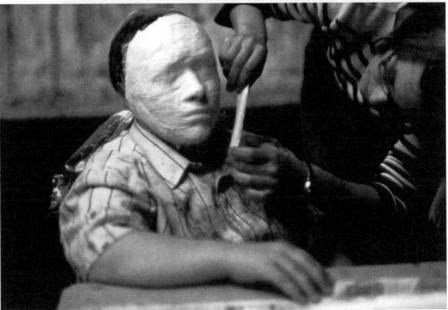

Sanja Iveković, *Women's House*,
workshop, 2009 (top: Utrecht, 2009, bottom: Luxembourg, 1998)

What, How & for Whom on *Women's House*

Croatian artist and activist Sanja Iveković has been active since the 1970s, taking a clear feminist position and pursuing projects that merge artistic practice and social activism. Her work examines and critiques the structuring forces of visual culture and mass media, particularly as they relate to the representation of gender and politics. Iveković works with women around the world for her ongoing project *Women's House* (1998–ongoing), revealing the geopolitical context of each location through exploring the issue of violence against women. *Women's House* engages with a wide variety of women and issues, including sex industry workers in Bangkok, honor killings in Turkey, and the impact of war in the former Yugoslavia. Through exhibitions, informal public display, and the process of creating the work itself, her project raises global awareness about domestic abuse. In 2011, the Museum of Modern Art, New York, mounted a survey exhibition of Iveković's career titled *Sweet Violence*, which chronicled her early work focused on the mass media, as part of the generation known as the Nova Umjetnička Praksa (New Art Practice), through to her recent work examining the transformation of the countries in the Balkans, especially those of former Yugoslavia, from socialist to post-socialist political systems.

Women's House is a project in progress. In each location, the project is realized through a series of workshops done in close collaboration with local women's shelters and the women who are taking refuge in them. Over the years, *Women's House* initiated collaborations with Autonomous House in Zagreb, the Frauenhaus in Luxembourg, the Bangkok Emergency Home in Bangkok, Safe House in Pejë, Kosovo, Casa per le donne in Genoa, the Center for Women and Children in Belgrade, Vie-Ja in Utrecht, Mor Cati in Istanbul, and Federation for Women

and Family Planning in Warsaw. Each realization of *Women's House* reveals a number of burning issues closely related to particular geopolitical contexts. The project started in Croatia in 1998, where the war in former Yugoslavia, with its rising nationalism and ethnic intolerance, was the backdrop. The particular set of issues at each of the localities, from decline of abortion rights in Poland, honor killings in Turkey, to a frightening level of domestic violence in the wealthy liberal democracies like those of Luxembourg or Genoa, Italy, form the background into which each of the particular stories is inscribed. The concerns and problems pertinent to each country come to the fore through discussions with feminist activists and workshops conducted in existing women's centers. During the workshops the artist gathers women's personal stories of violence and abuse, and casts their faces in plaster. While working with abused women, the artist does not victimize or use their stories as mere material for her work; rather, she offers concrete tools for empowerment and seeks active collaboration. Writing down one's story becomes an important means for women to speak up about their position, while the casting technique was chosen for its accessibility and ease, which enable the women to take an active part and make casts of each other, rather than the artist coming into the shelter as a "portraitist."

Women's House does not have a singular and defined form. Instead, Iveković applies various strategies of display and presentation, and the work is dispersed in different media. But in all forms of presentation it keeps its defining element—collaboration with women in shelters, whose testimonies are presented in different ways. For example, while exhibiting results of the workshops in museums and galleries, plaster casts of the women's faces taken during the workshops are

installed on pedestals accompanied by the women's personal stories, literally making the issue of violence more visible and also questioning the very role of the museum as a social institution. Beyond its presentations in art institutions, the other facet of the *Women's House* is media activism. Since the project's beginning, Iveković has been organizing a series of public and media campaigns, using postcards, posters, interventions, and advertisements in magazines and media. The series *Women's House (Sunglasses)* (2002–ongoing) uses advertisements for famous brands of sunglasses, alluding to the use of dark glasses to hide bruises, and juxtaposes the images of women that every average observer instantly recognizes as high-fashion models with personal stories that were collected through the workshops in the shelters. To make the issue of violence against women more visible, increase awareness of the need for safe houses for women, and to address these issues for a general public, the artist creates public installations such as the drawing of the plan of the women's shelter drawn on prominent public squares in Zagreb and Belgrade, or consciously uses and subverts mass media strategies. As an artist, Iveković does not see political ends and aesthetical investigations as mutually exclusive and incompatible actions. In her words, we can see art and activism "as circles of human activity that overlap in a relatively small area, and that is the area in which I try to do most of my work."[1]

Iveković takes advantage of the fact that the media produces its audience in the name of pleasure and voluntary entertainment during leisure time (and not in the name of politics or pedagogy) and uncovers the politics of representation to subvert it and invest into the capacity of images to dramatize and, through that dramatization, teach. In a global context—where violence against women is still a universal condition that affects East and West, North and South, regardless of class and race—*Women's House* stands out as a valuable effort that continuously tackles this critical issue, addressing a need and desire for the transformation of current social and political relations.

1 Katarzyna Pabijanek, "'Women's House': Sanja Iveković Discusses Recent Projects (Interview), Art Margins Online, December 20, 2009, http://www.artmargins.com/index.php/5-interviews/541-qwomens-houseq-sanja-ivekovic-discusses-recent-projects-interview.

Amar Kanwar
The Sovereign Forest

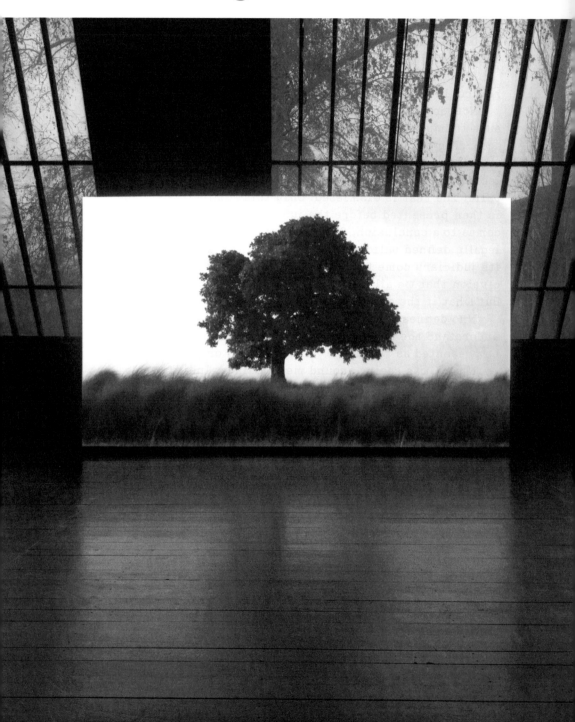

If a crime continues to occur regardless of the enormous
evidence available, then is the crime invisible or the evi-
dence invisible or are both visible but not seen?

If the meaning of what was lost itself is not clear, then
how could the conclusions about the loss be acceptable?

How do you understand the meaning of land? Do you mea-
sure it, multiply its dimensions, and then calculate the cost
according to current real estate value and be done with it?

Usually when a crime is investigated, evidence is col-
lected. The law of the land defines which piece of evidence is
valid. The rest is dismissed. Only this admissible evidence
is then presented before the judiciary, who analyzes it and
comes to a conclusion. On the basis of this permissible,
legally defined valid evidence, a criminal justice system and
its judiciary come to the conclusion about the crime—a con-
clusion that we all in a way accept to be the final conclusion.
But what if the definition of evidence itself was incorrect?

Who defines evidence? Is legally valid evidence adequate to
understand the meaning and extent of a crime? Can "poetry"
be presented as "evidence" in a criminal or political trial?

What I was seeing around me in Odisha, India, was so
colossal and so little understood that I felt the need to find
a form wherein we could present multiple vocabularies of
evidence, to open up another way—not just of comprehending
the crime or comprehending ecological disaster, but perhaps
even of comprehending life itself.

The "document" of the documentary has for long already
been thrown up into the air. Is an illusion more real than
a fact? Which vocabulary is more appropriate for a dream?
How can a pamphlet be a poem, how can a poem be the story
of a murder, how can a murder become a ballad, how can a
ballad become an argument, how can an argument become a
vulnerability the expression of which negates the argument
but eventually shifts all positions?

Sometimes I feel that it is only in the deep core of
separation that one can comprehend the meaning of life,
of compassion.

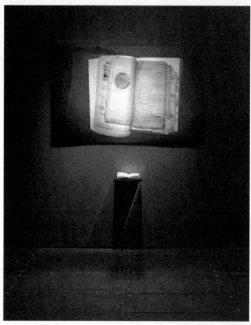

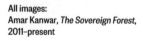

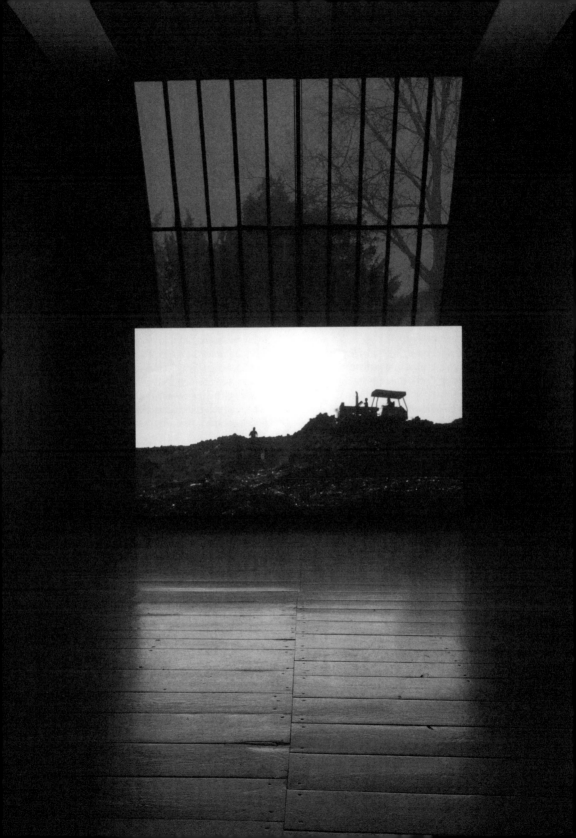

Pooja Sood on
The Sovereign Forest

Amar Kanwar is an activist, philosopher, and poet. An artist of deep integrity, he attempts through his work to reopen discussion and initiate a creative response to our understanding of crime, politics, human rights, and ecology.

The Sovereign Forest (2011–ongoing) has emerged through the artist's engagement in the state of Odisha in eastern India, where he has been working and showing his films for the past fifteen years. It is an ongoing multimedia research project that explores the social and environmental impact of industrial interventions on the local communities of Odisha. The installation centers around one film, *The Scene of Crime,* which depicts the landscape just prior to erasure. It is a complex narrative of Odisha's troubled history and the local community's resistance.

Odisha has been the epicenter of several ongoing conflicts between local communities, the government, and corporations over the control of agricultural lands, forests, rivers, and mineral sources. The forcible displacement of indigenous tribal communities and peasants has been a brutal cycle of life there since the 1950s. In the past fifteen years, several mountain ranges, wildernesses, and agricultural lands were sold or leased to mining cartels and other corporations for commercial use. In response, a series of local resistances by peasants, fishers, and tribal communities emerged. Powered by autonomous local leaderships, primarily nonviolent, stubbornly resilient, occasionally supported by urban activists, they have shared their experiences to enable a local discourse to emerge on development, industrialization, and rehabilitation. These resistances have faced police repression and violence by local mafias hired by politicians or corporations.

Like Kanwar's earlier works, *The Sovereign Forest* was rooted in the locale several years before it emerged as an artwork. Since its premiere at Documenta 13, in Kassel, Germany, in 2012, it has been shown as an almost permanent feature on the premises of Samadrusti, an activist media organization in Bhubaneswar, Odisha, while also traveling to many spaces around the world. With overlapping identities, *The Sovereign Forest* continuously reincarnates itself as an art installation, a library, a memorial, a public trial, a call for the collection of more evidence, an open school, a film studio, an archive, and also a proposition for a local space that engages with political issues as well as with art. The film is presented alongside shorter films, handmade books, stories, video projections, archival texts, images, and organic material such as samples of rice seeds.

Kanwar's work is particularly inspired by a search for possible answers to a series of questions: How to understand the conflict around us? How to understand crime? Who defines evidence? Is legally valid evidence adequate to understand the meaning and extent of a crime? Can poetry be presented as evidence in a criminal or political trial? What is the validity of such evidence? Can it create a new and valuable perspective about the crime? What is the vocabulary of a language that can talk about a series of simultaneous disappearances occurring across multiple dimensions of our lives? How to see, know, understand, and remember these disappearances? How to look again? Deeply political, Kanwar's work is never merely documentary commentary. His engagement with the politics of violence and social inequality is visceral, mirroring the actions on the ground. They are evidence in themselves.

Kanwar has contributed to three Documenta exhibitions with film-based work on the social and political conditions of the Indian subcontinent.

His films have addressed themes such as sectarian
violence and border conflicts (*A Season Outside*,
1998), the poetry of resistance (*A Night of Prophecy*,
2002), and sexual violence (*The Lightning
Testimonies*, 2007). He has also worked extensively
on the Burmese resistance, culminating in an epic
installation investigating five decades of the Burmese
resistance titled *The Torn First Pages* (2004–08).
The Torn First Pages emerged from his knowledge
and experience of the complexity of the Burmese
resistance, wherein he also trained young Burmese
activists to make their own programs to be aired
on unofficial radio and TV channels in Burma. He
continues to teach young filmmakers from areas of
political resistance.

Faustin Linyekula
more more more . . . future

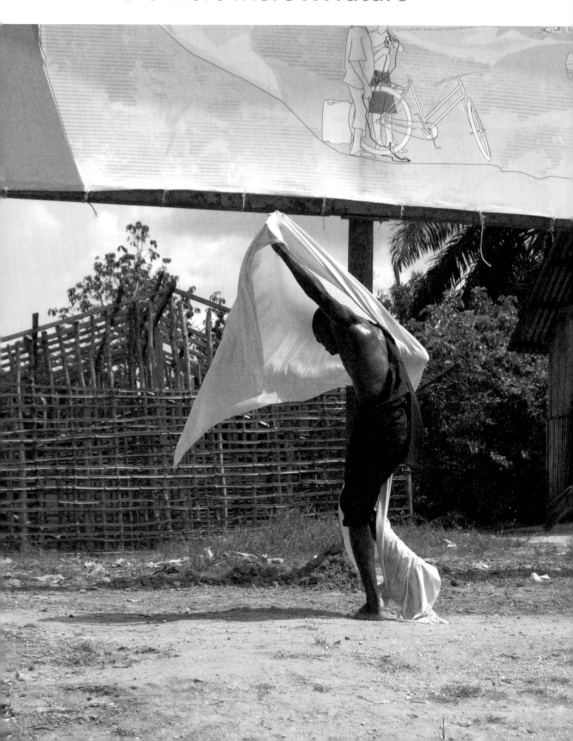

A few years ago I made a piece called *more more more...
future*. The ambition was to be punk. For while England in
the late 1970s "No Future" may have been a subversive state-
ment, I realized that in the Democratic Republic of Congo,
the country I call home, the only way to be subversive is
to be constructive because everyone seems busy destroying
something.

Being an artist is taking up one's responsibility as a cit-
izen. Refusing to add ugliness to the ugliness in and around
us. Acknowledging that social justice is not a given and will
never be, at least not in my lifetime. And if the heritage our
fathers handed down to my generation is a pile of ruins—not
only physical ruins, but ruins in our heads, our hearts, our
souls, what do I propose to make the space we have in com-
mon livable? For if I play my part, maybe others will too,
and who knows, in a hundred years something can happen...

Thus I step on stage. Trying to show a body that refuses
to die. Scavenging through the ruins of what I thought was a
house in search of clues: a poem by Rimbaud, Banyua rituals
my grandmother took me to, Ndombolo dance steps from a
music video by Papa Wemba, Latin classes with Father Pierre
Lommel. Whatever I find will be useful. Aesthetics of sur-
vival. Bundling together whatever comes my way to build a
temporary shelter. I improvise. Improvisation here is not
an aesthetic luxury, but a state of living, surviving.

It's never been about saving Congo, it's not even about
art but about creating something that people around me can
recognize and hopefully believe in, in a context where it's
almost impossible to believe in anything, even in God. It's
about creating breathing spaces in the middle of our daily
urgencies, above all it's about creating possibilities of
beauty.

Kisangani, Democratic Republic of the Congo

Studios Kabako, *Lubungamode* (with Yves
Mwamba and Trésor Mawese), 2014

This page, clockwise from top:
Studios Kabako, *Ecrire ses mondes*
(workshop directed by Sylvain
Prunenec), 2012

Studios Kabako, Laboratoire: *Ecrire ses
mondes*, Kisangani, 2013

Studios Kabako, *Lubungamode* (with Yves
Mwamba and Trésor Mawese), 2014

Opposite page, top:
Studios Kabako, *Nuit blanche à
Ouagadougou* (rehearsal with Serge Aimé
Coulibaly's Burkina Faso), 2014

Bottom:
Studios Kabako, *Statue of Loss*,
Theaterformen Hannover, 2014

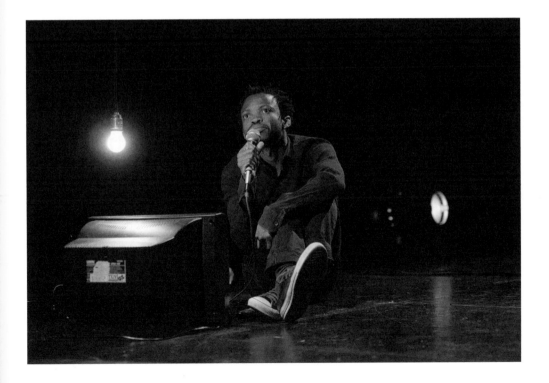

Shannon Jackson on
more more more . . . future

Faustin Linyekula is an internationally renowned choreographer who simultaneously maintains an arts-based community practice in the Democratic Republic of the Congo. His recent cross-disciplinary dance and music piece, *more more more . . . future*, exemplifies an aesthetic that is both refined and interventionist, one whose effects are felt at the international scale as well as in the local landscape of Kabalko, where he resides.

Linyekula is a leading figure amongst a generation of choreographers who address questions of race and culture in their work and who, more specifically, seek to reimagine post-colonial African dance on the world stage. Exiled from Congo in 1993, he studied art, philosophy, dance, and theater at universities in Kenya and London, returning in 2001 to found Studios Kabako in Kinshasa (later Kisangani). At the time, Linyekula began to craft community projects and discrete dance pieces that subtly addressed a fraught Congolese political culture, often symbolizing the ongoing effects of the Second Congo War indirectly, carefully navigating the constant threat of censorship and governmental punishment. His body of work includes nearly 25 original dance pieces and group collaborations that have toured to prestigious venues in Paris, Brussels, New York, San Francisco, Berlin, and Avignon and received notable awards, including the Prince Claus Foundation Prize of 2007. Meanwhile, Linyekula has used the funds he receives from commissions and prizes to support the creation and expansion of Studios Kabako, a network of buildings and support structures for Congolese neighbors as well as visiting international artists. He is thus responsible for sustaining a local infrastructure that seeks to have global reach. In developing Studios Kabako through a mixture of economic resources, Linyekula joins other high-profile artists who have created innovative ecosystems between artworld markets and under-resourced regions of the planet.

more more more . . . future continues Linyekula's exploration of contemporary African performance forms, actively resisting a variety of stereotypical associations along the way. This piece is part of *ndombolo*, a musical and dance idiom rooted in contemporary Congolese political culture and popular for its ebullient and occasionally aggressive effects. Indeed, scholars such as Filip de Boeck and Ariel Osterweis see *ndombolo* emerging as a response to a corrupted social landscape, metaphorically reenacting its gestures of political violence and empty materialism in ostentatious sounds and seemingly threatening dance styles. African social critic Achille Mbembe goes a step further by casting such Congolese musical forms as indexes of a wider necrophilia, exemplifying a brand of so-called "Afro-pessimism" in which the pervasive specters of doubt, distrust, and death determine African social imagination and African social expression. By placing *ndombolo* at the center of his practice, Linyekula enters this fraught landscape and begins to reimagine it from within. He began collaborating with Flamme Kapaya, one of (if not the) most famous *ndombolo* guitarists, as well as the popular Congolese hip-hop dancer Dinozord. Casting Kapaya and Dinozord as themselves on the concert dance stage, Linyekula asked these popular artists to replay their signature music and moves in a laboratory that makes them available for reflection. In *more more more . . . future*, Linyekula's illustrious cast mixes improvisation with prescribed movement. In the background, large images of current and past post-colonial leaders are projected on a screen; the soundscape integrates Kapaya's guitar with the voices of these

political figures, prompting emotions of joyful pride and oncoming menace in equal measure. At one point, Linyekula himself joins the cast to perform a virtuosic solo in which his limbs and body parts appear to break and reassemble, an embodied metaphor of the destructive creativity that so often characterizes a time of war. By devising this sonic and choreographic exploration under the title *more more more . . . future*, however, Linyekula offers the possibility of a different creative end. The all-male homosocial cast reckons with the legacies of their leaders and their fathers, using the *ndombolo* idiom as a vehicle for facing a history of violence, but also as a means for reassembling a shared, precarious life together.

The effects of *more more more . . . future* become all the more resonant when one considers how this piece interacts with the cultural economy and production system in which it is embedded. Even as Linyekula developed this work, he and the team at Studios Kabako erected a linked network of structures—studios, theaters, as well as a laboratory recording space—outside of Kinshasa for participating artists as well as local citizens to use. He calls these structures—built from indigenous materials of mud and clay—a kind of "acupuncture" in the Congolese landscape, a mode of intervention that might induce the body politic to heal from within. In these spaces, *ndombolo* has been revised as well—in classes, workshops, and ad-hoc dance performances for Kinshasa residents. In one exemplary event, Linyekula invited three local MCs to perform on the same stage. These popular figures, whose entourages usually "battle" each other, were asked to reconceptualize their practice within a theatrical public space. Such events reframed the *ndombolo* form as well as with the love and the dread that it typically inspires.

The event of *more more more . . . future* is thus one that includes the international tour of an experimental dance piece, and a series of local reenactments in the community spaces of Studios Kabako. The result is a dispersed and extended piece that is neither naïve nor purely necrophilic. This project's "future" is developed delicately, and it will not be capitalized. But it will not be overdetermined by a regulating pessimism either. Rather, Faustin Linyekula and his collaborators gather hope and trauma in one space; with clear-eyed intelligence, knowing compassion, and a relentless beat, they call for more more more.

Mosireen

Mosireen was a non-profit media collective in Downtown Cairo born out of the explosion of citizen-produced media and cultural activism in Egypt during the revolution. Armed with mobile phones and cameras, thousands upon thousands of citizens tried to keep the balance of truth in their country by recording events as they happened in front of them, wrong-footing censorship and empowering the voice of a street-level perspective.

Mosireen, which is a play on the Arabic words for "Egypt" and "determined," was founded in the wake of Hosni Mubarak's fall by a group of filmmakers and activists who got together to create a collective space dedicated to supporting citizen media of all kinds. They worked on filming the ongoing revolution, publishing videos that challenged state media narratives, provided training, technical support, and equipment, and organized screenings and events. Now, in 2015, in a political landscape that has changed immeasurably, they continue to work on archiving the world's largest collection of video footage from the revolution to make it publicly accessible in its entirety.

Within three months of publishing videos Mosireen was the most watched non-profit Youtube channel in Egypt of all time, and in the whole world in January 2012. Over four years of production, 300 videos were produced and released and continue to be viewed thousands of times a month. Mosireen films were regularly shown on television and have been downloaded, remixed, and reused an uncountable number of times.

The Mosireen workspace was open to everyone, regardless of their level of experience or ability to pay. The collective worked to help network a wide variety of initiatives and to share skills wherever possible. Hundreds of people received free training in video production. All services were run on a pay-what-you-can basis.

There may be future reincarnations of Mosireen, but, right now, we don't know quite how that will look.

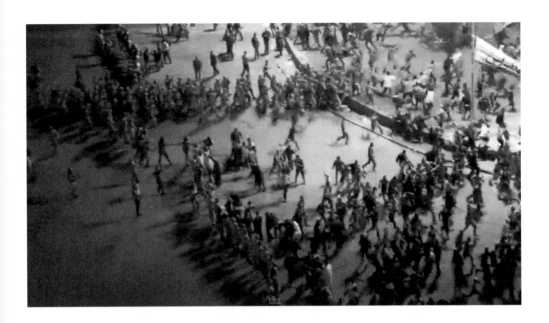

Cairo, Egypt

All images:
Mosireen, *The Maspero Massacre*
(video still), 2011

The Army was deployed across the country

Mona Seif
Co-ordinator: No to Military Trials for Civilians

On January 28th the Egyptian police
- unable to repress the popular uprising -
were withdrawn from the streets.

MARCH 9

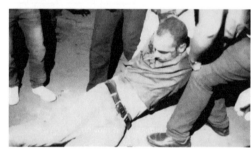

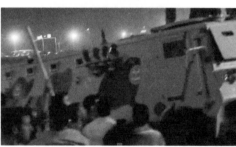

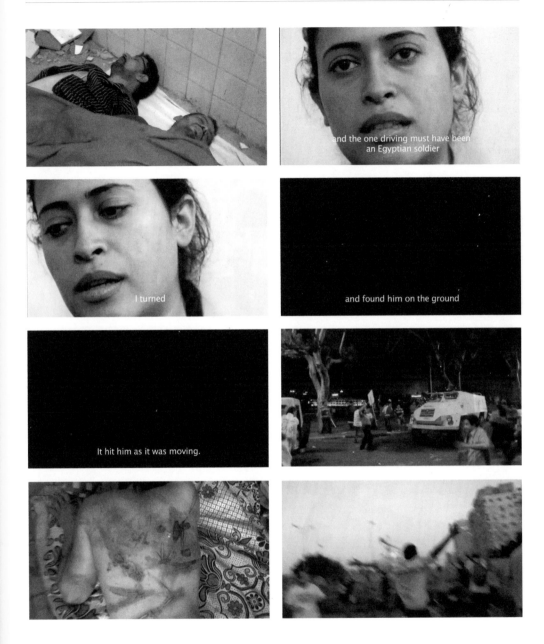

Negar Azimi on *Mosireen*

Since its founding in the first days of the Egyptian uprising of 2011, Mosireen, whose name is a clever *détournage* of the Arabic words for "determined" and "Egypt," has bent traditional ideas of what an artistic collective could be. During the eighteen days that climaxed with President Hosni Mubarak's dramatic fall, videos—most of them capturing demonstrations and government abuses—seemed to be uploaded to the Internet every minute, almost always marked by the telltale shakiness of a telephone camera. These vernacular "home" videos were enormously welcome, especially given that the official Egyptian news media barely acknowledged the spectacular eruption of popular opposition in its midst. Instead, as the country threatened to fall apart at the seams, the state television covered sports or showed static shots of empty streets. Business as usual. The government-owned newspapers were not entirely dissimilar. And yet, in spite of this vacuum, ordinary people stepped in, pushing back on the surreal denial in their midst.

Out of that angst and energy was born Mosireen—part documentarian, part curatorial, part educational, and part activist. Today, adapting to the immediate context around them, the core members of the Mosireen collective (they are actors, filmmakers, artists, activists) have carried on the tradition of documenting protests and abuses, but also run training sessions for would-be citizen journalists and opened a public space for people to access equipment and books, and exchange ideas. During the summer of 2011, they erected a screen downtown that came to be known as Cinema Tahrir. There, Mosireen screened films for three weeks—many of them documenting abuses by the military-led government. That is, before that very government disbanded the cinema.

In the aftermath of just about every iconic political event in Egypt for these last three years, Mosireen has been at the forefront of capturing footage, editing, and uploading it onto the Internet for rapid viewing. When it comes to abuses, Mosireen has provided invaluable testimony for legal purposes. In one case, Mosireen distributed cameras to the mothers of individuals awaiting military trial, so that the proceedings in the courtroom might be rendered transparent.

As an artistic gesture, Mosireen's testimonials embrace many of the tropes of the documentary and the self-portrait, embedding them in a larger visual archive of civil strife and suffering. While many of their individual testimonials might resonate with an art-world audience familiar with the documentary mode, they manage to take one step further into the world around us and have multiple and diverse lives, resonating outside the confines of traditional arts spaces.

At a time when media apparatuses in the Middle East are still dominated by sclerotic state and commercial interests, Mosireen has created an unprecedented physical and psychological space in which citizens can break the official consensus—whether Mubarak's, the army's, the Muslim Brotherhood's, or the international media's. Mosireen is equally critical at a time when international curators seek (and often find) one-liner artistic statements about the nature of a complex political situation that has been reduced to a stale cliché about good guys and bad guys (abundant "revolutionary art" exists; most of it is facile and panders to these tastes).

Finally, and perhaps most fundamentally, Mosireen represents a critical public archive without precedent, whose richness has yet to be tapped. The Egyptian Revolution of 2011 was no doubt a war of images, and as recent events have taught us, that battle is not going anywhere anytime soon.

Marina Naprushkina
Office for Anti-Propaganda

Marina Naprushkina,
People's Artist, 2012

I had never heard the words *contemporary art*. There was
just art, and art and I were the same thing: I stood in front
of the canvas for eight hours a day, crazy about painting,
crazy about the smell of pigments. I couldn't imagine living
without it anymore. And I received "recognition": people
told me I was talented. They said that I painted like a man.
I went abroad. Here, they told me to forget everything I had
learned up until then. I didn't fit into the art world here.
At the academy, everyone was supposed to talk about their
own work, but nobody explained to me what art is. Here, I
no longer had time for art, I had to earn a living: back home
there existed no real art, and here there was no time for it.
I saw what one could do with art here: exhibit, appreciate,
evaluate, and sell it. There were art officials and artists,
Frankfurt, Germany
the producers and the consumers of their own art. Not cre-
ative but precarious. In favor of the system, opposing the
system, the naïve and the angry. I returned home, I had my
art back. It was the old and the new. One could name it only
for a short time. It was like life, action, communication,
fast and uncertain, inevitable, ubiquitous, and for many
invisible and nameless.

Marina Naprushkina, *My daddy is a policeman. What is he doing at work?*, 2012

Top:
Marina Naprushkina, *Newspapers-Convincing Victory*, 2011–2012

Bottom:
Marina Naprushkina, *Take the Square*, 2013

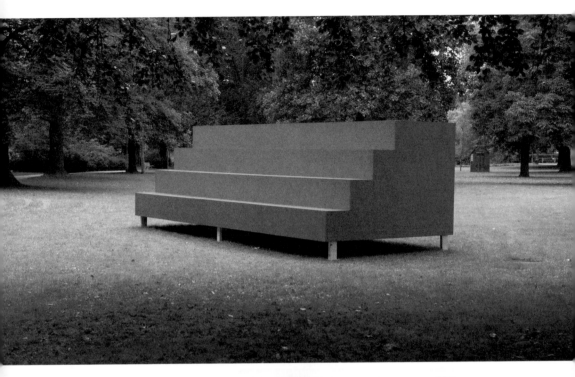

Top:
Marina Naprushkina,
The President's Platform, 2007

Bottom:
Marina Naprushkina, *Office for
Anti-Propaganda*, 2012

Gregory Sholette on
Office for Anti-Propaganda

Since 2007 Marina Naprushkina has focused her acerbic protest art against political corruption in her homeland of Belarus. Now living in Berlin, Naprushkina's work incorporates comics, photography, video, installation projects, and what she describes as fictive collectives such as her own trenchantly named Бюро контрпропаганды or *Office for Anti-Propaganda*, an entity she describes as an "artificial institution." Meanwhile, Western democracies have nicknamed Belarus "the last European dictatorship." Tucked between Russia and Poland, Belarus became independent in 1991, when the USSR collapsed, but has remained under authoritarian rule since the election of President Alexander Lukashenko three years later. While the country's centrally controlled media presents the image of a stable nation offering tourists "an outdoor enthusiasts' dream" according to the official website, in reality Belarus continues to be gripped by an intractable political and economic crisis. Overt suppression of free speech is not the only fallout from this situation. The unsolved disappearance of several oppositional journalists and the arrest, beating, and detainment of dissident political parties by state security officials mar every attempt at developing civil liberties through free elections in Belarus. Perhaps it is telling that state security still operates under the name KGB. Nevertheless, with increasing intensity the cultural sector has put pressure on Lukashenko's regime from abroad. Two of the most notable actors in this campaign include the avant-garde Belarus Free Theater, operating outside the country, and Naprushkina, who works closely with Belarus human rights activists while living in Germany.

Organized under the imaginary *Office for Anti-Propaganda*, Naprushkina's varied multimedia projects are aimed at rectifying the highly managed self-image Lukashenko has generated around his dictatorship. In one work the artist is seen strolling the streets of Minsk with a photographic portrait of the president under her arm. In works such as *Convincing Victory* and the children's coloring book *My daddy is a policeman. What is he doing at work?* the artist makes use of cartoon imagery to effectively document state violence, including the traumatic events of December 19, 2010, when police attacked peaceful protestors demonstrating against widespread election fraud. The outcome of this suppression was anything but comic, as Naprushkina's trenchant graphics illustrate the hospitalization of key opposition leaders along with the detention of others. Twelve remain in prison as of this writing.

In 2011 the artist initiated her own hand-drawn newspaper called *Self # Governing*, an oversized offset publication distributed both internationally, and clandestinely in Belarus with assistance from the human rights NGO "Nash Dom." Using a minimum of text to convey complex social concerns about life under dictatorship the artist has focused on such issues as "Belarusian self governing," and women's plight within the patriarchal system of government institutionalized in the country. With 60,000 copies printed in Russian, and an English version of the newspaper as well, she hopes to reach audiences inside and outside Belarus, including students, NGOs, and other policy makers. In light of the recent wave of protest and resistance across the globe, *Self # Governing* can be read—and used—as a guide for daring to think about political alternatives worldwide. While she elaborated on the piece for the controversial Berlin Biennial of 2012, such hopes do not come without risks and complications. Authorities in Vitebsk, Belarus, confiscated

a stack of Naprushkina's newspapers, detaining the
journalist who planned to distribute them. Meanwhile,
the *Office for Anti-Propaganda* serves as both the
overarching framework for the artist's work, as well as
a virtual archive amassing videos, texts, artworks, and
graphic images focused on analyzing how the author-
itarian system in Belarus was built, how it operates,
and what possible role critical culture might play in
bringing about a Belarusian Spring. Most recently she
has turned her attention from exhibiting her work in
"white cube" galleries and spaces to working directly
with immigrant communities in Berlin. In this case,
what Naprushkina has named *Neue Nachbarschaft//
Moabit*, or *New Neighborhood*, consists of an actual
institution whose primary mission is assisting refu-
gees. Though still a work in progress Naprushkina is
attempting to establish a local "sustainable" initiative
that includes a *Refugees Library* as well as a studio
for children and adults in which she and her collabo-
rators make protest posters and organize demonstra-
tions for asylum seekers.

Marina Naprushkina's expanded art practice
embodies a desire held today by a growing number
of contemporary artists to abandon art-for-art's-sake
in order to actualize social justice through cultural
engagement. More than that, Naprushkina carries
out this shift while simultaneously presenting other
artists with a model of self-empowerment poised
against forces far more powerful and threatening
than most of us will ever encounter. To put a spin on
anthropologist James C. Scott's expression "weapons
of the weak" in which he celebrates everyday acts of
political resistance, Marina Naprushkina's community
organizing, her use of familiar forms such as comic
books, zines, performances, and newspapers suggest
a complementary "aesthetics of the weak," fully armed
and ready for battle.

Tenzing Rigdol
Our Land, Our People

On September 18, 2009, my father, Norbu Wangdu, who was
born in Lobrak, Tibet, passed away as a Tibetan refugee in
the United States of America. My father was diagnosed with
liver cancer, and the doctor who made the diagnosis told us
that my father had only about six months to live.

After the diagnosis, my father started talking a lot about
his life in Tibet and how he wished to visit the place just
once before he passed away from this mundane world. His
wish did not come to fruition as he was too weak to travel and
the treatment required his presence in New York. After six
months of his diagnosis he did pass away as the doctor had
suggested. The whole inexplicable experience left a strong
imprint on me. There wasn't a day where I didn't think about
my father and his desire to visit his country, Tibet.

Slowly, it dawned upon me that my father's inherent wish
to visit his hometown and his sense of helplessness being a
refugee in a foreign land exemplifies all the other Tibetans liv-
ing in exile, who equally long to return to their country but
could not do so due to the political nature of Tibet. This idea
then gave birth to the art installation *Our Land, Our People*.

I made the installation in Dharamshala because in
Dharamshala there is a fully functioning Tibetan government
in exile, and it is also the residence of the H.H. 14th Dalai
Lama. Dharamshala is also known as the little Tibet because
it has one of the largest Tibetan refugee communities.

Then I made a site-specific installation, whereupon I
requested the Tibetans in exile to touch and walk on their
native soil and express whatever they feel through a stand-
ing microphone. With this site-specific installation, I hoped
that the Tibetans living in Dharamshala, who are separated
from their relatives and banished from their homeland, will
finally be able to once again step on the Tibetan soil.

The entire project took seventeen months and it involved
borders of three countries: occupied Tibet, Nepal, and India.
The difficulty arose as none of the countries allow transporta-
tion of soil, and therefore smuggling 20,000 kg of soil across
more than fifty major checkpoints was a big challenge in itself.

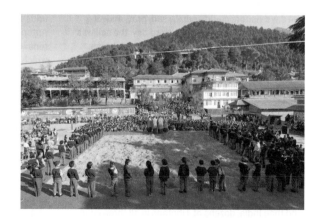

All images:
Tenzing Rigdol, *Our Land, Our People*, 2011

H.G. Masters on
Our Land, Our People

Born in Nepal, and currently a resident of Queens, New York, Tenzing Rigdol is a poet and visual artist. Though he primarily works in painting and collage, blending the vernacular of traditional thangka painting with imagery and motifs from contemporary life, for his project *Our Land, Our People* (2011), Tenzing shifted his practice from the studio into society. In a process that took many months of negotiations, he arranged to have twenty tons of soil smuggled out from the Special Autonomous Region of Tibet to Dharamshala, India, via Nepal. In Dharamshala, home to the largest exile community of Tibetans, as well as the Dalai Lama and the Tibetan government in exile, the soil was installed on a large platform in the town center, where over the course of two days in October 2011, Tibetans could touch a piece of their homeland—which many of those living in India have never seen. Additionally, two microphones were set up on the soil, and throughout the days visitors could speak, read, pray, and sing whatever they wished. On the third day, the soil was dispersed to anyone who wanted to take it home.

The logistics involved in this project were immense, requiring Tenzing to arrange the surreptitious (and illegal) transportation of the soil from Chinese-controlled Tibet, across the border into Nepal, and then again from Nepal to India. At each crossing, the soil had to be re-bagged and camouflaged to avoid detection by the authorities. Bribes needed to be paid; journeys were done at night on small roads through the mountains. According to the artist, over the course of the many months that it took for the Tibetan soil to be moved from Tibet to Nepal and then India, dozens of Tibetans in all three countries risked prosecution in order to help him.

The outcome was an enormous public success. Thousands of Tibetans came to kiss the ground and wept at the site of the soil. The Dalai Lama himself blessed a portion of the earth that was brought to him, writing "Tibet" in Tibetan characters in the soil.

While Tenzing was initially motivated to produce this work to honor his father, who had died in 2008 while the family was seeking asylum in the United States, *Our Land, Our People* has had a broad resonance among the small artistic community in Tibet, as I learned on a trip to Lhasa in December 2011, as well as in Tibetan communities abroad. A striking piece of sculpture—a large, square field of dirt ringed by a red carpet—it is an example of an artist deploying the vernacular of post-minimalism and land art for poetic, personal, and political ends.

However much the artist might explicitly eschew speaking about the latter—the potential for reprisals against those who aided him are very real—the political implications of *Our Land, Our People* are undeniable, given Tibet's contested status as a Special Autonomous Region of China. The project brought renewed attention to the Tibetan exile community, which is increasingly aggrieved about the lack of resolution of their status in India, as well as the continued degradation of Tibetan culture in Tibet proper. (This project was conceived and realized before the wave of self-immolations in India and the Tibetan regions of China in 2012 that have similarly brought media attention to the Chinese restrictions on Tibetan religious and cultural practices.) And, by all accounts, Tibetans in India, Lhasa, and the diaspora were deeply moved by the young artist's quixotic but ultimately successful gesture. The project is an example of how the forms and practices of contemporary art can transcend their often-abstruse formulation to speak directly about the sorrows and aspirations of a public largely unversed in such discourse.

Issa Samb
Laboratoire Agit'art

ON THE ART OF RECORDING TRIVIAL IDEAS, IN THE FORM OF A
PROJECT OF PLACING, DISPLACING, AND REPLACING THE CONCEPT
IN ITS ENVIRONMENT WITH A VIEW TO PRECIPITATING ITS FALL

When this glacial wind covers the sidewalk. These shoes of
clever women form a transmuting drawing. Would I find a
city that madmen hanged from trees celebrate? They are
there behind the windows. The night is there, empty of mys-
tery, that the wind filters. A young feather. The fresh chalk.
The traces around the central bank. The writing awakens,
beneath the lampposts, a country where glimmer waters
that burn. Was it predicted that a sun would descend into
the villages like rain, to then drill into the stone. The tree,
right to the roots where children wait? Milk is born in the
double heart beneath the coats—blood appears. Couscous in
the sand, boxes, shells, wool, linen, light that attracts flies.
The flies, they know where the holy meat lies. When the odor
clears the burnt market, the flies pass (but each time the
children come back). Other odors rise from the sea...
 The sea maps out oils that shimmer and waters on the
tiles. Don't walk there. Change direction. Avoid the holes.
Get used to the night. Among the ruins, walk without
destroying yourself. Get used to the dust of building sites
and to floods, to smoke, to the rust of cars. But nothing will
be similar. From whom I would receive the strength to reach
beyond the desert? An intact code all villous with baobab,
jujube, silk cotton fibers and totally fresh seaweed, barely
created bamboos. To hear with them the voices given back to
the sea and perhaps to at least see sparkle above the reefs
gravitations impervious to the winds and seisms that frac-
ture edifices, statues and monuments. The other man. A
man from the past beneath the acacia. Like each dawn before
the wind, the leaves roll on the machine, beneath the reac-
tors, the generators, the shadows, the footsteps...
 Something tries to break apart. Something in this city
which constantly defies the atom. But how to pass beneath
the wave? How to pray (and what prayer), to whom, from
whom, for what? No prayer distances from the waves the

Dakar, Senegal

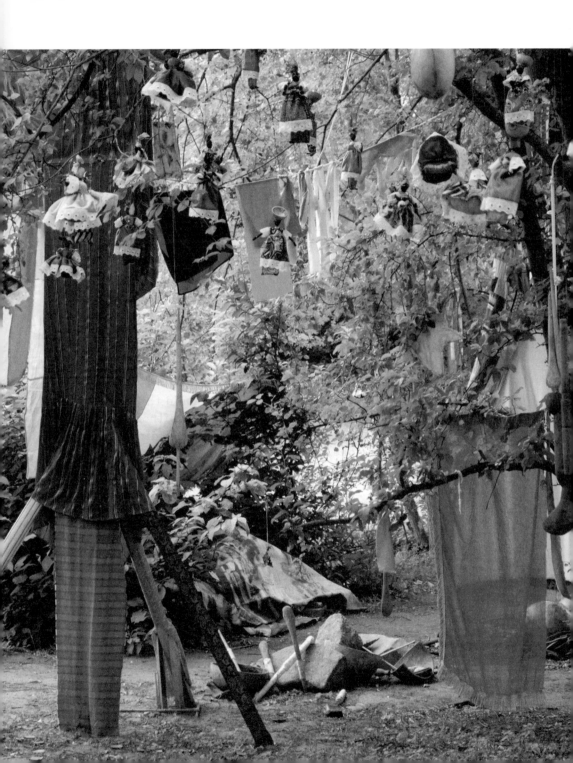

man who knew not how to open himself up to the world once
again. The Earth. In the middle of the fire, the metamor-
phosis of waters with a light where, in a circle, leaves like
loosened knots displace and replace themselves. Then the
crackling of silk cotton tree seeds and the kapok fleeing the
wind withdraws by ruse on the wall, settles at the edge of
the thorn bushes. The cocks in the silk cotton bark burn to
a cinder. After the leaves, the branches fall and break the
roof, the shelves and books. The rain falls. The books rot.
My heart is heavy. Beneath the rain, like a tree I resisted
the storm, death, its cost, creation. In garages, attics, bric-
à-brac traders, museums, stores, forests, oceans, wrecks,
in birds' nests we always find some things. The open sky,
the rain—and I standing, by dint of practical exercise. We
believe to have invented it. The image.

Excerpts from Issa Samb, *dOCUMENTA
(13): 100 Notes–100 Thoughts, No. 095*,
Eds. Carolyn Christov-Bakargiev and
Bettina Funcke (Kassel and Berlin:
Hatje-Cantz, 2012).

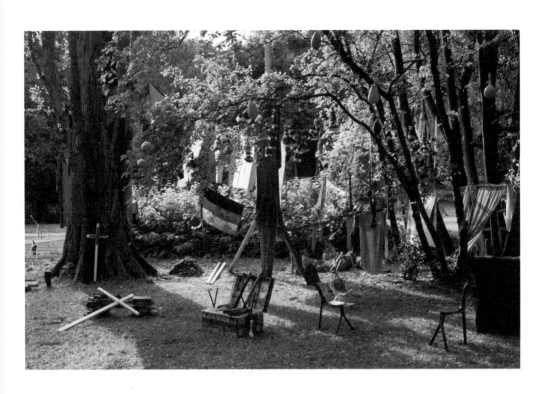

All images:
Issa Samb, *Laboratoire Agit'art,*
1974–present

Koyo Kouoh on
Laboratoire Agit'art

Issa Samb is a Senegalese sculptor, painter, actor, philosopher, performance artist, writer, and critic. For decades, he has been creating a galaxy of interconnected universes in which the signs of everyday life are transformed into altars to personal obsessions.

One of those obsessions is politics and politicians, in particular Senegalese politicians, whom he has frequently described as mindless people. In keeping with his readings of Marxist philosophy and aesthetics, many of his sculptural assemblages take the paradigm of revolutionaries—Che Guevara, Amílcar Cabral, Ahmed Sékou Touré, Lech Wałęsa, the Black Panthers—as their subject matter, suggesting the possibility of harnessing the energy of the visual arts to support the struggle of the weak and disadvantaged.

In 1974, along with filmmaker Djibril Diop Mambéty and an interdisciplinary group of artists, writers, musicians, actors, and filmmakers, Samb founded the *Laboratoire Agit'art*. Its multidisciplinary actions were directed against the formalism of the École de Dakar, a style of art practice developed at the National Art School of Dakar and drenched in Léopold Sédar Senghor's philosophy of Négritude, which promotes the difference between African and European in the same way that it strictly respects the separation of forms and disciplines in the use of African symbolism. Aiming to transform the nature of artistic practice from a formalist, object-bound fixation to a process that is based on experimentation and agitation, ephemerality rather than permanence, political and social ideas rather than aesthetic notions, Agit'art developed a distinct "aesthetic of the social." Audience participation was paramount to the group's work, which privileged communicative acts over the embodied object. Neither utopian nor self-referential,

it grounded its actions in the immediate sociopolitical situation. Today, many of the founding members have passed away, but the group's spirit persists and continues to be materialized in all of Samb's work.

The preceding text by Samb is written in the cryptic, elliptical, elusive, evanescent, and erratic style that he has developed throughout his career. Excerpts have been reproduced here. The full text begins with quotations in no particular order. The first one refers to an imaginary HE who is nevertheless a HE whom everyone is supposed to know: the African politician, and precisely the Senegalese politician. The quotations continue with a story that took place in Dakar in the mid-1980s, when the mayor had all stray dogs slaughtered because one of them had bitten his daughter. Samb reads this event as a process of the manipulation and brutalization of society, juxtaposing it with the actions of Hitler. Far-fetched? Exaggerated? Perhaps not. One can see it as a perfect example of associative thinking and writing: the line of thought begins with the slaughter of dogs, goes on to the German shepherd, an animal that for Samb has the same value as a human begin, and leads to Hitler, the personification of cruelty and manipulation.

The text ends with the death of Steve Jobs and the Internet's incapacity to solve emotional problems or to cure diseases, cancer in particular. Samb has neither an e-mail account, a bank account, nor a cell phone, does not watch TV or indulge in the modern frenzy of life and the constant pursuit of wealth and recognition. And yet one cannot fail to recognize the incisive character of his observations on the course of the world: how systems develop, how people develop, how they behave, how they relate, how they feel. *Le sentir* ("to feel," not the feeling itself), as he often states, is the most important human activity. Themes

such as affection, commitment, faith and beliefs, sorrows and joys, failures and success, are continually revisited and treated as fields for investigation the complexity (and simplicity) of being.

ON THE ART OF RECORDING TRIVIAL IDEAS, IN THE FORM OF A PROJECT OF PLACING, DISPLACING, AND REPLACING THE CONCEPT IN ITS ENVIRONMENT WITH A VIEW TO PRECIPITATING ITS FALL is a piece of writing that reads like a long, unpunctuated song. The style is elliptical, dense, and compact, interspersed with pauses, reflections, references and quotations, reminiscences and fabulations; a style that reflects the absence of boundaries between poetry, pamphlet, novel, and diary. It is an accumulation of real events and the thoughts and emotions they trigger. These are seemingly unrelated, and yet they are spun with a recognizable, common yarn: the duty of an artist to his immediate environment.

Published in Issa Samb, *dOCUMENTA
(13): 100 Notes–100 Thoughts, No. 095,*
Eds. Carolyn Christov-Bakargiev and
Bettina Funcke (Kassel and Berlin:
Hatje-Cantz, 2012).

Christoph Schäfer
Park Fiction

In her essay "Revolution and Public Happiness," Hannah
Arendt analyzes the term "public happiness," used by
Thomas Jefferson and the Enlightenment thinkers of his
time. The link between "public" and "happiness" had been
made to seem so natural by a widely shared practice of demo-
cratic meetings, political salons, and collective mobilization
that by the time Jefferson drafted the thirteen colonies'
Declaration of Independence it could never have occurred to
him that "pursuit of happiness" might mean anything other
than the right to (and enjoyment of) collective discussion,
decision making, and activity. Yet only a few decades later
this idea had sunk so far into oblivion that bourgeois society
was left more or less defined by the sharp division between
private and public spheres. Happiness becomes a personal
issue, a private matter, a field where politics should not
intrude. The dominant view that art is not political corre-
sponds to this division and has its roots in it.

Hamburg, Germany

 The opposite of all this—public space, public speech, and
political discourse—is incrementally reduced to bureaucracy
and accordingly impoverished. The groups and artists I like
to relate to in my work are linked by their search for a
practice that could be understood as a rediscovery of public
happiness. And they are also linked by something else: they
find this new commonality neither in political parties, nor
in the factory, nor in the field of discourse, but in space:
the urban space that Henri Lefebvre called "social space,"
produced exclusively through action. This urban space is
rapidly regaining importance as the site of production of
ideas, relationships, trends, atmosphere, networks, images,
innovations, lifestyles, and increasingly also of things
shaped by these soft, immaterial, urban qualities. In this
context, public happiness can also mean that we must now
develop forms of political agency that don't withhold the
payoff until after an imaginary revolution: while on the way
there, the particular projects and forms of action should
already be in themselves a utopian pulse that makes another
world possible.

Previous page:
Christoph Schäfer, Margit Czenki, and
quartiervier (in collaboration with students
and employees of Zeppelin University),
Moon Container from ContainerUni, 2012

This page, top:
Christoph Schäfer, *Iftar in Yeniköy* from
the series *Bostanorama*, 2013

This page, bottom:
Christoph Schäfer, *Gezi Park Fiction St.
Pauli*, 2013

Opposite page:
Christoph Schäfer, *Bostanorama*
(installation view), 2015

CAMP on
Park Fiction

Christoph Schäfer lives and works in Hamburg, Germany, where he has taken part in several artistic-political movements since the mid-1990s with *Park Fiction*, a project comprising of "interventionist residents" who imagined and then built a public park on land that was being sold to private developers. This practice is carried forward to the present day with the Right to the City movement in Hamburg. His drawings have continued to provide slogans, concepts, and, broadly speaking, an art that supports, inspires, and is closely in sync with a range of urban political activities. A certain proof of their vitality is that the title of his recent book of drawings, *The City Is Our Factory* (2010), was adapted as the Euro May Day slogan in Hamburg this year, as "Die Stadt ist unsere . . . " ("The City is our").

In 1995 *Park Fiction* began a process of what it referred to as "Collective Production of Desires" in order to imagine a public park. This meant a process of speculative planning based on community desires: for a dog park, tea garden, a pirate fountain, and other "islands of paradise." Schäfer was a principal initiator and artist-spokesperson of the movement, which quickly gained momentum and wide community support. Their approach was far from a classical notion of activism, and the initiative of artists and musicians in the group helped support several parallel planning processes that included modeling, sketching, filming, and collaging activities in a very complex but open system of participation. For example, the group built kits to serve as a portable planning studio, complete with a large panoramic view of the park that could be carried from home to home, among other sustained platforms of exchange between neighbors in the community. These neighbors included, in the words of the *Park Fiction* group: "musicians, priests,

a headmistress, a cook, café owners, bar-men, a psychologist, children, squatters, artists—Interventionist Residents." The tone of these platforms and kits was irreverent and joyful, and hundreds of ideas were produced. His longtime collaborator Margit Czenki made the film *Desire Will Leave the House and Take to the Streets* (1999), which imbue the spirit of the Park Fiction project.

In 2005, after a decade of negotiation, the park opened in Hamburg-St. Pauli, a red-light distict and traditional immigration quarter of the harbor city. Several drawings made by Schäfer and his collaborators were realized in concrete, wood, trees, flowers, and other materials. The opening event at the park was called a *Picnic Against Gentrification*. On the edge of the water, the park and its iconic fake palm trees continue to act as markers of a long and deep process of collective artistic imagination. Details of this process can be found in the *Park Fiction Archives of Independent Urbanism*, currently housed in the Golden Pudel Club, which is part of the park.

Schäfer's recent work combines an ongoing interest in the urban thinking of Henri Lefebvre with a keen eye for the changing everyday life in cities. This typically takes the form of drawings or drawing-installations, videos, and often very funny presentations in person. *The City Is Our Factory* shows yet another angle, that of speculation and the imaginings of histories of urbanism that may or may not have existed. The book is based on the thesis that cities have replaced factories as the places of production. As the classical forms of resistance in the industrial age, trade unions and strikes, increasingly fail "to get hold on the slippery ground of a de-regulated, postindustrial society,"[1] Schäfer suggests that the connection, the wiring-up and intensification of spatial urban

struggles could be a way to develop new forms of resistance. Making "unlikely encounters more likely"[2] (between different people, classes, cultural fields) becomes a key quality in the coming struggles.

Schäfer develops these thoughts while he draws and in drawings. They circulate in various ways—shown in rhizomatic arrangements or stencils on walls, as a linear story in a book, or fed back into political movements in talks accompanied by projected drawings. In 2012, Schäfer, together with Czenki and the firm quartier vier architects, designed a complete temporary university campus built from 180 shipping containers. His own drawings and a whole range of inspirations from film, architecture, music, and modern art appear as stenciled motifs on the walls of the rooms. Each of the three blocks features an "insert"—a folly-like element that falls out of the functionality of the University—like a 1:1 replica of George Bernhard Shaw's rotating Writing-Shack on the Garden-House, a GDR-Caravan on the roof of the Car-House, and the Moon-Container, equipped like a Jules Verne Fantasy Star Ship with padded buttons that trigger sounds from the future, and sci-fi books hidden in the gaps between the padding.

In 2013, he participated in the Istanbul Biennial with *Bostanorama*, another series of drawings that told a political history of Istanbul through its gardens, parks, and stadiums. The biennial opened two months after the violent eviction of Occupy Gezi. On the night of the attack, after a video still showing the police setting fire to the Gezi-Tree-of-Wishes had been posted on Twitter, Schäfer and a few of his comrades from Rote Flora, a squatted theater and cultural space in Hamburg, decided to rename *Park Fiction* to *Gezi Park Fiction St. Pauli*. Czenki called for a "public protest photo shoot," and sixteen hours later, a powerful image of hundreds of local Occupy Gezi supporters in the park went around the world. In the following weeks, the park turned into a location of informal protests, solidarity concerts, and a meeting ground for football fans of FC St. Pauli and Besiktas Istanbul.

Currently he and Czenski are working on *PlanBude* (planning shack), along with a new team of architects, artists, social workers, and neighbors. With the same ethos of *Park Fiction*, *PlanBude* will organize the participation and collective planning of a whole housing block in St. Pauli—with the community. The desire and hope here is to give urban planning a new direction and agenda, and to fill democracy with imagination and "public happiness," a term used by the early American revolutionaries and which Hannah Arendt reflected upon intensely.

Salon Public Happiness is also the title of a recent one-week exhibition that took place in the fall of 2014 at the Vienna Secession, which Schäfer "sub-curated." There he combined the videograms of Videoccupy, a group that formed itself in the first days of Occupy Gezi, with artistic groups from the Hamburg Right to the City network. Significantly, even though Schäfer often seems to be at the direct fringe of dramatic and very existential urban struggles, he is not interested in spectacular moments of confrontation and violence, but much rather in the moments of "happy" collectivity that arise when the many start to become aware of the power of commoning and acting together.

The breadth of engagement with the urban condition is perhaps what draws so many contemporary artists and activists to Schäfer's work, in and with the imaginations of the everyday life. We are all struggling with issues that seem temporary, but that are in fact unshakable and have deep roots. In other words, we feel that the artistic work done by Christoph Schäfer in the past two decades is an essential "archive" of what is possible with a combination of deep-historical thinking and everyday attention, with lightness, humor and music—and what is possible when aesthetics-politics are produced in a joint way that manifests as both carpentry (building activity) and charm (aesthetics).

1 Christoph Schäfer, *Revolution Non Stop* (2000), 16mm film, 19 minutes, looped, http://christophschaefer.net/revolution-non-stop-filminstallation-2000/.

2 "Park Fiction Presents: Unlikely Encounters in Urban Space," a conference and exhibition sub-curated by Schäfer with Margit Czenki, 2003, http://park-fiction.net/park-fiction-unlikely-encounters-in-urban-space/.

Take to the Sea

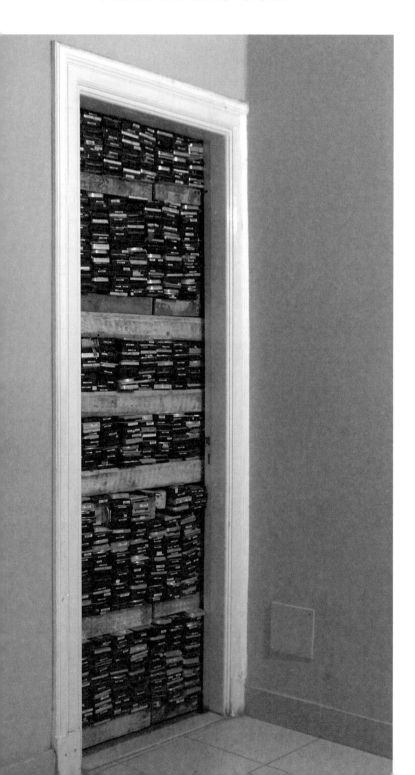

Long before it was named, Take to the Sea was conceived as
an attempt for someone with the wrong passport to have a
reason to obtain an official letter that would enable a visa
to stay on in Cairo. More formally, it was initiated in 2008
as an open-ended research project concerned with irregular
migration from Egypt to Italy via the Mediterranean Sea.

Since then it has mutated many times, and different
minds and motivations have migrated to and through it to
produce image, sound, and text-based work. In the process
of traveling to various villages from where people migrate
as well as to points of departure on the coast of Egypt col-
lecting accounts of both disillusion and desire, Take to the
Sea encountered, again and again, an imagination in which
the possibility of transformation rested entirely on arrival
to the other shore. These journeys were marked by memo-
ries that were not yet had, and somewhere along the way,
the project touched its own exile.

In entering, somewhat hesitantly, into the territories
of art, Take to the Sea turned the tide in on itself as its
members attempted to inhabit some of the very conditions

Cairo, Egypt

they sought to consider. Preoccupied with instances when
the sea becomes a wall, a waiting room, a passage to a prison
cell, the project began working through that which might
emerge from the vicinity of silence, to suggest an image
for the invisible drawn out of voice. More recently, for its
first solo show, Take to the Sea produced a single sculptural
installation, titled *A Roomful of Lost Memory*. It was an
attempt to quantify or measure the matter of time. It
was the possibility of retrieving a history that belongs
to no one.

Opposite page:
Take to the Sea, *A Roomful of Lost Memory*
(installation view), 2013

Top:
Take to the Sea, *A Roomful of Lost Memory* (installation detail), 2013

Bottom:
Take to the Sea, *When the Sea Became a Wall*, 2010

Clockwise from top left:
From the Take to the Sea archive
(installation detail), 2012

Take to the Sea, *I Swear I Saw This*
(video still), 2013

Take to the Sea, *A Mc Guffin for Art*, 2010

Jenifer Evans on
Take to the Sea

A creased, pale A4 page is divided into sixteen equal rectangles. Each section of this grid is filled to varying extents by stacked lines of printed black text. Of diverse lengths and font sizes, the resulting text blocks leave an irregular rhythm of blank gaps. Definitions, symbols, facts about computer malfunctions and the shipping of e-waste, musical notations, poetic questions, and quotes: "'You can't read erasures,' he said, 'but you can imagine reading that which has been erased for good.'" On the flipside of the flimsy page, equal amounts of lorem ipsum text, font size adjusted accordingly, have been made to fill three rectangles of different sizes. This publication, created in 2013, could be folded into a little boat. "Disappearance is a misnomer," it says. "Living or dead, each is in a very real place."

Take to the Sea emerged out of a research project that started in Egypt in 2008, affiliated with an academic institution, the American University in Cairo. An inquiry by a large and changing group of researchers into undocumented migration from Egypt to Italy became a compulsive, impossible quest to compile information on all the drownings of migrants in the Mediterranean, with hours spent trawling through the local press.

For a year and a half, trips were made from Cairo to out-of-the-way northern villages from which would-be migrants took to the sea. Later, a documentary film was made from the many conversations had with the travelers, their smugglers, and the travelers' families. But a core group of researchers—Laura Cugusi, Nida Ghouse, Lina Attalah, Mohamed Abdel Gawad, and Shaimaa Yehya—grappled with how to tell these stories in a way that avoided certain representational traps: the familiar images, numbers, problem-and-solution-oriented terminology, and tales of hardship that occur in news media and academic studies when irregular migrants are discussed.

A meeting in the summer of 2010 with writer and curator Bassam El Baroni, then co-curating Manifesta 8, generated a turn toward contemporary art. The migration of the researchers' practice into this field permitted their own stories to fold into their storytelling, and also brought in experimental formats and nonlinear modes of narration, new kinds of encounters, and a destabilizing of their own footing as they drifted into unknown territory. For Manifesta, Cugusi, Ghouse, and Attalah made *Not Yet Anywhere*, a disorientating, complex sound installation in an abandoned post office using recordings of historical correspondence discussing the sea, discipline, and exile in assorted languages alongside sound effects.

This marked the beginning of a sporadic, protean art practice that exists when Take to the Sea are invited to exhibit or perform or when they are in the same place at the same time. But it also impacts the in-between periods, when its members are silent as Take to the Sea but working separately in other professions, incorporating its fluid outlook into journalism, art writing, photography, or curating. Take to the Sea is a series of detours, impossible attempts, and shifting interests, and its exhibited outcomes are always temporary and site-specific.

An 2013 exhibition in a small space—Nile Sunset Annex in Cairo—consisted of a single sculptural gesture—blocking the doorway with old defunct hard drives, which had each once been part of a computer, by stacking them into a wall-like barricade, giving the illusion of a roomful. The weeks-long act of finding these hundreds of grey, metal hard drives, each the same but different (damaged and soiled differently, with different layers of surface or internal workings

visible), through speculative trips into computer malls, markets, and dumps on the outskirts of Cairo, was an unspoken part of the work, like the trips to Rashid and the villages of the Nile Delta back in 2008. The complications of calculating how many hard drives could fit in a room or a doorway, and how much hard-drive weight the room's floor and walls could hold, were reminders of their earlier, vain attempts to determine the length of time it took to get from Rashid to Sicily by talking to people who had made that trip.

Like a somber, detailed monument to those known and unknown passengers who were following their desires but drowned at sea, with their past memories and the future they were forbidden to have, to the survivors who were stacked together in ships' fish containers for days without food or drink, the silent impervious work makes us wonder about practicalities and numbers and other people's experiences, as well as whether anything could be retrieved.

A work made earlier that same year, titled *I Swear I Saw This*, was a brief repeating video projected vertically downward onto a blank paper on a small round table. A flickering, stop-frame sentence in black pen is written across the white page, but its beginning vanishes before it can be completed: "There are moments that seem to last forever." Idea inhabits form, the sentence disappears and keeps coming back, a loop of interrupted silences.

Take to the Sea was nominated by Bassam El Baroni.

Part 2

Dorchester Projects

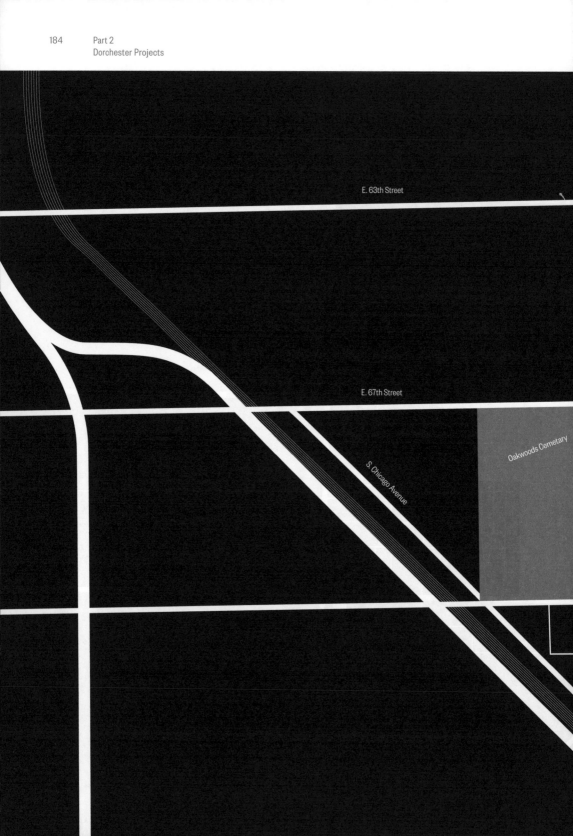

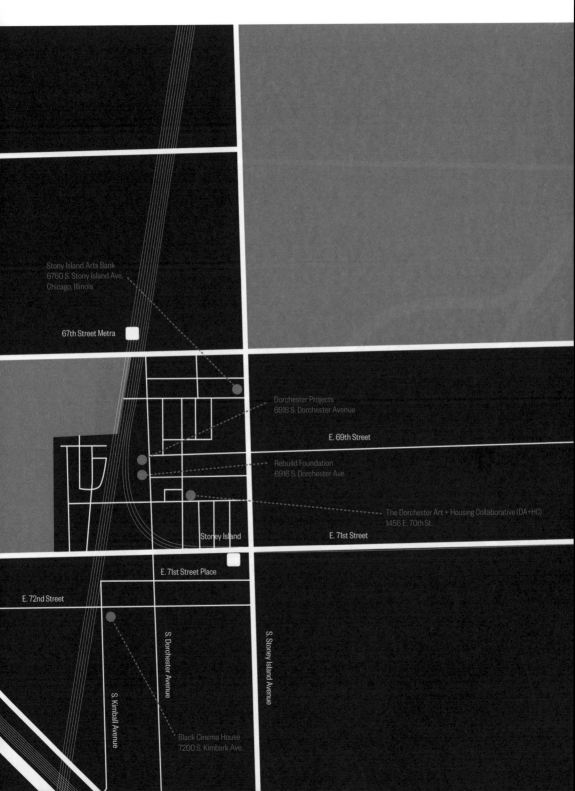

Stony Island Arts Bank
6760 S. Stony Island Ave.
Chicago, Illinois

67th Street Metra

Dorchester Projects
6918 S. Dorchester Avenue

E. 69th Street

Rebuild Foundation
6916 S. Dorchester Ave

The Dorchester Art + Housing Collaborative (DA+HC)
1456 E. 70th St.

Stoney Island

E. 71st Street

E. 71st Street Place

E. 72nd Street

S. Dorchester Avenue

S. Stoney Island Avenue

S. Kimball Avenue

Black Cinema House
7200 S. Kimbark Ave.

Theaster Gates
Dorchester Projects

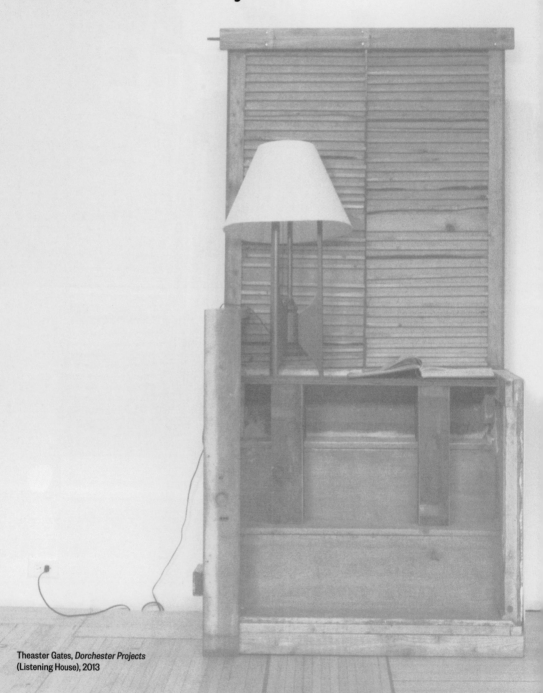

Theaster Gates, *Dorchester Projects*
(Listening House), 2013

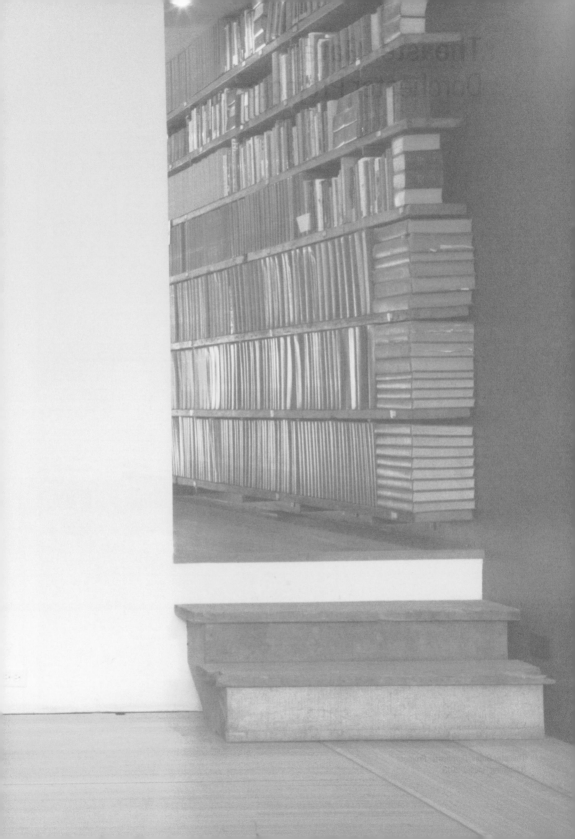

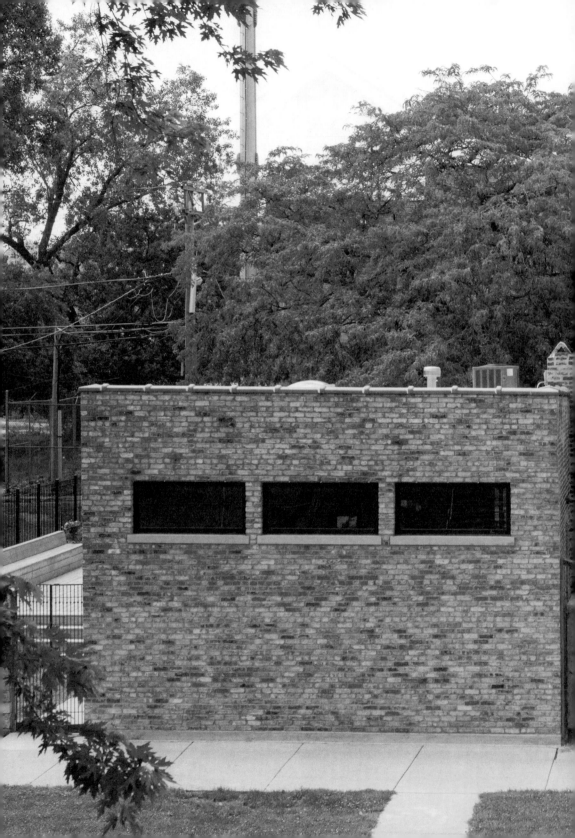

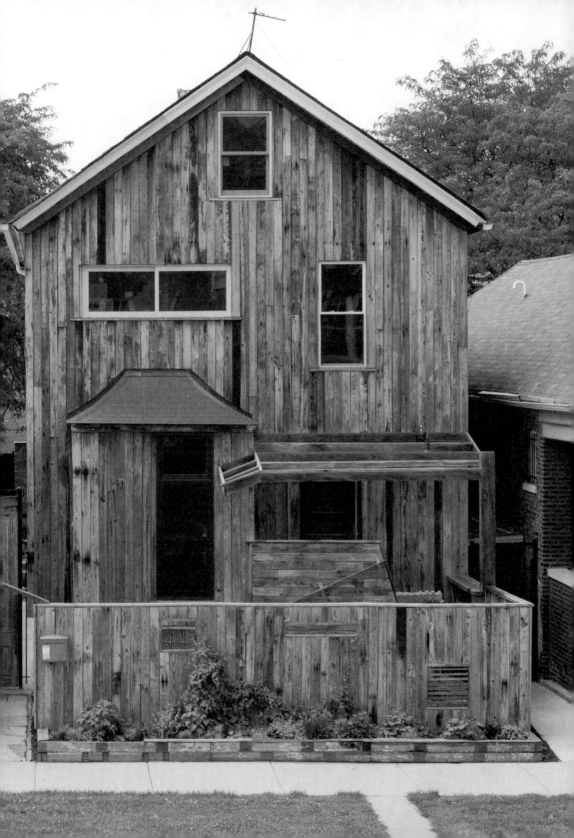

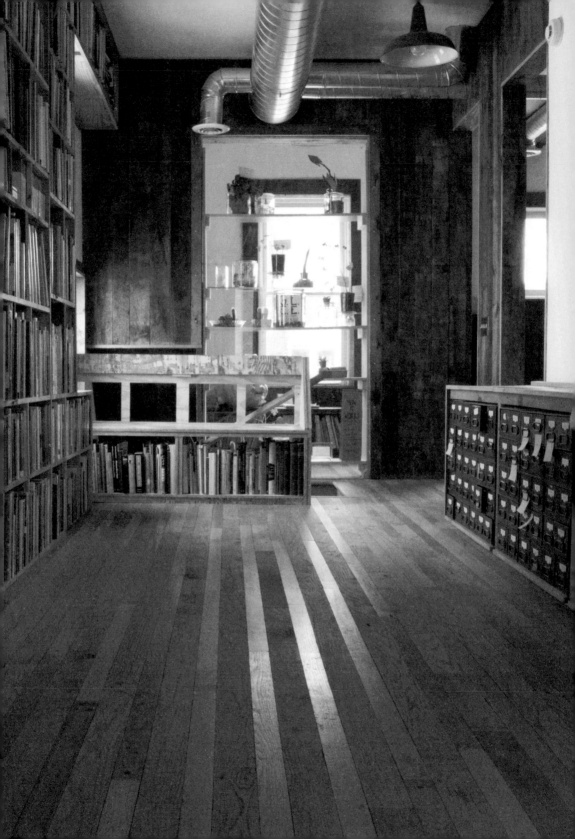

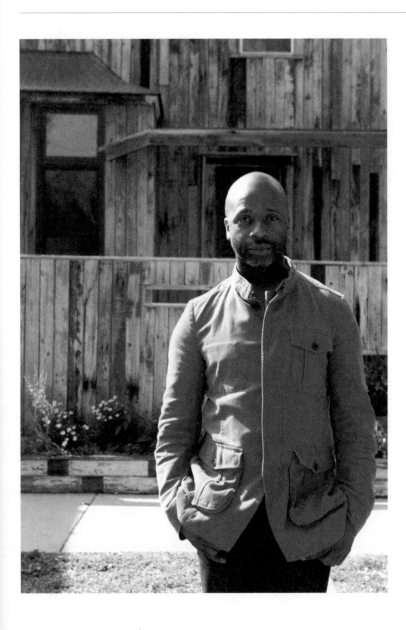

Previous pages:
Theaster Gates, *Dorchester Projects*
(left to right: Listening House and Archive
House), 2014

This page, top:
Theaster Gates at *Dorchester Projects*

Opposite page:
Theaster Gates, *Dorchester Projects*
(Archive House), 2013

This page, top:
Theaster Gates, Black Artists Retreat
(BAR), Washington Park, Currency
Exchange Café, 2014

This page, bottom:
Theaster Gates, Black Artists Retreat
(BAR), Black Cinema House, 2013

Opposite page:
Theaster Gates, *Dorchester Projects*, 2013

Previous page:
Theaster Gates, *Dorchester Projects*, 2012

This page, top:
Theaster Gates, Black Artists Retreat
(BAR), 2013

Opposite page:
Theaster Gates, *Dorchester Projects*
(Archive House Library), 2013

"Some Kind of Work Simply Needs to Happen."

Theaster Gates in conversation with Carin Kuoni

CARIN KUONI Given our pedagogical work at The New School,
I'd like to ask you about teaching works such as *Dorchester Projects*
in the classroom setting. How can we as educators and artists
make such projects understandable to students?

THEASTER GATES Let me try and pull that apart. On one level,
let's imagine that we are teaching Dorchester. Teaching
Dorchester would be like trying to teach someone how to make
a specific work of art. Teaching is a set of skills that might
allow something like Dorchester to emerge. But there is the
possibility of lots of other things that could also emerge. That
is, Dorchester is the byproduct; Dorchester is one emergent
possibility of a way of structuring my life as an artist, of using the
various interests that I have to try to make tangible some of the
things that I work towards.

So on one level I could have students consider the impact
of culture in a particular geology, on a particular economy, and
the role that economy and business play alongside an artistic
practice, the value of all that disciplinary rootedness and teaching
making a more complicated kind of work and a more complicated
discipline. But Dorchester is really an amalgam of disciplinary
practices, and some of those practices can't be evaluated.
Dorchester is also rooted in an order that is beyond economical
terms; it is an artistic adventure. It has to do with people who have
invested time and resources. It is the belief that this really matters.

The things that happened as a result of *Dorchester Projects*
are immeasurable. They're not all material: for certain aspects
of the transformation, there's no rubric for what happened.
You would have to "grade" the investment in the project beyond
the possibility of returns. There's a set of things that I could
teach, and then there is another set of things that have to do
with what people do when their heart is involved in work, when
the learning makes you dig deep into a place and give. These
are touchstones.

CK I completely agree that much is immeasurable, but there
must be a way to find a language and a vocabulary that describe
the experience of *Dorchester Projects*.

TG Yes, certainly. If we're going to be tactical for a moment, there is a clear understanding that if you give in to a system that continues to be responsive, limber, and change-oriented, you would feel sufficiently empowered to be publicly critical, to be publicly reflective, to be partners in the future of the work. Rather than just observing life, life should be a participant in the evaluation.

CK And what is the potential role of images or symbols? Can art, or an image, speak of the immeasurable in a way that is productive?

TG Yes, but not one image alone. Many images could. It's the combination of image and narrative—and multiple narratives— that can do so. It's what will happen when the New School faculty writes contradictory things about their experiences on the block. And it's through those contradictions that you actually get a sense of the root of the nuance of real life. One person might call *Dorchester Projects* the best thing in the world because of their social anthropological take, and another person regards it as a pseudo-capitalist story. I hope that between those two messages we start to peel back something that is much more complicated. Through multiple images and multiple narratives, ultimately the best byproduct of Dorchester would be if people would want to come visit in order to be a part of the structure that allows them to be considered friends of my neighbors. Ultimately, this is not about Dorchester, it's about a way of moving and transformations all over the world. It is not about Dorchester.

CK At the Vera List Center, we are currently working on a book on speculation. It proposes that people from many different disciplines—artists, financial experts, scientists, and others— all share this speculative moment. It makes me think of your references to the "belief muscle," the idea that belief relates to real life and can be trained.

TG For me, belief only takes place in the context of one's life. Belief only makes sense when it's administered through the real

Theater Gates, Vera List Center Prize for Art and Politics Award Ceremony at The New School, New York, September 18, 2013

world. When I use the word belief I'm using it as a part of a set of physical materials. It's the consequence of the idea that some kind of work simply needs to happen. It is no different from how I imagine my artistic practice. There are things, whether they make sense or not, whether they will live in the art market or in a gallery, that I need to make. It requires something that is not rational, that is not linear, that is not speculative in the way of finances. Rather, there is a kind of internal impulse to say, this is where I am and this is what I do, therefore I will do it here.

CK What is spiritual about the physical commitment?

TG Part of the makeup of my intellect, part of the makeup of how I operate in the world, part of my mode of operation has to do with a very strong understanding of and a very strong sensitivity for things you cannot see. Like the strong conviction that I feel when I drive past a building and I think about the possibilities of what could happen there. I might invest in these places because it feels like I'm supposed to. Regardless of the financial investment, I might just plow ahead, which is, in a sense, a certain kind of resource that I have that would not be available to a traditional developer. An unbelievable resource as a result of my unbelievable belief!

CK Can you cultivate and foster this belief?

TG Successful people whom I've met seem successful because they learned to move failures to success, and have gained courage and confidence and belief in doing so. People who don't

try things, who just try to play it safe, often fail. The cultivation actually consists of courage and fortitude and some kind of inner growth. Every day there is lots of pessimism and disbelief and critique. And every day I have to say, "I hear you, but I think I can be successful here. I know time is limited, but I believe that my team can make this happen. I know that was a failure last year, but I think this year we can do it."

CK Does courage then come from evaluating your impulses against an outside world, or from placing them in the world? Is it the withdrawal to a private personal meditative space where you sit every morning and contemplate?

TG Like all good attributes, I think courage comes from practice. And practice can happen in lots of ways. Practicing can happen through meditation where you think through good practices, but it can also be the action of the work. It's also the practice of naming things; it's the practice of being present; the practice of trying things that are much harder than you know how to do yourself; it's the practice of believing in other people in order to make things happen. In the trajectory of one artistic career your hope is that that practice becomes a life worth remembering. The byproducts of that practice are things that the world can say thank you for.

CK You are so precise and deliberate in the way you address quite distinct bodies of potential interlocutors, whether it is communities, city agencies, or academic institutions like The New School. My next question is about modes of address, in your case most sophisticated and individually tailored to each specific moment and situation. The modalities of address don't just find an audience but they also make it. The mode of address generates a public, it doesn't just identify it. Can you comment on that?

TG It's my belief that speech is the first form of creativity. For me, creation starts with talking about a project, talking about a set of values. I never exempt speech from the essence of

practice; it's always been a part of the way that I understand the world. So there is speech but also extended speech, which might be song or another sound. Sound is important because it has the capacity to call things into being. It has the ability to help create order, disorder, and resolution, to be a revolution.

Fortunately, I don't have the burden of thinking of myself as one kind of creative person, but I can be a wholly creative person. For instance, I found that I've been given this gift to convene others. I recognize this as power and I imagine the speech act to be part and parcel of the life of my overall artistic endeavor. I'm so very clear in my place in the world that I constantly try to determine what it is that should I beg of the moment. The moment as it relates to my access to people, to my place in the world, and to the stakes that are at play. And these questions contribute to making an art that is contemporary. So there is a new question every day based on who I am for that day. It's in real time.

> CK When looking at the various qualities of "coming together"—ranging from government-supported electoral initiatives to more circumstantial, personal situations of being neighbors—where is your main focus in convening? What kinds of publics do you bring to life through the various speech acts?

TG I don't have a politic of unity or civic-ness. I have projects that need a particular temperature and really specific ingredients that need to happen over a certain period of time in order for that project to fulfill itself in the way that I imagine. The kind of public that I need in order to demonstrate the hostile racism that might exist in North Omaha is different from the kind of public that I need to be critical of an art fair. It's also different from ways that I would like to constructively engage the black church in a critique of what's important for black church leadership. In this way, I really don't believe that there is a public anymore. I believe that we are a world of privates and that there are things that could call us to be momentarily, instantaneously, temporarily, "public." How we choose to be public is how we

should be. For Dorchester, this is a strategy that I used to invent
a temporary public so that we can learn things and be civil
and be civic minded, take charge, be citizens before returning
to be our private selves. So part of what I'm trying to do with
Dorchester is ask, is there a way to being that would expand our
notion of public to longer than the sixty-two days of the Occupy
movement? Is there a way we are willing to be on call of our
public-ness? That requires creating a platform that is mindful
of the possibility of an extended public. For me, public is
more about time than it is about people. How long do we want
to be public?

> CK This demands an intentional community, doesn't it? Just
> like the archive at Dorchester, there are demands and expec-
> tations put in place; it is not open at all times but available at
> certain moments only.

TG Yes. There are very practical reasons having to do with
sustainability. But there is also another aspect to how this func-
tions. Just as you would expect not to go to someone's house
whenever you want to every day of the week for dinner, it's a bit
like the invitation—that takes into account this life of mine that
is private, that has public moments, and that has an apparatus
for being public and one for being private, each with its own
limitations and capacities. We are going to create more special
moments because when it opens up, people can make the choice
to say yes, I want to be a part of that. It's not just a given.

> CK Addressing a public is utterly specific, extending to lan-
> guage, naming, and so on. There is, for instance, the Black
> Artists Retreat. In an interview with Carolyn Christov-Bakargiev,
> you speak of your desire to create ritual ceramic objects for the
> food of black people. What are the pitfalls of being so precise in
> whom you assume you address? What is the risk of such clarity,
> of naming the interlocutor, of adhering to (or creating) such
> categories, and is there a point when they need to be opened up
> and discarded?

TG There are clues that are operating at all times that are
ethnically specific. There is a way in which identity is always at
play in culture. What I found is that, in America, there's a set of
things that just are. I want to speak to some of those because my
entire project isn't only about blackness, but some things just
are about blackness. Like some things are just about Jewishness
or just about being Italian or a certain kind of white. In this way,
I've created one or two projects that really amplify the code.
If we had museums that weren't all white, I wouldn't have a need
for a Black Artists Retreat to talk about the need to create spaces
and opportunities for black artists.

> CK The way you connect and play off distinct cultural or eco-
> nomic systems is completely unique! A very sophisticated play
> with existing codes in one system and activating or leveraging
> them for results in another system.

TG It is amazing to me that in eco-tourism and green move-
ments around the world, most of the money comes from their
adversaries. There's a similarly complicated, murky relationship
between the tobacco and health industries.

> CK Right, but that's usually not visible. You make it actually
> visible, and by naming it, it becomes something new. It gener-
> ates something that we have not noticed before.

TG What you just said is what I'm supposed to do. When those
things slip by us, it's not that they're not happening, it's not that
they're not having an effect on us, and it's not that it's above
critique. There are reasons why we keep these things very quiet. I
want to expose those contradictions and my own contradictions.
 We can only have a hundred artists at the Black Artists
Retreat. It's all I can afford. But it's also the number at which
we can still all be together, and it feels like a family reunion, or
a time of actually pulling back from the world to make policy
decisions and to make sector-based decisions. It is trying to be a
little bit broader than a think tank. We wanted to invite younger
artists to think with us, so that they can get to know some of

these older, more established artists. There is so much desire
to know what we were talking about. Institutions like it when
artists don't talk to each other, so they can continue to exploit.
A byproduct of the retreat is that there are more artists who have
more things in common and now know it, and they'll be able to
leverage that in a different way in the market, or in the world.

I would be ill articulated if I didn't say that race mattered
in the context of my artistic practice, but there are other
things that matter. God, ghettos, racial segregation, the treat-
ment of women, there are these things that I think over the life
of my career will play out in lots of different ways. A lot of them
through works of art, poetically, through the convening of
people or through those fiscal projects, through me investing
resources that try to tackle some of these issues. I'm just living
it through life.

It's how do you begin to try to make things relevant that
have been irrelevant? It's a long road, Carin.

Theaster Gates
A Way of Working

Theaster Gates: A Way of Working,
2013. Installation view showing *We Buy
Houses* (2013) and *Huguenot Nightstand*
(1–5) (2012). Arnold and Sheila Aronson
Galleries, Sheila C. Johnson Design Center,
Parsons School of Design.

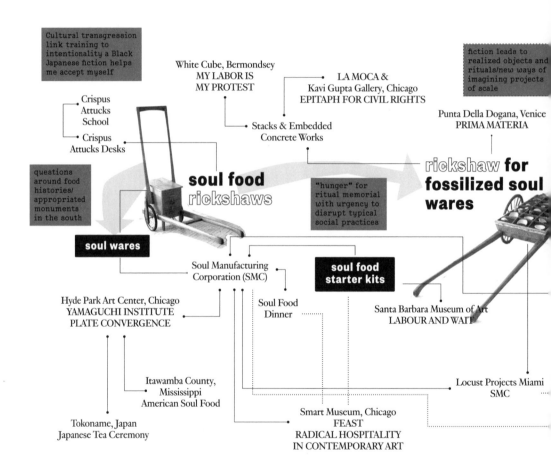

Cultural transgression link training to intentionality a Black Japanese fiction helps me accept myself

fiction leads to realized objects and rituals/new ways of imagining projects of scale

White Cube, Bermondsey
MY LABOR IS
MY PROTEST

LA MOCA &
Kavi Gupta Gallery, Chicago
EPITAPH FOR CIVIL RIGHTS

Crispus
Attucks
School

Punta Della Dogana, Venice
PRIMA MATERIA

Crispus
Attucks Desks

Stacks & Embedded
Concrete Works

questions around food histories/ appropriated monuments in the south

soul food
rickshaws

"hunger" for ritual memorial with urgency to disrupt typical social practices

rickshaw for
fossilized soul
wares

soul wares

Soul Manufacturing
Corporation (SMC)

soul food
starter kits

Hyde Park Art Center, Chicago
YAMAGUCHI INSTITUTE
PLATE CONVERGENCE

Soul Food
Dinner

Santa Barbara Museum of Art
LABOUR AND WAIT

Itawamba County,
Mississippi
American Soul Food

Locust Projects Miami
SMC

Tokoname, Japan
Japanese Tea Ceremony

Smart Museum, Chicago
FEAST
RADICAL HOSPITALITY
IN CONTEMPORARY ART

Theaster Gates, *Chart for Vera List
Center*, 2013. Designed by Garrick Gott and
Soulmaz Khazraei.

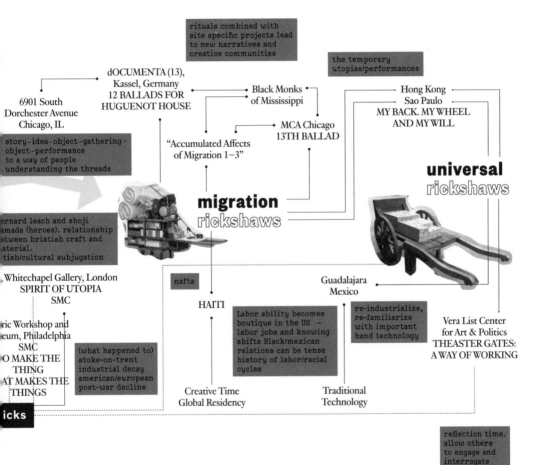

rituals combined with
site specific projects lead
to new narratives and
creative communities

the temporary
utopias/performances

dOCUMENTA (13),
Kassel, Germany
12 BALLADS FOR
HUGUENOT HOUSE

Black Monks
of Mississippi

Hong Kong
Sao Paulo
MY BACK. MY WHEEL
AND MY WILL

6901 South
Dorchester Avenue
Chicago, IL

MCA Chicago
13TH BALLAD

story-idea-object-gathering-
object-performance
to a way of people
understanding the threads

"Accumulated Affects
of Migration 1–3"

universal
rickshaws

ernard leach and shoji
amada (heroes). relationship
etween bristish craft and
aterial.
tish/cultural subjugation

migration
rickshaws

Whitechapel Gallery, London
SPIRIT OF UTOPIA
SMC

nafta

Guadalajara
Mexico

ric Workshop and
cum, Philadelphia
SMC
O MAKE THE
THING
AT MAKES THE
THINGS

HAITI

Labor ability becomes
boutique in the US →
labor jobs and knowing
shifts Black/mexican
relations can be tense
history of labor/racial
cycles

re-industrialize,
re-familiarize
with important
hand technology

Vera List Center
for Art & Politics
THEASTER GATES:
A WAY OF WORKING

(what happened to)
stoke-on-trent
industrial decay
american/european
post-war decline

Creative Time
Global Residency

Traditional
Technology

icks

reflection time.
allow others
to engage and
interrogate
the practice

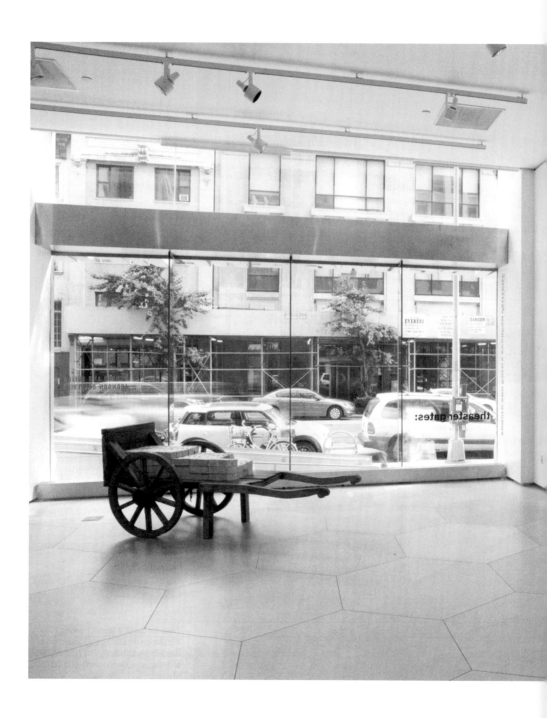

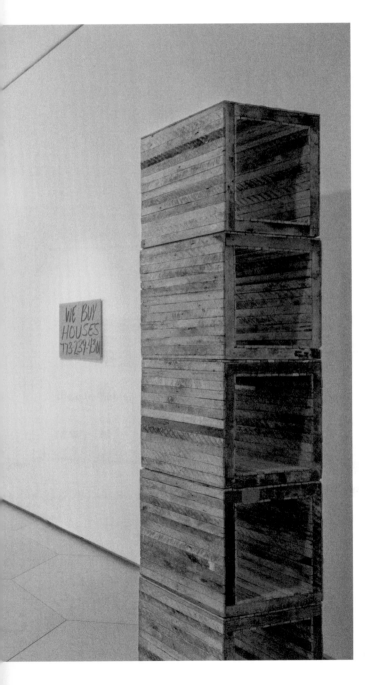

Theater Gates: A Way of Working, 2013.
Installation detail showing *Rickshaw for Black Bricks* (2013), *We Buy Houses* (2013), and *Huguenot Nightstand* (1–5) (2012) [left to right].

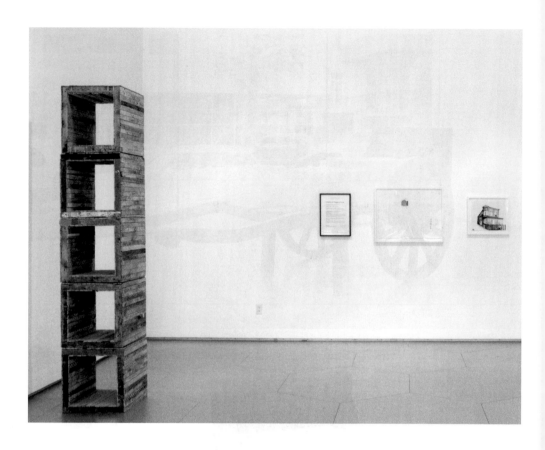

This page:
Theaster Gates: A Way of Working, 2013.
Installation detail showing *Huguenot
Nightstand* (1–5) (2012), *Huguenot House
Schedule of Events* (2012), *Shack: Utopic
Architectural Ambition, Study #15* (2011),
and *6901 S. Dorchester, Abandoned* (2011)
[left to right].

Opposite page:
Theaster Gates: A Way of Working, 2013.
Installation view showing *Rickshaw for
Black Bricks* (2013).

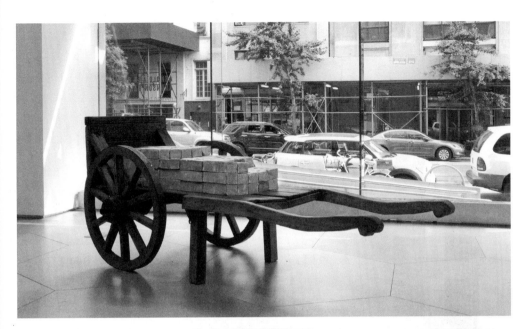

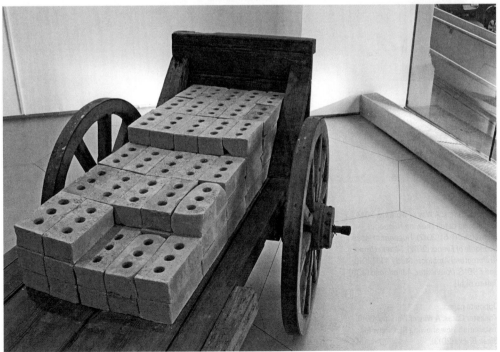

Utopian Operating Systems: Theaster's Way of Working

Shannon Jackson

The nominations for the Vera List Center Prize for Art and Politics
were due in the summer of 2012, and at that point, his career had gone
through the roof. At least, that was my view at the time. But a year later,
after he was picked to receive the prize and the ceremonial award was
bestowed, the roof had been not just further blown up but blown apart,
its pieces reassembled into new shapes to be sold at art fairs to raise
money to build more roofs back home. With hundreds of art reviews,
awards, and blockbuster openings to his credit, with major curators and
major politicians seeking a moment of his time, this is an artist whose
influence is felt and deployed in a range of powerful systems.

 Indeed, critics, curators, and everyday spectators have an increas-
ingly shared understanding of where the innovations of his practice lie,
with nearly every review or feature article touching on similar themes,
moments, and systems. While an art world perspective might worry
about routinization, an urban planning perspective might welcome such
dissemination as the circulation and scaling up of a body of best prac-
tices. But of course what is not resolved is the significance of a practice
that addresses so many perspectives—as well as the future of a practice
that seems still to depend upon the charisma, tirelessness, and unat-
tached attachments of what he himself calls "the silly charismatic magic
man," that artist associated with the signature Theaster Gates, Jr.[1]

 So what do we think we know about the person associated with this
signature? We can say that he is a potter, cross-media artist, urban plan-
ner, community organizer, and DIY policy wonk whose work engages
concepts of home, spirituality, and neighborhood, with a particular focus
on the history of African American cultural life. Part installation, part
relational aesthetics, and part urban revitalization, *Dorchester Projects* has
come to exemplify a wide-ranging practice while simultaneously provid-
ing the ground from which new work emerges.

 With multiple degrees in art, religious studies, and urban planning
as well as a varied professional career, Gates's background pushes the

1 Theaster Gates, *12 Ballads for
Huguenot House (Cologne: Walther
König, 2012), p. 34.

concept of "interdisciplinary." He is a trained ceramicist whose objects appear in major collections. He grew up singing in the gospel choir of his local church and later launched the Black Monks of Mississippi, a group that regularly sings and plays inside his installations, reminding the art world of performing art histories that exceed the category of performance art. He is an urban planner who devised an art program for the Chicago Transit Authority (and is now transforming the CTA into a public art project of its own) and who rehabilitates found buildings with the combined imagination of a sculptor, a social worker, and a public historian. He is also an artist whose international reputation has skyrocketed in the last few years, with commissions from the 2010 Whitney Biennial, Miami Basel (2011), the 2012 Armory Show, Documenta 13 (2012), and retrospectives and solo exhibitions at high profile museums in Seattle, New York, Minneapolis, Milwaukee, Los Angeles, and Chicago. And now he is the first to receive what will be a biennial prize from the Vera List Center for Art and Politics.

Let's recall some of the basic history of *Dorchester Projects*, an art project that began opportunistically in 2006 while Gates was residing in a South Side Chicago neighborhood at 69th Street and Dorchester Avenue. Watching his neighbors be threatened with eviction or foreclosure in a neighborhood where forty percent of the buildings were already abandoned, he purchased leftover structures and began to reimagine their social use. He began with a house next door, rehabilitating it and filling it with books and "outmoded" glass lantern slides procured from the art history department of the University of Chicago, just as they were about to give them away. Collecting more houses, a former candy shop, and—more recently—a bank, he repaired and altered their interiors and exteriors to devise more social spaces—a kitchen for collective cooking and eating (Soul Food Pavilion), another restored first floor for video watching (Black Cinema House), and a

2 Maura Guyote, "Theaster Gates' Dorchester Art + Housing Collaborative Offers Affordable Housing & Art Space in Chicago," *Creative Capital* blog, Aug. 29, 2014, http://blog.creative-capital. org/2014/08/theaster-gates-dorchester-arthousing- collaborative-offers-affordable-housing-community-space-chicago/. Gates told an interviewer, "By 2009 I realized that not only would I live there but I would try to make a substantial impact on the place where I lived. And so it started to feel like a project five years ago … If we think not only about these artist housing units but also start to think about other types of spaces that might grow up over the next couple of years to support artists who live in a larger community, and that larger community that wants culture to be part of it, then not

space for secular worship (carrying forward the *Temple Exercises* that first appeared at the Museum of Contemporary Art, Chicago, when he was still an "emerging artist"). He calls his own residence "Listening House," as it doubles as a place for storing and playing preserved vinyl recordings. Gates used funds he received from commissions and sales to repair these structures as well as to create collective support systems for the maintenance, gardening, security, and sidewalk repair of neighbors on his block. He has been compared consistently to artists like Houston-based Rick Lowe who have committed to rebuilding local infrastructure. Like Lowe, Gates frames *Dorchester Projects* as a commitment to the art of "staying." "Like I could live in other places... but the impact that I could have on Dorchester is so much more substantial... I can help my whole block get fences by the end of the year... For the cost of one year's condominium fees, anything might happen."[2] Gates thus also joins a growing group of high-profile artists (Paul Chan, Vik Muniz) who have created short- and long-term systems of redistribution between art-world markets and under-resourced regions of the planet.[3]

Within the sphere of community-engaged art or social practice aesthetics, artists face many occupational hazards. And the work of Theaster Gates and his team compels, in part, for the way it skirts those hazards and scoffs at those who want to make it accountable to certain kinds of binary framing. Take, for instance, the presumed risk of "instrumentalization," the accusation that socially oriented art subordinates its forms to the predetermined values and "outcomes" of a given context. Managing that risk in turn opens one to other kinds of accusations, the concern that "aestheticization" will only create spectacles, escape, or elitist panaceas that neutralize revolutionary thinking. But what happens, really, when a work boot is retrieved, dipped in tar, and lined up with its fellows? What happens, really, when the vinyl of the record and the glass of the lantern are placed in relation to a candy store

only are we making a good housing project but we are building and transforming a community... The buildings had old joists and were in bad shape. But we were able to capture those joists and then they were reclaimed to make shelving, countertops and baseboards, and some of the crawl spaces. So we were really mindful of what materials were available locally that could go back into the building; and even if they can't be structural members as they had been, how can we use the materials to make these apartments even more special than they were."

3 See Shannon Jackson, *Social Works: Performing Art, Supporting Publics* (Abingdon, Oxon: Routledge, 2011).

that has become a home? The acts, and so many others like them, are invitations to think about the aesthetics of the instrument, repurposing the heretofore purposeless and divesting the same forms (say, the fire hose) of its most horrific historical function. Indeed, the riveting effect of Dorchester Projects's rivet-making comes from a willingness, not only to challenge categorical boundaries, but to force an awareness of how differently positioned receivers conceive categories like form and function, product and process, artist and neighbor, instrumental and artistic in the first place. To those binaries, we might add others that are continually antagonized in the process of making a project like Dorchester:

Form/Content
Background/Foreground
Inside/Outside
Medium/Support
Autonomy/Heteronomy
Art/Apparatus
Text/Context
Form/Function
Figure/Ground
Medium/Support

I myself have meditated quite a bit on all of the above, especially that last pairing, recalling as it does the formal experiments of the twentieth century that exposed the art medium's dependence upon the frames, walls, spectators, and buildings that support it. If we recall those art histories of institutional critique, and the site-specific practices that questioned our ability to cordon off the ground and the surround, then we have at Dorchester an unexpected extension and lateralization of the omnipresence of aesthetic support. At Dorchester, the art object isn't separable from the pedestal that holds it, which itself is not separate

from the floor that supports it, or from the wood furnished to make the floor, or from the people who furnished the wood and built the structure upon which that floor was laid. The radical outside of the thing we understand to be inside is matched, in reverse, by the radical interiority of that which we all thought was most comfortable outside. This means bringing the exterior inside the artistic frame, where the fence is the art, and where the "found" wall can be framed or stacked or varnished, or re-formed with quotation marks into objects that can be sold to rich people. How much farther can we move aesthetically into the outside? How much of the outside can we allow in? And how does every one of Gates's answers trouble the assumptions behind such questions?

> I was drawn to the use of metaphor and specifically the use of the word 'niche.' In biological terms a niche is generated and sustained by the very things it supports. In the case of stem cell niches, the stem cells secrete growth factors and biopolymers that create scaffolds that serve as depots for these factors that can be accessed at specific times in response to environmental cues.
> —Katayoun Chamany[4]

Other binaries are undone and confounded in this work—for instance, those that would oppose the ameliorative effects of a socially engaged work from the conceptually "negative" edge of a socially antagonistic work. As those embedded in contemporary movements for art and social justice know too well, this oppositional frame dogs many current debates in the field of social practice art. In social practice discourse, the effects mobilized and produced are varied, but they are often framed in polarizing terms that propose a choice between the consensus-building, harmony-seeking emotions of some projects next to the disturbing, "antagonistic" emotions of others. To some scholars[5] socially engaged art only does the deep work of aesthetics when it maintains discomfort

4 See Katayoun Chamany, "The Meaning of Domain," pp. 254–55 in this volume.

5 Claire Bishop, "Antagonism and Relational Aesthetics," *October* 110 (Fall 2004), pp. 51–79.

and tension, a twenty-first-century version of aesthetic refusal that recalls Theodor Adorno's modernist critiques of "committed" art.[6] In fact, the phrase social practice and the concept of antagonism have another history that is worth remembering now, one associated with a particular Marxist and post-Marxist tangle of critical puzzles. Karl Marx's notoriously complex but notoriously generative introduction to the *Grundrisse* exposed what he called the "relationality" of persons, worlds, and things that appear to be given, natural, and autonomous.[7] Marx's stance on the commodity, on the laborer, and on all varieties of beings and objects was to expose their sociality, their spatiotemporal connection to other beings and objects on which their self-definition depended. The effort here was to show a thing to be a relation, a person to be a social practice. The trick of capitalism and of other constraining forces was that they prompted us to repress that relationality, repress the social practice that is a person, to sublimate the social practice that is a thing. That repression and sublimation, that alienation, worked its magic to create the sense of a world where individuals and objects were discrete, rather than embedded in an interdependent relation of capital, labor, or a variety of other hierarchies and social systems. Marx wrote, "The reciprocal and all-sided dependence of individuals who are indifferent to one another forms their social connection."[8] This kind of alienation needed to be combated by thinking and making that foregrounded our repressed, connective relationality, that showed the object's contingency in a social system, that revealed the interdependence of persons who thought of themselves as independent. This then is social practice in social theory. Social practice denoted a way of seeing and making that exposed the contingency and interdependence of our world.

Following Marx, Louis Althusser, Antonio Gramsci, Stuart Hall, and many others, Ernesto Laclau and Chantal Mouffe advanced post-Marxist thinking through the concept of antagonism.[9] Here,

6 Theodor Adorno, "Commitment," *The Essential Frankfurt School Reader*, ed. Andrew Arato and Eike Gebhardt (New York: Continuum, 1982), pp. 300–18.

7 Karl Marx, *Grundrisse* (London: Penguin Books, 1993), pp. 83–112.

8 Marx, *Grundrisse*, p. 156.

9 Elements of this argument were first articulated in my essay "Social Turns: In Theory and Across the Arts." See Shannon Jackson, "Social Turns: In Theory and Across the Arts," in Randy Martin, ed., *The Routledge Companion to Art and Politics* (New York: Routledge, 2015).

Marx's conception of social practice as contingent relationality
informed Laclau and Mouffe's resonant elaboration of "antagonism" as
a potent conceptual challenge to a naturalized world. Laclau and Mouffe
were careful to emphasize that antagonism is not about "opposition" or
any of the other simpler synonyms with which it is aligned:

> antagonism cannot be a *real* opposition. There is nothing antago-
> nistic in a crash between two vehicles: it is a material fact obeying
> positive physical laws. To apply the same principles to the social
> terrain would be tantamount to saying that what is antagonistic in
> class struggle is the physical act by which a policeman hits a worker
> militant, or the shouts of a group in Parliament which prevent a
> member of an opposing sector from speaking.... It is because a
> physical force *is* a physical force that a countervailing force leads it
> to rest; in contrast, it is because a peasant *cannot be* a peasant that an
> antagonism exists with the landowner expelling him.... Real oppo-
> sition is an objective relation... antagonism constitutes the limits of
> every objectivity.[10]

In Mouffe and Laclau's frame, then, antagonism is the dimension
and process that would question the givenness of a human being, the
givenness of a peasant or landowner, rather than the social relation that
constitutes both. To antagonize would be to expose the contingency of
this supposed objectivity, to engage with humans and things as social
practice, in social practice. Antagonism has a degree of compatibility
with a Conceptual art practice; it finds ways to question the conventions
that produce persons and objects as given and natural and discrete.
Most importantly, antagonism is not just about being edgy, ironic,
or uncomfortable, but about initiating thinking and making that expose
the constructedness of spaces whose identities and divisions are natu-
ralized and experienced as given and normal. Antagonism thus might

10 Ernesto Laclau and Chantal
Mouffe, *Hegemony and Socialist
Strategy: Towards a Radical
Democratic Politics* (London: Verso,
1990), pp. 122–25.

have a range of affects, sometimes those of doubt and distress, but also those that elicit compassion, sincerity, or earnestness. Antagonism exists in the denaturalizing social effect of a gesture or affect, not in the attributes of the affect itself.

This kind of reframing seems essential to understanding the affective world of Gates. It seems partly necessary to understand the personal postsecularism of his practice, one that knows that a degree of social privilege often undergirds the capacity to trash those who believe, one that suspects that the ratification of perpetual doubt actually has a class politics. It seems necessary to understand the radically equalizing power of Dorchester's domestic welcome, one that takes in and smiles equally at a table of persons and things that usually receive differential treatment. What Fred Moten has elsewhere called "radical hospitality" can feel quite insecure in both art-world and academic circles; it requires one to risk a degree of earnestness or trust.[11] But its oddity in spaces unused to the idiom might provoke its own antagonisms, even a compassionate antagonism that disrupts the habitual conventions by offering sincerity at a moment that one least suspects it. "There's an earnestness that almost comes from a naïve vantage point," says Gates's friend, curator Hamza Walker. "Some of the moves I would look at and say, 'I can't believe you would do that—or anybody' . . . there's something else on his mind that didn't get beat down."[12] Such commentary exemplifies once again the range of perspectives and sensibilities Gates's work invites and manages. The "naïve vantage point" is accepted in one circle, ordinary knowledge in another. One person's earnestness might be another's capitulation. One receiver's antagonism is another's do-gooderism. One person's form is another's function. Some aesthetic sensibilities might worry about the hyperearnestness or hyperpragmatism of Gates's practice, but to other urban planners, Gates's work seems utopian, hardly pragmatic at all. "It's important that the utopian choose a greater and more clever operating system,"

11 Fred Moten and Stefano Harvey, *The Undercommons: Fugitive Planning and Black Study* (Brooklyn, NY: Autonomedia, 2013) and the exhibition *Feast: An Exhibition of Radical Hospitality* at Smart Museum of Art, University of Chicago, in 2012.

12 John Colapinto, "The Real-Estate Artist," *New Yorker*, Jan. 20, 2014, http://www.newyorker.com/magazine/2014/01/20/the-real-estate-artist.

writes Gates in response to this conceptual challenge, one that does
not seek to disenchant utopian hopes so much as to allow enchantment
and disenchantment to coexist. "It is first vision and a hope so quiet
and precious that I could never tell that art world its importance."[13]
Without full disclosure to the art world or, for that matter, to the policy
world, these practices alter what it means to rehabilitate, refresh, or
rejuvenate a space by exposing the antagonism within every effort to do
so. I think about this next to Gates's own visual representation of what
he calls "Utopian Tension."[14] The zigzagging lines reverberate within a
tensely affective sphere, a movement that vacillates from side to side as
it presses forward, a simultaneous inhabiting of opposing spaces. The
zigzag exposes promises made and not kept; it occupies the unlikeliness
of actual redress at the same moment that it repairs a door and shares
a meal.

> Demystification is an indispensable tool in a democratic, plural-
> ist politics that seeks to hold officials accountable to the rule of
> law. . . . But there are limits to its political efficacy. . . . What is more,
> ethical political action on the part of humans seems to require not
> only vigilant critique of existing institutions but also positive even
> utopian alternatives. . . . Demystification tends to screen from view
> the vitality of matter and to reduce political agency to human agency.
> Those are the tendencies I resist. The capacity to detect the pres-
> ence of impersonal affect requires that one is caught up in it. One
> needs, at least for a while, to suspect suspicion and adapt a more
> open-ended comportment. If we think we already know what is out
> there, we will almost surely miss much of it.[15]

New Materialist scholar Jane Bennett's directive to "suspect suspicion"
resonates in Gates's domain, as does her admission that a vitalist stance
sometimes requires a "willingness to appear naïve or foolish."[16] To me,

13 Gates, *12 Ballads*, p. 42.

14 Gates, "Visual Thoughts," in *12 Ballads*, p. 30.

15 Jane Bennett, *Vibrant Matter: A Political Ecology of Things* (Durham,

N.C.: Duke University Press, 2010), pp. xiv–xv.

16 Bennett, p. xiii: "willingness to appear naïve or foolish, to affirm what Adorno called his 'clownish traits.'"

such affective complexity also helps to understand a key element of
Gates's practice that is oft-remarked and less often analyzed; that is, his
performative capacities as a speaker and as an interlocutor who knows
how to sing. When asked about his performances in museum galleries,
Gates eschewed any connection to the practice of performance art.[17]
Gospel, blues, and jazz performances—whether from local choirs or
from the Black Monks of Mississippi—foreground a wide history of the
performing arts, one sourced from Black Atlantic genealogies of creativ-
ity and oppression.[18] The intervention defamiliarizes the visual art space
both politically and formally; the radical interventions of performance
art suddenly look like easy accommodations of the museum's white
cube. Gates has created similar effects, not only with his ensembles, but
also as a soloist. Consider his performance of David Drake—or Dave
the Potter—an African American slave whose pots bear his signature
and who Gates embodies in song and laboring gesture. Consider too
Gates's capacities, not only as a singer, but as a trickster speaker whose
voice channels the tones and rhythms of the urban planner, the art
world snob, the testy neighbor, the radical activist, and more. "Gates is
possessed of a flexible speaking voice that . . . can embody half a dozen
characters," wrote John Colapinto in the *New Yorker* after following
Gates around on his many appearances.[19] In his public lectures and
impromptu conversations, Gates's flexible voice deftly embodies a range
of demographic positions. The polyphony offers a twenty-first-century
iteration of what Mikhail Bakhtin called *heteroglossia*, a representation of
a society's double-voicedness that will not achieve Hegelian resolution
but that lives in perpetual, dialogic tension.[20] It also makes potent use
of what J.L. Austin described as the performative power of the speech
act, soliciting a range of receivers who may hear themselves in his
phrases and tones, implicating receivers who have to manage their own
responses to his locutions.[21] At a time when "performance" is celebrated

17 Colapinto, "The Real-Estate
Artist."

18 Paul Gilroy, *The Black Atlantic:
Modernity and Double Consciousness*
(Cambridge, Mass.: Harvard University
Press, 1995); Fred Moten, *In the
Break: The Aesthetics of the Black*

Radical Tradition (Minneapolis:
University of Minnesota Press, 2003).

19 Colapinto, "The Real-Estate
Artist." Full quote: "Gates is
possessed of a flexible speaking voice
that, to suit his message and the
mood of his audience, can embody half

a dozen characters: a trash-talking
homeboy who grew up on the city's
tough West Side; a rarefied academic,
who refers to Derrida and Sontag;
an inspirational leader whose voice
swells in the Baptist-church cadences
he heard as a child; or an opaque
modern artist who speaks in koans."

and condemned for its capitulations to the pleasures and thrills of a so-called "experience economy," it seems important to emphasize the antagonistic power of such performances as well.[22] Many of us have been in the room when audiences ask Gates to sing, and he actively seems not to hear the request, as if he knows that what the room wants is not what the room needs. At other times, we have heard him suddenly begin to harmonize during someone else's lecture, turning the speaker's words into an unexpected melody. These and other heteroglossic performances zigzag across social spaces and perspectives, transforming the sound by giving voice to content and forms that are in fact already there. Sometimes, such performances puncture liberal pluralist harmony with inconvenient reminders of structural racism; other times, they transform the dry and sedate into unexpected opportunities for vitalist connection.

> Let's consider Theaster's entire practice a form of pottery. Like the basic form of clay, his project is essentially a vessel that contains as it omits, that absorbs as it pours. Whatever is inside is defined by what is outside, and the work's meaning and impact lie in the beautiful, exquisite and visionary sweet spot where the crossing happens between what is inside and what is outside, between interior and exterior systems, of exchanges across and through the porous, metaphorical, and literal skin.
> —Carin Kuoni[23]

Carin Kuoni's elaboration in this volume offers a link between vital materialism and the systemic interdependence of artistic form and its supporting apparatus. Indeed, Kuoni's sense of this "sweet spot" echoes the insights of thing theorist Bill Brown, who mined the links between Gates's practice and the fictive Yamaguchi's influence.

20 Mikhail Bakhtin, *The Dialogic Imagination* (Austin: University of Texas Press, 1981), pp. 324–27.

21 J.L. Austin, *How to Do Things with Words* (Oxford: Oxford University Press, 1976), pp. 1–11.

22 B. Joseph Pine II and James H. Gilmore, *The Experience Economy: Work is Theatre & Every Business a Stage* (Boston: Harvard Business School, 1999).

23 See Carin Kuoni, "Gates Gatherings," pp. 260–61 in this volume.

If you want to say that Theaster Gates has his hands all over every-
thing, you should recognize those hands as potter's hands.... Of
course Yamaguchi had to object to any idea of a start to the process
that does not originate in matter. At the origin, 'you gather the clay,'
he taught: With hands held as though poised for prayer, you gently
squeeze in and then press down, squeeze and press down, before the
thumb finally begins to hollow the 'void that holds.'[24]

In this metaphor of the "void that holds," we have an image that sus-
tains a range of necessary paradoxes. The prayerful press of the hands
defines the interior of the object that holds them. At the same time, the
press of the hand announces its dependence upon an outside, upon the
body of the laborer and the apparatus of the wheel; unlike other aes-
thetic objects, the craft object has rarely felt it necessary to disavow that
dependence, a position that goes in and out of favor. Indeed, as craft
historians such as Glenn Adamson and Valerie Cassel Oliver argue, the
presumably static craft object has been both enlivened and devalued by
its attachment to the laboring bodies who make and use it.[25] Whether
the "live demonstration" that typically accompanies the display of
craft or the utilitarian ethos that places the craft object "below" the
art object, craft's association with bodily enactment is now in favor,
reminding us of yet another performing art history that exceeds the
canon of performance art.

 In Gates's hands, the materiality of clay and pottery has a materi-
alist politics that remembers the vitality of craft *and* the inequities
of systems; such hands propel an integrated practice that is in perpetual
tension with itself.[26] When asked by Carolyn Christov-Bakargiev about
his focus on matter and materiality at a time when there is so much
focus on so-called immaterial information, he told the story of a
set of glass lantern slides that were no longer useful to the University
of Chicago.

24 Bill Brown, "Redemptive
Reification (Theaster Gates,
Gathering)," *My Labor Is My Protest*,
exh. cat. (London: White Cube, 2013),
pp. 36–37.

25 Valerie Cassel Oliver, "Craft
Out of Action," *Hand + Made: The
Performative Impulse in Art and
Craft* (Houston: Contemporary Art
Museum Houston, 2010), p. 5.

26 Glen Adamson, "Craft and the
Romance of the Studio," *American
Art* 21, no. 1 (Spring 2007), pp. 14–18.

> I realized that what I was interested in was not only found objects
> but also discarded knowledge—that there was a relationship. The
> knowledge was disposable because it was on archaic material. . . . I
> think that one of the great travesties of this world we will get to is
> that people will forget how to touch things, and they will forget how
> things look and feel in three dimensions.[27]

In that same interview, Gates made a connection between pottery and
urban renewal, between the materialist politics of the tactile object
and the materialist politics of an urban economy. "I think that studying
clay helped me understand that ugly things, muddy things, or things
that are unformed are just waiting for the right set of hands. So, in a
way, maybe clay became a metaphor that helped me understand the rest
of the world."[28] Taking the epistemology of the pot to "the rest of the
world" means seeing potential in "muddy" structures, in abandoned
buildings and streets, in places that get labeled "blight." But "the right
set of hands" needs to connect the dots among humans and things with
an aesthetic stance and a political stance that undo the damage done
by past programs of urban renewal. It seems for that reason that Gates is
interested in the material vitality of social systems, the affective power
of alternative policy. "Restoring the buildings is important, but that is
the beginning of the work. Some larger transaction needs to continue to
occur between the structures that have been reactivated and the ether.
I want karmic consequence and ineffable results, not just sound, but
things that start with 'trans-.'"[29]
 It is here, of course, that trickster politics get even trickier.
Indeed, the aesthetic of the "large transaction" is now a key element
of the practice attached to the signature of Theaster Gates, Jr. In this
volume, Julia Foulkes gives the name "Theastering" to this merger of
signature and system; he "combines the emphasis on community-
based arts that emerged in the 1970s with the promotion of 'creative

27 Gates interviewed by Carolyn
Christov-Bakargiev, 12 Ballads, p. 14.

28 Ibid., p. 13.

29 Ibid., p. 48.

economies' in city centers starting in the 1990s. He moves the creative
sector to the peripheral neighborhood." Indeed, taking a cue from a field
that used to call itself "non-profit management" and now calls itself
"social entrepreneurship," Theastering means combining the energies
and resources of heretofore distinct non-profit, for-profit, and public
sectors. As the prices for Gates's art objects rose, it meant using the
profits to fund the purchase of neighborhood buildings before they were
torn down, and now that those prices have risen all the more, it means
overtly scaling up object production for a hungry art market in order to
generate revenue for Gates's non-profit, the Rebuild Foundation. Gates
keeps no secret about his DIY model of redistribution. "I wanted people
in my neighborhood to benefit from all of this cultural, physical activity
that was happening around my art practice. If I was intentional about
that, a new revenue stream would be a by-product of an art happen-
ing."[30] And elsewhere, he is even clearer about the highly inequitable
system with which he works; in speaking of his connections to wealthy
art collectors, he admits to deciding "to leverage the fuck out of them
as they were leveraging me."[31] For some, a Robin Hood practice can't
do anything but corrupt the person at the center of it. For others, it is
a strategic redirection from within, channeling pleasure, material, and
money to "work the system," in Brown's words, "to pervert it." Fred
Moten too addresses Gates's enmeshment in "the kinds of ominous
public/private partnerships—the corporate entanglements and mer-
cantile impurities—that stripe and striate modernity and its erstwhile
subjects/citizens." And at the same time, Moten spies, or asks if others
can spy, something else: "Or is Gates's work productive of precisely
that rich insistent, anti-racist, common, communist meditation on 'the
interpretive significance of slaves having themselves once been com-
modities'?"[32] In the answer to this dangling generative question, Gates,
Dorchester, and all of the persons and things that surround it offer the
possibility of joining an economic materialism, to use one language, to a

30 Ibid., p. 16.

31 Colapinto, "The Real-Estate
Artist."

32 Moten, *My Labor Is My Protest*,
exh. cat. (London: White Cube, 2013),
p. 5. Moten is quoting Paul Gilroy.

vital materialism, to use one another. The accusation of market impurity
must confront the face of someone whose ancestors and neighbors have
already been placed violently inside it. When Gates frames "money"
as a kind of material, or speaks of deploying his "clay" and his "cash," he
occupies the zigzagging space between appropriating and being appro-
priated, leveraging and being leveraged. Far more radically, his practice
suggests that the confident ability to differentiate those polarities
comes with racial privilege; so too, the impulse to declare mercantile
impurity is more breezily exercised by those who are not descendants
of slaves.

 "Urban planning taught me to make big projects," said Gates of
the scale and infrastructural imagination required now to mobilize all
forms of cultural, economic, human, and social capital. And to all of
us would-be artists and organizers who worry about scale, about being
leveraged, and about who is being appropriated by whom, he cites the
Bible for wisdom. Channeling all at once the values and know-how of
the Shepherd and the Charlatan, the Homebuilder and the Hustler,
he declares:

 "Be Not Afraid."[33]

33 Gates, "Visual Thoughts," 12
Ballads, p. 29.

Collecting Publics: The Spatial Politics of *Dorchester Projects*

Mabel O. Wilson

Houses are unsettling hybrid structures. A house is, in all its figur-
ings, always *thing*, *domain*, and *meaning*—*home*, *dwelling*, and *property*;
shelter, *lodging*, and *equity*; *roof*, *protection*, and *aspiration*—*oikos*, that is,
house, household, and home. A house is a juridical-economic-moral
entity that, as *property*, has material (as asset), political (as dominium),
and symbolic (as shelter) value.[1]
—Paula Chakravartty and Denise Ferreira da Silva

The crowded CTA bus dropped me along with several other bundled-up
passengers off at the stop on Stony Island Avenue and East 70th Street
in the South Side of Chicago. On this frigid February morning I was on
my way to the group of houses that comprises artist Theaster Gates's
Dorchester Projects. I caught my bearings and walked westward. Since the
sidewalks were still treacherously frozen over from the accumulation
of several snowfalls, the middle of street seemed the ideal choice. The
area west of Stony Island Avenue occupies a borderland between the
Southshore neighborhood to the east and the nearby Greater Grand
Crossing's Oakwood Cemetery to the west. Its urban fabric of houses
and corner stores backs up against the train tracks that supplied the
famous Chicago stockyards with their cargo of cattle from the western
ranges and sent train cars of meat heading to eastern markets. Once a
formerly European immigrant working class neighborhood that made
its wages of whiteness in the stockyards, this pocket of the city has
stayed primarily working class and has since the mid-twentieth century
become almost all African American—with many arriving from the
South during and after the Great Migration.

As I ambled down East 70th Street, the staccato sounds of ham-
mers and power drills punctuated the frozen air. The noise emanated
from a boarded up block-and-a-half-long public housing project—the
former Dante Harper Townhouse projects—built in the 1970s by the
Chicago Housing Authority. Construction crews scurried around the

1 Paula Chakravartty and Denise
Ferreira da Silva, "Accumulation,
Dispossession, and Debt: The Racial
Logic of Global Capitalism—An
Introduction," *American Quarterly*,
Vol. 64, no. 3 (September 2012), p. 361.

jobsite working on the units that were in various stages of construction, with some building interiors completely gutted. The workers were rehabilitating thirty-six low-rise brick units, a project undertaken by a consortium of organizations including Gates's Rebuild Foundation, a non-profit offshoot of Gates's multiplex practice. Once completed, the Dorchester Art + Housing Collaborative will provide mixed-income housing and a community arts center for the neighborhood.

As I turned up South Dorchester Street, brick appeared to be the common denominator of the local buildings, which came in all sizes, from single-family houses and three-story multi-unit apartments to small industrial buildings and storefronts. The houses sat in their lots nestled side by side or were separated by empty lots deep with snow, where neighboring houses must have once sat. Rental signs tagged a house whose windows were carefully boarded up with plywood. It was a home absent of residents but not yet abandoned and not yet torn down. From the character of the neighborhood one had the feeling that along with the intermittent vacant lots empty houses were common. I was after all in the middle of the epicenter of the U.S. foreclosure crisis—an economic downturn that has devastated populations and homes in black and Hispanic neighborhoods across the country.

Mid-block along South Dorchester Street, Gates houses the core of the *Dorchester Projects* in two neighboring buildings—one a brick storefront that began as his studio and the other in a wood frame house next door, Archive House, which he acquired for the purpose of housing various collections. Beginning in 2006 and strategically using repurposed material, Gates first made the renovations to his studio himself; he then shared his knowledge of construction with locals as he acquired more space. Gates has now transformed his former studio, which had once been a neighborhood candy store, into the Listening House. That space hosts a collection of 8,000 records from Dr. Wax Records, a now shuttered record shop in nearby Hyde Park. In the rear of the structure,

he has constructed a temporary home for archival material from
Johnson Publishing—a black-owned company that publishes the popu-
lar magazines *Jet* and *Ebony* and who recently sold its signature Michigan
Avenue headquarters buildings, designed by black architect John
Moutoussamy. This archive will eventually be moved to its permanent
home in a large former bank building under renovation by the Rebuild
Foundation, henceforth to be named The Stony Island Arts Bank a few
blocks north. Next door at the Archive House, the rooms that were once
home to the routines of everyday life now contain the material archives
of two Chicago institutions—a glass lantern slide library from the
art history department at the University of Chicago occupies the area
where the kitchen once was and books from Prairie Avenue Bookstore,
a store that specialized in architecture and art books, line walls in the
second floor where the bedrooms once were. Across the street a third
house has been added to the *Dorchester Projects* constellation—the Black
Cinema House—where screenings of films are shown on a regular basis.
Through an ever-growing agenda of events, Gates has cultivated rela-
tionships with his neighbors and fellow Chicagoans. Wall by wall, room
by room, house by house, they have built the *Dorchester Projects* while also
constructing community.

Understanding *Dorchester Projects* in the context of the Greater
Grand Crossing neighborhood and larger metropolitan area of Chicago
raises several questions about how a critical practice—a hybrid one
that combines art, architecture, and planning—can operate within and
against processes of urbanization. How does Gates and his collabora-
tors, for example, redirect the economic, political, and social forces
shaping the contemporary American city—particularly the growing
income inequality that supplements the decades' long process of eco-
nomic and political disenfranchisement of the poor and working class?
In what ways does Gates's process of conversion—a collective and col-
laborative endeavor—inform a practice of what I want to call the *creative*

reclamation of urban space from the political forces of renewal and the market forces of gentrification, to remake the house as a domicile for social life and the neighborhood as a public sphere? Another question worth considering is how *Dorchester Projects* reworks the devastating racialized public policies that created the mid-century public housing problem and redresses the racially motivated predatory practices that fostered the recent foreclosure crisis? As a critical practice how does *Dorchester Projects* not only house collections but also collect publics?

The Project of Housing

For African Americans, the house was always a site of transition—it was "never quite ours." During slavery the house—the master's property—served as a place for the enslaved body—it too the master's property—to rest and revive before returning to the labors that increased the master's wealth. Even though upon emancipation from enslavement laws constituted equality between black and white citizens, under Jim Crow segregation white Americans used spatial policing and violence to control where African Americans could work and live, ideally on the wrong side of the tracks, on polluted and undesirable land such as the "bottoms," and preferably far away from white families and public amenities. Many white Americans benefited from preventing black Americans access to wage labor, property ownership, and full suffrage. For unscrupulous landlords these prohibitions and limitations became a mechanism for profit, particularly in Chicago's historic Black Belt, where exorbitant rents were exacted from black residents who could not move elsewhere in the city. With Chicago a magnet for black Americans fleeing the scourge of blighted land and the unrelenting violence of Southern whites beginning around 1910, many newly arrived migrants had very few choices of where to live because restrictive covenants prevented home ownership in many areas and racist landlords refused

to rent in neighborhoods other than the South Side. Crowding in substandard housing became an urban crisis. By the 1950s the German, Irish, English, Swedish, and other European immigrants who had made Greater Grand Crossing their home quickly fled to other parts of city when black families started moving into the area due to overcrowding in the wards to the north.

One solution to the acute housing crisis was the construction of publicly financed multi-family units. Beginning with National Housing Act in 1934 and the Wagner-Steagall Act of 1937, the federal government gave monies to agencies such as the newly formed Chicago Housing Authority (CHA) to erect housing for low-income residents to alleviate overcrowding and slum conditions. White families, many of them immigrants, were the first to benefit from the new construction initiative. Eventually black residents living in untenable conditions demanded as a civil right access to publicly financed housing. Given the contentious racial climate, riots ensued in CHA projects like the Airport Homes (1946) when black families tried to move into new housing. This backlash prompted the agency to continue to segregate its properties. The question of where to house black residents as long as white neighborhoods resorted to violence to keep them out forced the CHA to innovate new types of housing.

Public housing in the U.S. are called "the projects" perhaps because it was a social and civic experiment in housing the poor. Moreover, as a "project," public housing was by nature a speculative endeavor, a plan for how people might live; whether or not it was how they wanted to or should live was rarely the question. The CHA hatched a plan to develop high-rise housing for poor black residents. The monolithic modernist blocks of the South Side's Robert Taylor Homes (1960) that housed close to 22,000 residents and the patchwork of the Near North Side's Cabrini Extensions (1957) and Green Homes (1962), resident to 15,000 tenants, were two of the outcomes of this grand

scheme. It was an experiment in high-rise, high-density that ended in
failure with both projects demolished in 2007 and 2011 respectively.
One of the underlying failures of these housing projects was that the
CHA had deliberately concentrated the high-rises in ghettos and away
from more prosperous white neighborhoods (who mobilized political
leverage to prevent housing construction), which meant that employ-
ment opportunities, quality education, and other public services were
unavailable.[2] The racially motivated decision to segregate black resi-
dents led to a Supreme Court adjudicated lawsuit filed by a coalition
of residents against the CHA and the U.S. Department of Housing
and Urban Development. The plaintiffs won and the CHA initiated a
new program to scatter public housing projects on sites throughout
the city—the Dante Harper Townhomes was one such outcome. And
yet Dante Harper Townhomes was also a dismal failure, with the
CHA shuttering the units in 2005. It failed in large part because even
after the lawsuit and new efforts like scatter-site housing, the agency
continued to place its developments in poorer, racially segregated
neighborhoods. White Chicagoans remained vigilant in using political
pressure to keep scatter-site projects out of their backyards.[3] The phys-
ical slums had been cleared, but in these new publicly funded housing
projects the socio-economic slum remained.

 At the same time the federal government provided monies
for public housing projects, the National Housing Act of 1934 also
established the Federal Housing Administration to make home mort-
gages available. In the postwar period, the availability of mortgages
fed the expansion of the middle class, the single-family house, and the
suburbs. In Chicago, as in other major metropolitan areas and regions
around the U.S., black Americans were routinely discriminated against
when applying for home loans. If they did have the money to purchase
a home, deeds in suburban subdivisions often contained restrictive
covenants that prevented the sale of the property to black or Jewish

2 D. Bradford Hunt, *Blueprint for
Disaster: The Unraveling of Chicago
Public Housing* (Chicago: University
of Chicago Press, 2009), p. 240. Also
see Lawrence Vale, *Purging the
Poorest: Public Housing and the
Design Politics of Twice-Cleared*

Communities (Chicago: University of
Chicago Press, 2013).

3 The CHA failed to initiate
a program of "responsive
maintenance, secure surroundings,
and improved schools." Black

Chicagoans living in public housing
"wanted housing freedoms but also
job opportunities, neighborhood
reinvestment, and equal treatment
under the law," Hunt, *Blueprint for
Disaster*, p. 257.

applicants.[4] By deploying underhanded redlining practices, banks also colluded to keep black families out of white neighborhoods like Greater Grand Crossing. One access to wealth—homeownership—was therefore unavailable to black Americans. The migration of industry from inner cities to suburbs also meant that with the inability to live in these areas black residents were also denied easy access to new and better employment opportunities.

Eventually, public and private sector efforts would be launched to increase homeownership, particularly within the untapped black homeowner market. In 2002 the Bush Administration promoted its new program "A Home of Your Own" to increase homeownership especially among minority groups (its folksy title embodied all of its latent neoliberal ethos). Simplifying the home-buying process, however, opened the floodgates for widespread abuse and deception in the mortgage and banking industry. Pushing "subprime" loans on eager buyers with the assumption that they were at risk of not being able to pay it back because of an absence of wealth or unstable employment occurred again and again. Not only was profit gleaned from high-risk loans, but these loans were also packaged and sold to other investors in an effort to distribute the risk. Financial institutions made billions through this process. Banks and investors also profited when the loans failed by selling complex "products" called credit default swaps. Profit was exacted at each stage through every transaction from purchase to foreclosure. The abuse of black homeowners followed a long history of racial exploitation. Scholars Denise Ferreira da Silva and Paula Chakravartty astutely observe: "the subprime crisis facilitated this exacting of profits from *places* and *persons* produced as unsuitable economic subjects."[5] Banks and mortgage companies seized hold of low-cost assets, in this instance black wealth and the territory of the house, to turn them into profitable use. This is what David Harvey has termed "accumulation by dispossession."[6] The proliferation of foreclosed properties in black

4 For an excellent history of blacks and U.S. suburbs see Andrew Wiese, *Places of Their Own: African American Suburbanization in the Twentieth Century* (Chicago: University of Chicago Press, 2005).

5 Chakravartty and da Silva, "Accumulation, Dispossession, and Debt," p. 365.

6 David Harvey, *The New Imperialism* (Oxford: Oxford University Press, 2014), p. 149; also see Chakravartty and da Silva, "Accumulation, Dispossession, and Debt," pp. 365–67.

neighborhoods like Greater Grand Crossing illustrates how, just like the unethical landlords during the Great Migration, unethical bankers and brokers profited from the black Chicagoan's basic need to find a home.

Dorchester Projects

The iconic image of *Dorchester Projects* takes the form of a house. Its transformation reminds us that a house is more than an abstract space, a property that can be exchanged for capital. The house is a thing, but it is also a locus of time and space where dwelling happens. The traces of domestic activities that mark the floors, walls, cupboards, and door-sills serve as a palimpsest of those who once lived there. For Gates the creative reclamation of a storefront as his studio wrested it away from the market—no longer a commodity from which to extract value, a phenomenon made popular by the recent practice of "buying and flip-ping" houses for profit. The repurposed materials utilized to rebuild the spaces also tell stories of other places; as Michel de Certeau reminds us "a space is a practiced place," it is a condensation of actions and hab-its.[7] The storefront became a place where Gates lived, but also a place to make art and to engage in a critical practice that instigates urban transformation. His deployment of creative reclamation has arrested the relentless forces of accumulation by dispossession that created a neighborhood of foreclosed properties and failed public housing.

Once Gates decided he would live elsewhere, he determined that books, records, and other collections along with artworks and com-munity projects would occupy the storefront née Listening House and Archive House he acquired next door. Those who take care of the col-lections, use them, and join events like the film screenings at the Black Cinema House, visit installations, or attend meetings have become the new home dwellers. Dorchester Projects invites others to take up resi-dency—for a year, a month, a day or an hour. By reclaiming the Dante

7 Michel de Certeau, *The Practice of Everyday Life* (Berkeley: University of California Press, 1984), p. 117.

Harper Townhouses, the CHA's failed project of collective dwelling, *Dorchester Projects* has expanded its scope beyond South Dorchester Street. Whether the ambitious project of mixed income housing, which will place art and artists as creative agents to rebuild the neighborhood, will transgress the deeply entrenched racialized and classed boundaries that have divided Chicago for more than a century will be one major challenge. But by locating an arts center in the middle the Dorchester Artist Housing Collaborative, creative alliances between locals and outsiders will become the catalyst for the transformation of the physical and social spaces to create a new form of housing project, one that critically recuperates the work-in-progress spirit that the term "project" implies. Joined by the future Stony Island Arts Bank, the *Dorchester Projects* network cultivates and connects new spaces of social and public life—collective dwelling, a constellation of institutions of art, culture, and housing sharing origins and missions—for the neighborhood and the city.

Like Chicago, like the Greater Grand Crossing neighborhood where it is located, the rhizomatic *Dorchester Projects* is always in transition. In that regard it is a project, a draft, a scheme, a notion, a proposal. It is an enterprise that casts the idea of creative reclamation toward the future. In that sense, like the city, it will never be finished but always en route to becoming something else.

Gauging the Racial Times in the Work of Theaster Gates

Romi N. Crawford

The definition of race is increasingly elusive. Sociologists Michael Omi
and Howard Winant describe it in *Racial Formation in the United States:
From the 1960s to the 1990s* as "a concept which signifies and symbolizes
social conflicts and interests by referring to different types of human
bodies."[1] For the purposes of these reflections, this description is useful
because it puts into focus the social troubles and uneven advantages
that precede and also enliven notions of "race." Even with the scientific
proof that the biological concept of race is spurious and unfounded,
the social discord and power differentials that it signifies are profound
enough to ensure the longevity of the concept. Nonetheless, it is import-
ant to consider how race is signified during certain historical moments,
such as the present one, when it simultaneously gains and loses its
momentum as a meaningful category. Writers and scholars regularly
propose new and inventive ways to address race that fortify its very real
and material bearing on certain people's lives, especially the lives of
blacks in the United States, without asserting it as a fully determining
and all-consuming factor in the ways people identify themselves or val-
idate their work. An example includes Ralph Ellison's "black is . . . black
ain't" refrain in *Invisible Man*, which incites a method of sorts for avowing
and disavowing race.[2] Similarly, literary scholar Henry Louis Gates, Jr.,
helped to solidify the brackets around "race" and has been instrumental
to the deconstructing the idea in his scholarship as well as his foray into
television and journalism with the PBS series *Finding Your Roots*.[3]

Artists, too, help breathe life into new ways of expressing the
weight of race, which in the U.S. is currently marked by two extremes:
seemingly limitless social polarities, police misconduct towards black
men, wealth concentrated among whites, the mass incarceration of
black and brown bodies; and the empowering notions of trans-raciality,
post-blackness, and the first black American president.

The work of Theaster Gates registers this tide of racial formation.[4]
This is not to suggest that he is an artist who is only committed to a

1 Michael Omi and Howard Winant,
*Racial Formation in the United
States: From the 1960s to the 1990s*
(New York: Routledge, 1994), p. 55.

2 Ralph Ellison, *Invisible
Man* (1952; New York: Vintage
International, 1995), p. 9.

3 See Henry Louis Gates, Jr. and
Anthony Appiah, *"Race," Writing, and
Difference* (Chicago: University of
Chicago Press, 1986).

4 See Omi and Winant, p. 55.
"Racial formation" is defined as
the "sociohistorical process by
which racial categories are created,
inhabited, transformed, and
destroyed."

race-centered aesthetic, or a black aesthetic, as represented by Harlem Renaissance or Black Arts Movement artists.[5] The notion of race is not the predominant consideration in Gates's work. He frequently attests to this and reminds curators, interviewers, and art historians that race matters, but there are also other things that matter.[6] This approach reflects an ethos that aligns with the current sociohistorical context in the U.S., where race is variously centralized and sidelined, sometimes "*freaked*" (as Gates might say) and sometimes *not freaked.*

Gates's practice is so commanding that it has spawned a genre of its own kind, an art that revitalizes urban spaces and brings new life to abandoned materials, objects, and archives, often through the act of transitioning them from one region or context to another.[7] *Dorchester Projects*, Black Cinema House, and Black Artists Retreat are notable among these efforts, offering places for making art and film, music, poetry, and for film screenings in general, or for the convening of black artists and cultural workers in particular. Yet here I argue that in the rush to discuss his projects within the context of socially engaged art practices, we must not neglect how his work influences formations of race. In fact, I propose to stray from the usual discussion of Gates's projects as evidence of commitment to community engagement in order to assess the degree of their innovation in terms of the contributions they make to concepts of race.

Racial intentionality often peeks out of Gates's work, but to the extent that race becomes visible it tends to also signal its demise and the end of its usefulness. *Dorchester Projects*, Black Cinema House, and Black Artists Retreat are three iterations of Gates's practice that reveal this tendency to assert blackness and also deflate it. Even as the word "black" is often part of the moniker, none of these efforts are prescriptively or restrictively black, neither at the level of programming and curatorial intention, nor at the level of audience, staffing, or participation. The "black" that appears in the titles of Black Cinema House, Black Music

5 During both the Harlem Renaissance and Black Arts Movement there was a serious effort given to portraying black people and black experience. Alain Locke describes how "careful" and "seriously" the Negro is being portrayed during this time. Locke, *The New Negro* (1925; New York: Touchstone, 1997), p. 9.

6 See Theaster Gates's conversation with Carin Kuoni, "Some Kind of Work Simply Needs to Happen," p. 198 in this volume.

7 Both his Documenta 13 (Huguenot House) and 2015 Venice Biennale (*Gone Are the Days of Shelter and Martyr*) projects hinged upon re-animating Chicago materials in Kassel, Germany, and Venice, Italy, respectively.

House, and Black Artists Retreat, all of which were at some point in time
attached to *Dorchester Projects*, located at 68th Street and South Dorchester
Avenue in Chicago, flaunts the (radical) intention to include people
of African descent more than it seeks to exclude others. Gates quietly
eschews the long history of "whites only" signage in the U.S. by making
places that resolutely speak of their availability and openness to black
people. This is a salacious and provocative proposition for black people
living in the current moment, who regularly contend with the unfinished
business of integration and who are what legal scholar Sheryll Cashin
describes as "integration-weary" and craving places for "we-ness."[8] At the
same time, Black Cinema House and Black Artists Retreat are burdened
by the very hyperracialized spatial zones going back to the Jim Crow era
that they critique. Even as they intone a (black) racial parameter, they do
not do so in stable and constant ways: Gates regularly alters the spatial
terms and temporal limits of these undertakings. Black Cinema House
has moved from the original site at *Dorchester Projects* to a less domestic
setting, the Kimbark Studio; and the scale, scope, and longevity of Black
Artists Retreat is constantly in question. Gates reassesses and re-posits
his framing of these entities, barring them from being fully consummated
and smug in the potential to construct a raced place.

 Ultimately the racial significance of these projects has little to
do with how they exist in Chicago's black neighborhoods, that they are
rendered by a black artist, that they are frequented by mostly black
audiences, or that they mostly house the art and works of black peo-
ple. Much more important in my view is how Gates innovates a critical
double speak that puts race into play but doesn't allow it to overshadow
other factors. In this volume's interview with Carin Kuoni, he states:

 What I found is that in America there's a set of things that just are.
 I want to speak to some of those because my entire project isn't only
 about blackness, but some things just are about blackness.[9]

8 Sheryll Cashin, *The Failures of* 9 Gates, "Some Kind of Work Simply
Integration: How Race and Class Are Needs to Happen," p. 205.
Undermining the American Dream
(New York: Public Affairs, 2005), pp.
xiii–xx.

Gates periodically diminishes the significance of the matter of blackness in his practice. By occasionally speaking up against race's existence and by diversifying projects and work so that race is not the only thematic concern, the artist casts light on how race evolves and transforms within a given sociohistorical context. Rather than encapsulating, or rendering a portrayal of, blackness his projects reveal the state of ideological flux that envelops them. In lieu of a straightforward definition, Gates offers an expanded interpretation of it, one that invariably both encourages and thwarts its over-articulation and predominance in the work.

In addition to his place-making practice, which has become more multifaceted each year, the artist's paintings, ceramics, and installation works such as *Gone Are the Days of Shelter and Martyr*, shown at the 2015 Venice Biennale, are increasingly poignant and compelling. They also reflect the topos of racial formation in these times. Often intriguing layers of storytelling abut these works by Gates. The predominant theme in these narratives is family. At his induction into the Union League Club of Chicago in 2014 Gates addressed the topic of his varied making by explaining that his father was a roofer, also owned an arcade and gas station, and did several other things as well, implying that he inherited his manner of working in multiple forms from him. He also narrates his father into the story of the *Tar Paintings* series from 2014, crediting his father for assistance—the tar kettle that he used to make them, as well as the inspiration. Gates often addresses race and blackness through the trope of "kin" and "family." He describes Black Artists Retreat, a convening of black artists that has taken place for the past three years, where he is able to "amplify the code"—that is, put an amplified focus on race—in terms of family reunion.[10] It is a less direct but clear and obvious way of getting to matters of race and ethnicity. Bringing his father or mother into the narrative space that surrounds the artwork is a way of invoking the racial (and cultural) values and influences that he inherits from them. Some of these values and influences

10 Ibid.

are what Gates calls "things that just are," part of the American cultural landscape, and some pertain explicitly to race.[11] In effect, narratives about his family are indexical. They refer back to his ancestral, cultural, and racial experience. By asserting these narratives Gates constructs an explanatory apparatus—the story about a family member—that addresses race while he deflects it.

Gates's innovativeness goes beyond forms of social engagement, urban intervention, and visual art. He also lends to the store of explanatory structures and apparatuses that simultaneously support the devaluing and the relishing of blackness and are indicative of the current racial times in the United States.

11 Ibid.

Neither "Black Church" nor "White Cube"

Horace D. Ballard, Jr.

Semiotics (noun): 1) the study of how humans make meaning; 2) a study closely related to linguistics and the way meaning is encoded in acts of rhetoric and sound. Some semioticians—like myself—study non-verbal communication, such as signs, images, gesture, and symbols. Pragmatics is a subfield of semiotics that explores the broader context in which an image, utterance, or gesture is made.

E.g., *Pragmatics* is the vein of *semiotics* I teach. It is my belief that a conversation or a work of art (much like a sermon, a saxophone solo, or the line of haute couture at a runway show) can have multiple meanings, and these meanings can only be understood by situating the object or event in relation to a larger context of *signs*. Everything from popular culture to technological innovation to world events can be used to inform the meaning of things.

As a scholar of eighteenth- and nineteenth-century art and aesthetics; as a graduate student writing a dissertation in the history of photography; as an American of African descent; as a freelance curator; as a former Episcopalian priest; as an artist whose medium is dance; as a queer man; *et cetera* . . . I come to works of art with multiple lenses through which I actively construct interpretations.

I was introduced to the name and the work of Theaster Gates as one is introduced to G-d. Someone would give a synopsis of his latest project, and those listening would bow their heads; another would rise from her seat with glistening eyes and give testimony of a chance encounter that changed *everything*; and sometimes, in the spaces where nothing was said, the collective would place a palm over the heart and let fall a sigh accompanied by a smile. It was as if the moments Gates facilitated served as both a lens onto the zeitgeist of the cultural political moment and provided a parable from which we could deduce the *Gestalt* of possibility.

So how do I engage the work and the ideas of Theaster Gates, an artist whose very presence at the pinnacle of contemporary art evinces

frisson around what it means to name and to categorize in our contemporary moment? How did the name of one man become a conjure-word, a symbol by which all that is possible in contemporary art praxis gets transliterated from text to image to voice and back again?

Theaster Gates, by what shall I call your works? African American art? Afro-American art? African-American art? (African) American art?

Socially engaged art? Large-scale assemblage? Neo-Process art? Installation art? Performance art? Political art? Neo-Constructivism? Postmodern art? Post-postmodern art? PoMo/HoMo art? Conceptual art? Architect? Starchitect? Post-Katrina art? Afro-Pessimist art? Identity politics? Community organizing? Relational aesthetics? History/Genre painting of postmodern life? Visionary art? Art of the Americas? Diasporic art?

All of the above? None of the above? Some of the above? "O, be some other name!" Why does it matter if he is an African American artist? Would the world think differently of his work if he identified as Filipino? Chicano? White?

David Driskell once gave me a definition of African American art as we sat around the dinner table: "Think of it as an ongoing, unfinished conversation," he reasoned, "one carried across the ages and continents, one dropped for intervals then picked up again and again through 1) performance; 2) an artist's self-identification with (or struggle against) a social construct such as 'race' or 'ethnicity'; 3) the visible color of skin; or 4) the patterns of these aforementioned concepts throughout history." If I may be so bold as to add to Dr. Driskell's sage words, I must add the question of theodicy. In a 1710 aesthetic treatise, Gottfried Leibniz framed *Theodicy* thus: "If I believe in an omniscient, loving, good, perfect, and loving G-d, why does evil and violence continue to exist in my world?" Without theodicy, the risk of essentializing blackness as an existential crisis at the vertex of a phenotypical complexion and an experience of lifetime prejudice becomes natural and accepted.

We must not, cannot make this leap. On the other hand, the existence of and intellectual rigor of African American art has never been stronger. So when Theaster Gates breaks through the ranks and ascends to the level of a household name—with invitations to biennials and career retrospectives—it is time to reflect and to praise, to give context and contemplate new frontiers.

Mother Teresa was fond of saying that as humans we cannot do great things, but "only small things out of great love." Reflecting on the various ways people encounter each other and themselves in urban centers of the world, Elaine Scarry suggests that "if we allow it to happen," if "we are open to its strange lilting tune," the encounter with Beauty "prepares us for justice."[1] I have to disagree. It is not justice that makes the gypsy Esmeralda trust Quasimodo. It is mercy. Beauty leads us to mercy. Mercy is the primary aesthetic tenet of Gates's work and one that is wholly political. It teaches us daring and the categorical imperative of intuition and radical giving. It transposes loss into something more than hardship, into something that should be acknowledged and made space for, so that maturity becomes equal parts attainment and equal parts letting go.

Mercy takes the experience of loss, adds an adhesive primer that is considerate of worldviews other than one's own, and goes out into the world, washing the feet of the ruins with grace. Mercy realizes that Jesus's retort that the poor would always be with us is not an act of resignation, but an artfully concealed anger, shrouded in the daily task of ministering to the poor with goals and hard work rather than promises or dreams.

What Gates realizes is that those who have lost do not wish to forget, but require a space to sit and remember and strategize the next course of action. This is what Listening House provides: a break, a cut, a respite in the normative day-to-day where music (the food of the spirit ... the food of love) and soul food (those calories consumed at meal time that provided energy, and sometimes, a much-needed excuse

1 Elaine Scarry, *On Beauty and Being Just* (Princeton: Princeton University Press, 1999), p. 78.

for rest, and even now an outlet for those who wish to say I love you
but know that love is high, so very high on Maslow's hierarchy of needs
to those who do not own the land on which they farm) become a sanc-
tuary. The 8,000 albums salvaged from the old Dr. Wax music shop
are the doorways to dreams and prayers for the opportunities of new
generations. The dark wood of the heavy minister's seat with its velvet
panel to rest the weary back becomes enough of a cathedral, enough of
an alter-native, alter-narrative space, that race, gender, sexuality, and
social class become identities whose interweaving grant us proximity to
the throne room of the Divine, rather than remove us, wholesale, from
the Palace of Art.

I am intrigued by the return of materiality and form in the work
of contemporary visual and literary artists. Attention to the surface of
the object has re-surfaced at the same time that the three-piece suit has
returned to men's fashion or the sonnet and villanelle have returned as
categories we might give to the layout of the poem on the page. This
"new" formalism intrigues me as it reminds me that in times of great
cultural upheaval, humans often return to the past for sanctuary; the
past becomes purposeful again as we begin to consider small things.

Black bodies in the Americas have long been viewed as loud and
too much. The corporeal weight of being central to cultural produc-
tion as subject and arbiter, yet peripheral to the economic modes that
would allow one to attain these artifacts critically, is not new. Yet at a
temporal and critical juncture when materiality and form are becoming
once again the hallmark of aesthetic production, one must look closely
at repurposed forms. Gates uses found woods, mostly old pine logs,
cypress, American oak, and elm pressboard—whose heartwood nodes
and knots are apparent even in pictures, whose age leaves physical trace
on the surface of the wood itself—woods that show up time and time
again in the history of black folklore and oral tradition. Woods that when
treated with oils and moisturizing agents imitate the range of colors

and plasticity noted in black skin. These are trees slaves built their first
cabins from, the trees Native American communities recognized as
guardians and fought to protect…the trees whose upturned leaves and
moss-covered sides were said to point the way to freedom.

As Gates is fond of saying, his work is in facilitating the encounter
of individuals with materials and individuals with individuals—in the
museum space; the street corner where two roads that divide two neigh-
borhoods meet; and even the hyperreality of the Black Artists Retreat
(BAR) in which artists have an virtual space of infinite possibility in
which to share articles, photographs, syllabi, reflections, and concerns
that will live beyond the physical and psychological barriers of time,
space, and artistic discipline. These encounters, these interventions are
small but significant. In moving each of us (now as a collective) to attend
to each other in spaces near and far, Gates's artistic gesture has become
parable. In these specific venues of Greater Grand Crossing that can be
replicated anywhere people may gather, out of their endemic hopes and
desires, Gates has given us a new way of thinking about locations and
conversions, borderlands and forgiveness.

The age of epistemology is over. In the neoliberal, post-
postmodern turn, a cohesive cultural myth is neither needed nor suffi-
cient for the ways we as individuals and groups frame what we know or
what we believe. Thus as a curator of African American art I am con-
flicted over the category of African American art. I do not think it exists.
There is art. There are artists and makers. There are as many ways to
categorize people and label works and their influences as there are art-
ists and makers. That is it.

Theaster Gates is neither a black artist nor a religious artist. He
belongs neither to the idioms of the black church nor the white cube
of the modern art museum. Instead he is a black man with a spiritual
sense of the world focused on the one-to-one interaction that over time
forms a collective. I suggest that this concern for space and repurposing

arises from that question of theodicy, which all oppressed, peripheral, and subaltern persons of faith have asked themselves since the age of colonialism.

Leibniz's question, "If I believe in an omniscient, loving, good, perfect, and loving G-d, why does evil and violence continue to exist in my world?" has halted many on the way to their calling to serve the public good. This question put fear in the heart of St. Augustine, Thomas Aquinas, and Kahlil Gibran. It is regarding the contemplation of this question for which J.D. Salinger's Franny cries and contemplates a life of continuous prayer and for which Nietzsche warns, "Have you ever known, my brother, the word 'contempt'? And the anguish of your justice in being just to those that despise you?"[2] And yet, Gates continues to do the work of connecting, of making links, of moving through mercy to re-invest in the mutilated world. This does not make him a black artist or a religious artist; it makes him a visionary, engaged, and/or relational artist. It makes Theaster Gates a twenty-first-century artist.

2 Friedrich Nietzsche, I. xvii, *Thus Spoke Zarathustra* (New York: Penguin Classics, 1998).

Learning from Chicago

Responses to *Dorchester Projects* from The New School Faculty

The following reflections capture a very precise moment. On an exceedingly cold weekend in February 2013, fifteen faculty members of The New School spent three days in and around Theaster Gates's *Dorchester Projects*, in the course of it also visiting some programs that Gates considers important for his own development—Dan Peterman's Experimental Station, the Jane Addams Hull-House Museum and the Reva and David Logan Center for the Arts, University of Chicago. Interspersed with these site visits were discussions with Gates himself, at the Listening House, the Black Cinema House, and the Archive House on S. Dorchester Avenue, at the Washington Arts Incubator, the shuttered Stony Island State Savings Bank, and in the artist's future studio in a former Anheuser-Busch distribution warehouse. All photographs are by Parsons faculty member Andrea Geyer.

All photos:
Andrea Geyer, Untitled (Impressions from The New School faculty trip to Chicago), 2013

Katayoun Chamany
The Meaning of Domain

Dorchester Projects sits on the south side of Chicago, known for its diversity and activism for social justice. Though the project is a more recent addition to the neighborhood, it builds upon the efforts of those who have since the 1960s challenged the bounded nature of the South Side. By mixing old with new, recycling, reinventing, and reconstruction become concrete practices that have a ripple effect that reverberates beyond the radius of Dorchester. The horizontal organization of power in the shape of a rhizome has a unique power to spread, with each new structure connected at many points to the preexisting structures.

As my work centers on designing biology curricula that incorporate social justice themes, and more specifically a curriculum centered on stem cell research, I was drawn to the use of metaphor and specifically the use of the word "niche" as it applies to Theaster Gates's artistic practice in Dorchester and beyond. In biological terms, a niche is generated and sustained by the very things it supports. In the case of stem cell niches, the stem cells secrete growth factors and biopolymers that create scaffolds and depots for these factors, which can be accessed at specific times in response to environmental cues. The three-dimensionality of the architecture of each niche is different; a story of form and function specific to each tissue type or cell culture. In the niche, regeneration plays a vital role in tissue maintenance and wound repair, but this ability to generate is highly controlled, as unregulated cell growth results in cancer. Just as important is the programmed cell death of those cells that have served their function and are removed and recycled. As Gates has said about his own process of urban rehabilitation, "I don't believe everything should last forever . . . some things should die, expire, and evolve into something else."

Yet there are some things in Gates's work that evoke a sense of permanence, serving as reminders that mundane objects can be used and reused for good or evil. Upon closer inspection it is clear that though the physical object itself may be the same in a variety of works, the context and the surrounding environment give the form a new function. This is true of the fire hose, a symbol attached to black history, civil rights, and oppression. In a gallery the fire hose takes on an abstract meaning, drawing on the lived experience of the viewer. Some may see the fire hose in Gates's work as an object that saves lives, something that rescues one from the tragedy of fire, but as the titles of his works indicate, the fire hose can be used to devalue life as *In Event of a Race Riot* (2011–onwards).

As the fire hose has become a recurrent refrain in Gates's artwork, so too in biology, a protein domain can be echoed and co-opted for multiple uses in thousands of proteins in organisms as divergent as mammals and the microbes that live in harmony in

our intestines. A protein domain is a small sequence of amino acids, which, due to its chemistry, acquires a unique three-dimensional shape based on thermodynamic stability rules. It can be combined in endless permutations with other domains, creating new forms and functions for the future while maintaining an evolutionary link to the past. But like the fire hose a protein domain is not static in its function nor is it singular in its existence. It responds to circumstance and can be utilized for very different functions. There are countless proteins in our bodies that can act as both tumor suppressor and tumor promoter, the outcome dependent on domain exposures and partnerships with other proteins. The cells in our bodies are always taking note of environmental changes, adjusting these partnerships, dynamic to the point of transformation.

Yet all of this action, inaction, interaction, is dependent on the push and pull of dynamic systems that situate each cell, making it aware of its place ... a single unit in a complex whole. Pioneering cancer researcher Robert Weinberg claimed that a cell that does not recognize its place, its intersection with the others, its boundaries, and limits, is considered a renegade, and it is the renegade cell with no regard for its "social" and built environment that triggers the onset of cancer.

Like this one renegade cell, capitalism can be viewed

as the parasite of communities, destroying the social fabric that is weaved through cooperation and interdependence.

Julia Foulkes
Theastering Art, Places, and Lives

Theaster Gates himself and the spaces he has created are inspiring. Interrogating absence—identifying what's missing—and harboring what's thrown out fills the places and allows us to see "what could happen." There is more deliberation in the filling than this explanation of the process suggests, however. He generally has filled spaces not with whatever is thrown out but with resources of value to African Americans, whether past issues of *Ebony* and *Jet* or the records of Dr. Wax. He wants to see what happens in a largely overlooked neighborhood that is populated by 99.2% African

Americans, 72% of whom are under 18. This is crucial to the art and the impact, and yet how race and youth structure his practice is rarely articulated. There is a way to see it as literally self-evident but his embrace of the trickster suggests subtler plotting. There are far more life-changing, system-altering objectives. Theaster transforms places to change the practices of art from pointing out problems, however insightful and provocative, to solving them, however mundane and limited. His success has at least partly come about because of his stealth. Little did the neighborhood or the art world know of the extent of Theaster's goals and the transformation he seeded at the heart of the renovation of houses. So now that many of us know—his fame keeps rising—does the transformation continue?

Part of Theaster's stealth comes from his awareness and use of historical traditions that meet the contemporary moment in a new way. By combining the skills of the artist and the urban planner, he brings together the emphasis on community-based arts that emerged in the 1970s with the promotion of "creative economies" in city centers starting in the 1990s. He moves the creative sector to the peripheral neighborhood. His explicit concern with the opportunities created for his team as well as the skill-building opportunities for neighborhood residents makes the impact of art-making personal, economic, and possibly transformational in a longer term than the theories of relational aesthetics suggest.

Theaster's new project to retrofit abandoned city public housing into artist residencies

is another move in this effort. It is reminiscent of Project Row Houses initiated by Rick Lowe in Houston, Texas, in 1990, but also slightly different. Rick's project has many of the same goals as that of Theaster; in it, art is best described as the transformation of lives—young women with children given housing and resources in one part of the Project Row Houses, for example—rather than the creation of an object. Artists themselves are almost ancillary in Project Row Houses, where they come for a visiting residency rather than to live more permanently in the community. In fact, Project Row Houses may transform artists even more than residents by placing them in the midst of a distinct community and raising the stakes on the purposes of their art. Theaster's project, on the other hand, asks artists to stay in place. Their relation to the community is looser; they could interact with longstanding residents, or they could not. But all the residents need groceries. The presence of artists—their demands and ability to advocate—may better the life of the community by bringing resources and amenities to an underserved area.

Both these examples are needed ripostes to the framework of the arts as abetting gentrification, The guttural response to artist-led gentrification erases local particularities of segregation, municipal policy, and demography. Here Theaster's interest in

Richard Harper
*"People Do Not Like to Be
in a Village Where There Are
No Musicians."*[1]

Theaster Gates is using art to revitalize neighborhoods. His neighborhood—or "village"—is on Chicago's South Side, historically the northern port of call for bluesmen travelling up the Mississippi and jazz players migrating from New Orleans.[2] *Dorchester Projects* started in 2008 with Gates buying one of Chicago's many abandoned buildings. He used recycled materials, some cash and sweat, and transformed the house both physically and aesthetically,[3] practicing what could be called "functional" art, which is art that is to be used as much as it is to be admired. That conception of art is basic to many African societies.[4]

Rather than fill the house with tenants (his father, a builder, referred to real estate as a "revenue stream"), Gates acquired the music collection of a failing store, Dr. Wax Records,[5] and installed the records in his house. He then named the refurbished building the Listening House, and it became a space where people could come to the South Side to hear live blues, soul, and jazz. Mixing music with art was not new for Gates. Ever since he formed the musical group the Black Monks of Mississippi he has incorporated music with his installations. Invited to participate in the international exhibition

conception rather than replication as the answer to scaling up his efforts is quite astute, I think. He demands that specific locales need specific solutions. The challenge is the conception, the way to respond to particular environments. This makes art bound to the workings and meanings of cities and reveals his dual role as urban planner and artist.

Theaster warns that worrying over gentrification on the far south side of Chicago is taking a New Yorker's view of the situation, where Bushwick is only blocks from Williamsburg, where the path of artists moving in to gentrification that pushes them and other more marginal residents out has sped up exponentially. He insists that the threat of white folks moving down to the area of Dorchester is decades away. Perhaps even more important, the prospect is less problematic in deeply segregated Chicago than more fluid New York. A racially integrated neighborhood with more resources: where is the problem?

Theaster himself nailed the still niggling question, though: the problem with the arts as place-makers is that the process tends to instrumentalize art for economic development. Or, as Klaus Klunzman summarized, "each story of regeneration begins with poetry and ends with real estate."[1] How does he (or we?) ensure that the poetry remains, even flourishes against the language of real estate? Where is the art in the artist-as-bank? Or is the attention—in concern, dollars, and sociability—exactly the transformation needed?

1 Klaus Klunzman, Keynote speech to Intereg III Mid-term Conference, Lille, in *Regeneration and Renewal* (November 19, 2004).

Documenta in Kassel, Germany, in 2012, Gates gutted 6901 South Dorchester in Chicago to transfer materials to Kassel. Before doing so, he celebrated 6901 with hours of live music. Then he brought the Black Monks, along with lots of material from 6901 South Dorchester, to Germany to place some of the sonic energy of Chicago into Huguenot House there,[6] in the words of John Preus, "a love song from one vacant building to another."

Just as Gates finds new purpose for old materials, the Black Monks reform and reframe elements of music. Features such as call-and-response, improvisation, blues inflection, gospel spirit and jazz riffs, which are in the music of Chicago, are merged with Eastern chants and French Huguenot songs.[8] The result is a hybrid form of music making, very old and typical of African American musical

culture. The process of musical reframing for a new purpose was, for instance, evident in eighteenth- and nineteenth-century America: African American congregants were taught the hymns of British psalmists Isaac Watts and Charles Wesley,[9] and while the lyrics remained largely unchanged, the music was transformed through heterophony, call-and-response, and blues inflections into dirges or moans with the purpose of inviting the spirit of God to descend.[10]

A century later, Scott Joplin and his contemporaries reformulated the 2/4 march. The "um-pah" of the bass was fused with the syncopations of the treble. Strict march discipline was replaced with a jagged, elegant, high-stepping, parasol-twirling dance.[11] The Cakewalk became an expression of dignity-in-motion at a time of strict segregation. The accompanying music of rags and

ragtime succeeded in becoming the soundtrack of turn-of-the-century American life.[12] In the 1970s, young African Americans again borrowed, refurbished, and sampled the drumbeats, bass lines, and grooves of their parents and rap became the sonic embodiment of the emerging hip-hop culture.[13] Contemporary music historian Tricia Rose has written, "The arrangement and selection of sounds by rap musicians are at once deconstructive (in that they actually take apart recorded musical compositions) and recuperative (because they re-contextualize these elements, creating new meanings for cultural sounds that have been relegated to commercial waste bins)."[14] Over these repurposed and recycled beats, young people would tell the stories and travails of urban, ghetto life.

In his musical as well as his sculptural incarnations Gates recombines and reutilizes older materials to give them a second iteration. But in both he points out that repurposing old structures and materials in-and-of-itself is insufficient. Only the arts, artists, and creative people *within* revitalized buildings can bring vitality and life into neglected communities and neighborhoods. Perhaps the old African saying quoted above should be rephrased to describe Theaster Gates's practice: "People like to be in a village where there are musicians (artists and creative people)."

1 Alan P. Merriam, "The Bala Musicians," in Warren D'Azevedo, *The Traditional Artist in African Societies* (Bloomington: Indiana University Press, 1973), p. 269.

2 As legendary guitarist Robert Johnson put it, Chicago has been a "sweet home" for the blues, the most recognizable cultural signature this city has produced. Author's note: Bill Broonzy moved to Chicago in 1924, Blind Lemon Jefferson in 1925, Louis Armstrong and King Oliver in 1923.

3 Theaster Gates, in interview with Naomi Beckwith of the Studio Museum and Franklin Sirmans.

4 See John C. Messenger, "The Carver in Anang Society" in *The Traditional Artist in African Societies*, p. 124. "Although the Anang admit that most carvings serve utilitarian ends, they nevertheless recognize that human and animal figurines, when used as house decorations, are non-utilitarian and that other pieces have, in addition to utilitarian elements, symbolic and decorative ones which serve aesthetic ends."

5 Gates, in interview with Beckwith and Sirmans.

6 Gates, "12 Ballads for Huguenot House," http://whitecube.com/channel/in_the_museum/theaster_gates_12_ballads_for_huguenot_house_documenta_13_2012/.

7 "Whitney Biennial: Theaster Gates: The Black Monks of Mississippi," YouTube, http://www.youtube.com/watch?v=wD_UYFisBro.

8 William T. Dargan, *Lining Out the Word: Dr. Watts Hymn Singing in the Music of Black Americans* (Oakland: University of California Press, 2006), p.134. Correlations abound between the prayer-moan context of black hymn singing and that of dirge singing at Akan funerals. Just as lining out begins Afro-Baptist devotions, so does dirge singing set an opening tone of gravity and solemnity.

9 Dena Epstein, *Sinful Tunes and Spirituals* (Champaign: University of Illinois Press, 1977), p. 308. Quoted from W.F. Allen diary of 1867. "The tune was evidently Old One Hundred which was maintained throughout by one voice or another but curiously varied at every note so as to form an intricate intertwining of harmonious sounds. It was something very different from what I ever heard."

10 Eileen Southern, *The Music of Black Americans* (New York: W.W. Norton & Company, 1983), p. 316. The most significant element of ragtime was, of course, syncopation. The syncopated patterns might be simple ones or they might be complex, resulting from the play of additive rhythms in the right hand— such as 3+3+2—against consistent duple meters in the left hand.

11 Rudi Blesh and Janis Harriet, *They All Played Ragtime* (New York: Oak Publications, 1971), p. 129. "The music went along with the Cakewalk and suddenly late that year [1896], the roustabouts name for it, ragtime, clicked and was taken up by everyone."

12 Tricia Rose, *Black Noise* (Hanover, NY: Wesleyan University Press, 1994), p. 2. Rap music is a black cultural expression that prioritizes black voices from the margins of urban America. It began in the mid-1970s in the South Bronx in New York City as a part of hip-hop, an African American and Afro-Caribbean youth culture composed of graffiti, breakdancing, and rap music. From the outset, rap music has articulated the pleasures and problems of black urban life in America.

13 Ibid., p. 65.

Carin Kuoni
Gates Gatherings

Let's consider Theaster's entire practice a form of pottery. Like the basic form of clay, his project is essentially a vessel that contains as it omits, that absorbs as it pours. Whatever is inside is defined by what is outside, and the work's meaning and impact lie in the beautiful, exquisite, and visionary sweet spot where the crossing happens between what is inside and what is outside, between interior and exterior systems, of exchanges across and through the porous, metaphorical and literal skin.

This applies, for instance, to the distinct and finite collection of art historical glass slides, the *Ebony* magazine library or the LPs from Dr. Wax Records store, that are contained in various Gates houses. They are not the type of "living" archives that get expanded and added on in kind, but are closed units that transcend physical boundaries—the walls of the buildings or vessels that contain them—by force of their history.

In this way, the Listening House contains the historical Wax records, but is expanded on and enhanced through different sound situations: the concert stage inside with musicians present or absent, the silent voices/witnesses pressed into the vinyl records, and the resounding walls of the building, itself an acoustic instrument.

Similarly, the collection of art historical slides in the Archive and Soul Kitchen Building contains multiple moments: preserved in the original order in which it was arranged and used at the Chicago Art Institute, it registers a dominant historical canon translated into materials. It represents the materiality of the works depicted, yet is material itself. In the Archive House, the slide collection is matched with a communal dining room, a jarring and provocative juxtaposition symptomatic of Gates's practice where unexpected expansions enhance systems of meaning and knowledge.

Gates is both utterly fearless and infinitely gentle in directing independent systems towards that common spot, the vessel's skin, so to speak, to enable and facilitate their interesting, precise and transformative encounters. Scales, time-spans/durations, and investments vary: the University of Chicago is brought to a two-story print shop, the Washington Arts Incubator; the interior paneling or lining of the Black Cinema House gets shipped to Germany, and returns a few months later to Chicago, now with layers of the eighteenth century Hugenotten Haus that sheltered it embedded into it; the invitation for a group show at P.S. 1 becomes a two-year factory for toys; the *Ebony* "slush pile"—those books that are submitted for review and usually never looked at—becomes the basis of a most precious (and high-value) artwork.

As Gates builds and molds his vessel, seemingly incongruous systems become connected: city government with private interest, artists with bankers, soul food with high-end Italian kitchen design. The sweet spot he consistently identifies is incredibly delicate, vulnerable, and precise. What exactly happens there?

It's the encounter between individuals and commercial, social, material, and artistic infrastructures that nurtures openings, new possibilities, new ways of social and civic engagement. The risk of ethical, political, commercial, and artistic failure is high, the stakes are enormous—current and past lives are cast, fortunes are invested, communities are brought in—but so are the rewards of

a haunting, exemplary, and exuberant beauty that conveys history in both knowledge and material. This is not the work of a trickster who fools his audience. If it looks familiar it's that we can't see it yet. It is new constellations that are not always recognized as such. The challenge for us is whether you can or should attempt to duplicate it, and what happens in the course of doing so. We will require new, parallel evaluation tools. If *Dorchester Projects* is artwork, economic initiative, congregational meeting ground combined—how can we account for its success, to whom or what? How to account for a situation that is more than symbolic yet singular, that is a gesture with repercussions, a catalyst for new micro-networks that, yes,

result in more equitable conditions, in social justice. Born with clay in his veins, is how Theaster has referred to his approach. Does clay in veins ever become policies?

Mark Larrimore
Concerning the Belief Muscle

As a scholar of religion unfamiliar with movements in contemporary art and performance, I'm somewhat at a loss for how to articulate what I experienced in *Dorchester Projects* and its world. So I offer some scattered reflections, starting with thoughts on the repeated references to "belief" in Theaster Gates's first talk to us, before we'd even met. I was struck by his phrase "belief muscle" and spent the rest of our sojourn in and around *Dorchester Projects* thinking about it. Jacqueline Terrassa's essay "Finding Form"[1] helped me think about it, too.

In religious studies, we have spent the last few decades taking apart the modern idea that religion consists mainly of belief, an essentially private, cognitive, and intellectual activity, rather than being affective, embodied, participatory, and searching. Scholars have traced the etymology of the Latin word *credo* to the heart, and of the English *belief* to love. Religion is more like believing *in* someone or plighting one's troth than detached intellectual commitment to a system of propositions about the nature of life, the universe, and everything. Gates's Dorchester gym for the belief muscle recalls this older sense, although there is a cool intellectual precision to it as seen—as we saw it—from backstage, too. Gates's work reaches

out to others and trusts them, entrusts them, not primarily (or not only) to do work continuous with his projects, but to do their own work in a setting conducive to the emergence of affinities. This seems to be what he meant by belief that first day, and its main hope seems to be the cultivation of a kindred belief in others.

Pottery is a mythical art, and in trying to make sense of the many media in which Gates now works as in some way continuations of that art, it was hard for me not to think about the godlike (or demiurge-like) work of the potter, what it means to make vessels, and, most of all, the particular gifts—another kind of belief, this—involved with glaze in the kinds of Japanese pottery we saw. The patterns won't happen if you don't know how to apply the glaze, and yet you don't know what form they will take. I felt in Gates's belief talk the charged, at once anxious and thrilled patience of waiting to see what unforeseen colors bloomed as the potter waited for heat to do its work.

Belief is not just for people. Part of what's most compelling about *Dorchester Projects* is the strange new life of old materials. Personally I'm interested in the reuse of religious spaces (half of Manhattan's houses of worship were built for another community or purpose, so there are many occasions to taste and see here). Gates's work seems neither the cooptation of *spolia* nor the nostalgic cultivation of traces of

a building's or furnishing's earlier use in another tradition. The human worlds facilitated or framed by them are in some indirect way recalled and remembered in this new use. I was reminded of the "ghostly silt" Philip Larkin found in old churches (in his poem "Church Going").[2] In uses different from those they were originally crafted for, wood and chalkboard and book collection seemed at once content and self-conscious, working out their own mute forms of belief in the possibility of new life.

In his last talk, Gates noted that he no longer thinks of his work as redeeming materials; it's something closer to resurrection. I wonder if it isn't rebirth in a pretty karmic sense. For Buddhists there is no self, but there is rebirth—a chain whose links will be seen and understood only in retrospect at the moment of enlightenment. I'm intrigued at the confluence of religious traditions in Gates's work, from Baptist music to South African liberation theology, but find myself ultimately most intrigued at its relationship to the miraculous workings of the Lotus Sutra, which chants you as you chant it and suggests more than metaphorically redemptive potential in every form and material.

1 Jacqueline Terrassa, "Finding Form," in *Theaster Gates: My Labor Is My Protest* (London: White Cube, 2012).

2 Philip Larkin, "Church Going," in *Philip Larkin Poems* (London: Faber & Faber, 2011).

Lydia Matthews
The Sensitive Acupuncturist

When visiting a Gates space, you experience it bodily, but this encounter is not just between you and the building's unique material and spatial qualities. It also occurs between the bodies that share that space, leading us to discover other people's ways of understanding and knowing. This is at the core of how transdisciplinary dialogues may generate new possibilities: in the case of Dorchester Projects, we may find ourselves exchanging ideas about what organizing and mobilizing can mean, based on our distinct practices. How might we borrow metaphors that are useful for one field and apply them within another?

I would like to bring some ideas within design discourse to the table to suggest that they may be transferable within these dialogues. For example, "wicked problems." This now popular term arose out of a transdisciplinary dialogue between a sociologist and an urban planner at the University of California in 1973. Its premise is that how you define a problem may be part of the problem itself. Horst Rittel and Melvin M. Webber coined the term to describe troubling conditions that are not fixed entities nor solvable through any one disciplinary expertise alone. Wicked problems are multidimensional, complex, and constantly morphing, always responding to a

specific environmental condition dictated by a particular time and place. If creative people decide to intervene in "wicked" situations, then we need to accept that the most we can hope for is to constantly ameliorate problems rather than solve them in some finite way. This requires a perpetual, dialogic, critically evolving practice. If we reject previous models and accept that today's urban problems are inherently wicked, then we must learn to borrow, share, and even graft many kinds of knowledge onto one another. Crafting those kinds of collaborative exchanges are when things begin to become most interesting and exciting in my view.

Another evocative metaphor from design discourse is

"urban acupuncture." How do we understand the health of an urban space? Too often, we apply a Western medical notion of a body when considering a neighborhood full of wicked problems. We may assume that we need to diagnose the problem and then try to surgically remove it (e.g., the heroic logic of traditional urban renewal schemes). But since 1999, when Spanish architect and urbanist Manuel de Solà-Morales coined the term urban acupuncture, thinking about cities has evolved to consider them living, breathing, multidimensional organisms. In traditional Chinese medicine, the healing or restoring body is understood as something that has a system of flows and energies within in it, which are

connected or interrelated. When someone is ill or having problems, acupuncturists characterize this as a systemic blockage: there is excess in one area and lack in another. The "problem" calls for very small gestures to pinpoint and relieve the pressure so that those blockages can be released for the flow to resume. This strikes me as an apt metaphor for small-scale interventions that transform large urban contexts. It is not something that happens in one treatment, you have to constantly be doing it over time, and always within the here and now.

Another aspect of urban acupuncture—also known as "eco or social acupuncture"—is its demand to understand relationships within a larger, networked system, how the parts impact one another. If you're the sensitive acupuncturist, this is what you do: precisely pinpoint key locations or situations in the city that can be leveraged to influence each part and the whole. You target the spots that need to be opened up to encourage wider flows. Those aren't necessarily the hottest spots on the body, but rather those that could bring more heat to the general area.

What kinds of urban flows are most therapeutic? I find Pierre Bourdieu's ideas from *Distinction: A Social Critique of the Judgment of Taste* inspiring here. He argues for the need to differentiate various forms of capital. There is, of course the most familiar type, financial capital, but there is also social capital, with personal relationships and forms of reciprocity and networks; and cultural capital, with types of knowledge, skill sets, and education that offers higher status in society. By extending Bourdieu's logic, we can imagine ecological capital, with attention to sourcing and reusing materials; and physical capital, including infrastructure, transportation systems, markets, cultural centers, et cetera. Artists like Gates have the capacity to envision relationships between all types of capital flows, leveraging resources and spaces to enrich a community's well-being in the face of wicked problems. *Dorchester Projects* requires a perpetual process of rechanneling monies, repurposing materials and spaces, harnessing blocked labor forces, coalescing diverse communities, et cetera. So understanding these forms of capital metaphorically as energy flows through a social body helps me better understand the ability of creative people, the Theaster Gateses of this world, to make small scale interventions that ultimately, over time, produce a different kind of existence.

Kevin McQueen
Creative Placemaking and Community Economic Development: Learning from Theaster Gates

The economic development field in this country consists of an entire ecosystem of local residents, organizations, developers, bureaucrats, and financial institutions that allows services to be delivered, housing to be built, programs to evolve, and risks to be undertaken. Similarly, Theaster Gates's work encompasses an ecosystem of global and local artists, universities, community organizations, and neighborhood residents, which collectively participates in a process of reimaging urban life. Through his installations and performance pieces, Gates makes a connection between buildings and communities, while introducing new, replicable strategies for linking local residents and organizations to cultural initiatives as a means of strengthening the economic fabric of a neighborhood.

This linking of communities with arts and culture to reignite local economies has come to be known as "creative placemaking." Successful strategies utilize the cultural vibrancy created through the making of art to transform economic opportunity, viability, and desirability of downtrodden and often forgotten core urban neighborhoods. Some constituents within the economic development

ecosystem try to manufacture cultural vibrancy as a means of redeveloping and selling unused and underused urban spaces. The Wynwood Art District in Miami is a prime example of real estate investors, developers, and politicians seeking to infuse cultural meaning and value into postindustrial space. However, the rapid growth brought about by successful creative placemaking often results in substantial displacement and an overall change in neighborhood character. This change is liable to be detrimental to the very creative sector elements that brought it about in the first place.

True and lasting creative placemaking often occurs informally, almost as an improvisational approach, with local redevelopment catalyzed by individual arts and cultural entities connected to bottom-up efforts in community organizing, public performance, and local visioning. Such strategies have a strong and clear intent of avoiding gentrification and the exclusion of more marginalized local populations. Creative placemaking should introduce local residents to ideas of self-government and expression, to build confidence, independence, and political awareness and support the creation of community. Fourth Arts Block in Manhattan exemplifies this grassroots approach to helping artists connect with affordable space and thereby infuse cultural vibrancy into a formerly neglected section of this New York City borough.

Moreover, creative placemaking partnership should rely on long-term community stakeholders and less on the direct engagement of external actors, such as real estate developers. It should be a dynamic process that involves the entire community development ecosystem of local residents, cultural organizations, small businesses, local elected leaders, corporations and foundations, creative sector trade associations, and nonprofits. It should allow for the spontaneous and for a variety of experiences and encounters in order to generate vibrancy.

Most if not all of these qualities are present in the projects that Gates created in the Dorchester neighborhood of Chicago's South Side. His work in this community is emblematic of how design and use of physical space can be effective and lead to create positive changes in under-resourced communities. *Dorchester Projects* transforms a street from anonymous, sometimes hostile, urban wasteland into a vibrant, supportive, and productive block. The renovation of the former Schlitz property into artist studio space will likely extend economic transformation into another area on the South Side. Similarly, the creation of the Arts Incubator in Washington Park will anchor the revitalization of a commercial strip that serves as a gateway for a new University of Chicago campus.

Creative placemaking best happens within the context of a community ecosystem. As such,

Gates uses his multiple roles as an artist, urban planner, and university administrator to forge relationships between the various players at the local and institutional levels in order to accomplish his dual artistic and community development goals. As a result, the placemaking he is creating will likely transcend the initial boundaries of the few small blocks where his work started and engage audiences and stakeholders beyond the confines of Chicago's South Side.

Jasmine Rault
Housing Foreclosure:
Theaster Gates's Queer
Architectural Practice

I'm feeling utopic.
—Theaster Gates[1]

Gates has engineered a miniature
urban utopia.
—*T Magazine*[2]

[Gates is] unabashedly utopian yet
eminently pragmatic.
—Christian Viveros-Fauné[3]

Black studies might best be
described as a location habitually

lost and found within a moving
tendency where one looks back
and forth and wonders how utopia
came to be submerged in the
interstices and on the outskirts of
the fierce and urgent now.
—Fred Moten[4]

Since our Chicago weekend
introduction to Theaster Gates's
work in early February 2013, and
each time I look him up to see
what he's working on next—a new
building acquired or renovation
and redevelopment underway
seemingly every other week—I
have been thinking about Gates's
queer architectural practice. Of
course, his work is not exactly

lgbtqueer, as in a noun or identity,
but more like the adjective or
orientation or tendency towards
the people, things, spaces, and
potentials that have been deemed,
rendered, and dismissed as
inviable, impossible, disposable,
untenable. This is the "utopian"
orientation that puts Gates's work
into conversation with a creative
and intellectual tradition shared
by blackness and queerness which
attends to that better place and
time "submerged in the interstices
and on the outskirts of the fierce
and urgent now."[5] As José Esteban
Muñoz puts it in *Cruising Utopia*,
"Queerness is that thing that
lets us feel that this world is not

enough, that indeed something is missing.... Queerness is essentially about the rejection of a here and now and an insistence on potentiality or concrete possibility for another world."[6] Muñoz traces queerness as those aesthetic, affective, and erotic tendencies that draw attention by gesturing beyond the limits of a present place, offering a sense of immanent potentiality in the material and concrete that concrete materiality might foreclose, the viscera of not-yet-here.[7] I want to suggest that Gates's architectural practice performs some queer temporal and social intimacies that ask us to wonder/wander

beyond the foreclosures of our now and here.

Walking into each of the *Dorchester Projects* buildings, I was struck by the rich historical resonances of disappeared black lives—evicted, foreclosed, and abandoned—on this residential street and in these three renovated and repurposed buildings,[8] but also by the traces of their presence, activated or presented in the salvaged materials that make up these places. "Gates's sculptural [and architectural] practice is based on remnants—humble materials 'potent' (a word he favors) with associations. He saves furnishings and pieces of derelict

buildings, formerly inhabited by black people, for reuse in his sculptures [and architecture] ... [which] all speak to aspects of black history and black daily life."[9] That is, these houses are dressed in the garments of Chicago's black past: floors from redwood water tanks demolished for high-end loft conversions in the 1990s; wall paneling of chalkboards salvaged from the now-closed South Side Crispus Attucks Elementary School (named after a black-native slave who was the first casualty of the Revolutionary War); long-tables and shelving made from structural beams recovered during renovations of the once-abandoned,

fire-damaged home that is now the Library and Archive house; dusty layers of old paint and gaudy flaking wallpaper uncovered during the restoration of the boarded up domestic ruin that became the Black Cinema House, the decorative vestiges of an undervalued past bearing now upon the present through a long rectangular frame cut into the new Gyprock.

The material intimacies with black pasts that Gates's houses effect seem to work like an architectural performance of what Elizabeth Freeman calls "temporal drag"–where "'drag' [is] a *productive* obstacle to progress, a usefully distorting pull backward, and a necessary pressure upon the present tense."[10] While Freeman focuses on the political work of anachronistic gender and sexual attachments,[11] temporal drag is also a way of indexing one's attachments to a past that we are normatively compelled to get over, forget, disavow, or at least be well passed. Gates's architecture seems to perform this anachronistic investment in the material "remnants of black daily life" to preserve precisely the feelings, political commitments, modes and spaces of sociality, styles and areas of inhabitation that have been construed as the unproductive, immature, irresponsible, and empty obstacles to development and progress.

We might see this as an architectural preservation of the "fugitive public" that Fred Moten and

Stefano Harney associate with "the undercommons."[12] This is a commons made up not of commonality or community or neighborhood but of what they call a black radical tradition of "bad debt,"

which is to say real debt, the debt that cannot be repaid, the debt at a distance, the debt without creditor, the black debt, the queer debt, the criminal debt. . . . This refuge, this place of bad debt, is what we call the fugitive public. . . . To creditors it is just a place where something is wrong, though that something wrong–the invaluable thing, the thing that has no value–is desired. Creditors seek to demolish that place, that project, in order to save the ones who live there from themselves and their lives.[13]

This is the debt that keeps on giving and taking, does not recognize credit or creditors, refuses to count or be counted–the debt to those homes and livelihoods displaced or destroyed for that water tower redwood; to the kids and not-kids who worked at a now-closed school named in hope of honoring an enslaved dockworker who was killed by British military (and eventually celebrated as a patriotic freedom fighter for the very country that enslaved him); to the lives that filled the houses that were left or lost or taken before Gates returned some of their remnants and textures. Bad debt

is limitless hospitality–"We felt it in the way someone saves the best stuff just to give it to you and then it's gone, given, a debt. They don't want nothing. You have got to accept it, you have got to accept that. You're in debt but you can't give credit because they won't hold it."[14] Gates's architectural practice might be seen as part of a much more ambitious project (led by groups like the Chicago Anti-Eviction Campaign, Communities United Against Foreclosure and Eviction, Liberate the Southside, and Centro Autonomo) against the foreclosure and demolition of these projects and places, to preserve the fugitive public and house bad, black, queer debt, "the invaluable thing, the thing that has no value."

1 Quoted in Libby Rosof, "Theaster Gates Talks at the Fabric Workshop and Museum," *theartblog* (January 21, 2013), http://www.theartblog.org/2013/01/theaster-gates-talks-at-the-fabric-workshop-and-museum/.

2 "Connecting the Dots: Perry Chen and Theaster Gates on Community-Driven Creativity," *New York Times's T Magazine*, June 2, 2013, p. M230.

3 Christian Viveros-Fauné, "Theaster Gates," *Art Review* 56 (2012), p. 68.

4 Fred Moten, "Black Op," *PMLA* 123.5 (2008), p. 1746.

5 Ibid.

6 José Esteban Muñoz, *Cruising Utopia* (New York: NYU Press, 2009), p. 1.

7 Of course, the worrying flipside of the utopian scope and reach of Gates's architectural projects is that it brings Gates into the territory of providing the comfortable complimentary supplement to contemporary capitalism—where the artist-cum-entrepreneur/community developer is rewarded for a "social practice" which works to (temporarily and partially) fill in the gaps created by the privatization of social and cultural services, enabling the ongoing divestment of resources from the lives of people of color. Marina Vishmidt articulates the cautionary note on the celebrated utopianism of contemporary social practice art (and Gates's in particular), arguing that it can contribute to the cruel social, economic, and political forms of exploitation that it purports to disrupt: "activism and business pair up in a utopian vision of social desire that is, at bottom, a vision of money brokering intimate and meaningful exchanges that can have actual 'empowering' effects. This is a seductive vision with great social resonance at the moment, echoing the gospel of financial abstraction 'out-cooperated' by small-scale enterprise, alternative economic models, and networks of trust. We thus seem to be living through a moment of semantically frictionless yet socially devastating fusion between the social and capital." Maria Vishmidt, "'Mimesis of the Hardened and Alienated': Social Practice as Business Model," *e-flux* #43 (March 2013). Indeed, empowered by city, state and private investors/partners (many of them in some large part responsible for the very resource divestments that Gates wants to rectify), Gates is quickly becoming one of the largest real estate developers of Chicago's South Side—with the three houses that make up the Dorchester Projects; the 25,000-square-foot former Anheuser-Busch distribution center; the 20,000-square-foot former Illinois State Bank Building; and thirty-two units of former Chicago Housing Authority buildings.

8 The Dorchester Projects are part of the Grand Crossings area of Chicago's South Side, which currently faces the highest foreclosure rate of any metropolitan area in the U.S., on top of having already some of the highest numbers of vacant homes in the nation. See Ben Austen, "The Death and Life of Chicago" in *New York Times* (May 29, 2013); Alison Burdo, "Chicago leads nation in vacant homes in foreclosure" in *Chicago Real Estate Daily* (June 20, 2013); Miles Kampf-Lassin, "Chicago Communities Demand Eviction Moratorium" in *In These Times* (August 10, 2012); Miles Kampf-Lassin, "A People's Movement for Housing Justice Builds in Chicago" in *The Occupied Chicago Tribune* (March 20, 2012).

9 Lilly Wei, "Theaster Gates," *Art in America* (December 2011), pp. 121.

10 Elizabeth Freeman, *Time Binds: Queer Temporalities, Queer Histories* (Durham, NC: Duke University Press, 2010), p. 64.

11 One of Freeman's examples is "the purportedly humorless radical feminist" (ibid., p. 68) whose persistence Sara Ahmed has brilliantly traced in her work on "the feminist killjoy." Sara Ahmed, "Feminist Killjoys (And Other Willful Subjects)," in *The Scholar and the Feminist* 8, no. 3 (Summer 2010), p. 50–87. For more on queer temporality, see the special issue of *GLQ* that Freeman edited on the topic. "Queer Temporalities," Elizabeth Freeman, ed., *GLQ: A Journal of Lesbian and Gay Studies* 13(2), special issue (2007), as well as Judith Halberstam, *In a Queer Time and Place: Transgender Bodies, Subcultural Lives* (New York: NYU Press, 2005).

12 Fred Moten and Stefano Harney, *The Undercommons: Fugitive Planning and Black Study* (New York: Minor Compositions, 2013).

13 Ibid., pp. 61–62.

14 Ibid., p. 62.

Radhika Subramaniam
Developing Neighbors

What does it mean to live next to Theaster Gates? He moves in next door on Dorchester Avenue in Chicago, then across the street, only to acquire another place farther down. During this lateral expansion, the houses are gutted, reused, and rebuilt, and they turn into archives, cinema houses, libraries, and arts incubators. Sometimes the doors are open: you might be invited in. There's dinner and music. Folks from elsewhere stop by. What's happening on the block?

Gates is quick to say that what he does and what he's done has nothing to do with having a "mission"; it's about staying and building the place in which you want to be. Such building takes time and trust so that it's actually an honor both to invite others in and be invited by them. With such a model, he sets his work apart from other projects with a social orientation, cautious not to use the vocabulary of community or outreach. He isn't out to "do good" for anyone or insist on forms of obligatory friendliness and conviviality. This isn't outreach—he actually lives there, but his sort of living isn't like any other. And here, there, somewhere goes the neighborhood.

The collapse or transformation of a neighborhood, often associated with gentrification and homogeneity, has a genealogy deeply rooted in the histories of race and class divisions in the United States. And it's right in the middle of that history that Gates plonks himself with unusual and energetic enterprise. The sort of "neighborliness" he proffers is a potent mix of planning, developing, and building that sounds like living next door to live yeast, continually growing, rising, expanding. But where a real estate developer might see dilapidated houses as abandonment, an absence waiting to be filled, Gates seems to see in the same boarded up house the bones of a presence waiting to fill out. He wonders, in fact, what it might mean for neighbors to be developers.[1]

What indeed could that mean? Gates is interested in adjacencies: the acts of placing alongside, of placing atop, of placing within. The boards of an old bowling alley become the floors of 6918 South Dorchester, and the dismantled timbers and materials of 6901 travel across the Atlantic where they are reassembled to repair the Huguenot House in Kassel, Germany. This is restoration as in re-store: storing anew. Meaning adheres to these materials. Rather than a purposeful adaptation to signify something new, they are being reworked and repositioned to reveal their own embedded meanings, acquire a new sheen, and in so doing, both illuminate and create new shadows. *Dorchester Projects* houses entire collections that were in danger of being tossed out but were waylaid by Gates, who sees in them forms of "discarded knowledge": a glass slide collection from the University of Chicago Art History Department fallen victim to newer technology, vinyl LPs from a failing record store, collections of *Jet* and *Ebony* magazines, all find a home here, *in toto*. They too live side by side as neighbors to generate other contexts and meanings.

The politics and responsibilities of place and placement are part of every curator's ambit. Those of us who work in universities find our practices and publics shaped by the role of our institutions in the city. Many universities are the largest landholders in their area, major landlords and major tenants, and their academic calendar cycles can have a strong impact on local economies. Their expansion plans and various forms of infrastructural investment affect their surroundings, often rousing spirited local responses from residents and local businesses. These days, universities are rarely content to be local, most having satellite programs, campuses and partnerships in other locations in the world. Driven in good measure by economic considerations, these distributed network models only make manifest the complicated politics of place, particularly the participation of the university as a neighbor.

Models of neighborliness at universities have usually been

framed as community development, public and civic engagement. Gates too is square in the middle of the questions raised by these frameworks. As director of the Arts and Public Life initiative at the University of Chicago, in whose hinterland of the South Side the Dorchester Projects is located, he is now spearheading a new arts incubator in a converted bank that offers artist residencies, workshops, and a gallery. Through this, he develops the university as a neighbor, in fact, as *his* neighbor. What possibilities might exist were a university to fully explore this process—developing neighborliness over real estate not through pat "good neighbor" formulations but the enhancement of settings that are inclusive, open to change, nonprescriptive, resulting in diverse forms of reciprocal but undemanding investment? Perhaps it is here that Gates's idea of "neighbors as developers" gains significance for its singular recognition of the investment in spaces and things—not for presentation or display but to attend to what's in them, what surrounds them, to shine 'em special, because they are there, next door, to where we live.

1 Harry Backlund, "House Plans," *Chicago Weekly*, March 9, 2011.

Theaster Gates:
A Way of Reception

Chelsea Haines and
Jocelyn Edens

Theaster Gates's projects respond to and take advantage of the political and economic climate of the United States since 2008. The multifaceted, multidisciplinary, quintessentially difficult-to-classify practice is both shaped by and has shaped contemporary ideas on the housing crash and real estate crisis, entrepreneurship and alternative economies, President Barack Obama's Chicago and race in the U.S., upcycling and repurposing, faith and critique—the list goes on. Gates's fast, superlative-filled rise to fame has been supported by a range of systems, from the contemporary art world and its markets to private and public economic development engines to on-trend life and style writers.

Gates's practice is based on a principle of synthesis: the juxtaposition and sometimes suturing of contradictions. The ecosystem of Gates's work, which operates at intersecting registers of objects-exhibition-performance-development-apprenticeship, is a complex and shifting one. It is perhaps this slipperiness that leads most responders to rely on Gates's biography and his own words as anchors for investigating and evaluating the work. Interviews with Gates have been published or broadcast in venues ranging from *Art in America* to *The Guardian* to *The Colbert Report*. Gates's biography is infused with almost mythological dimensions that grant him exceptional insight into North American cultural politics; in articles and reviews, Gates's words tend to guide the interpretive framework and critical judgment of the work, whether positive or negative. Thus Spoke Theaster. It is an indispensable tool for those who write on living artists to benefit from primary source material, and perhaps even more so for those writing about long-term work that is used and lived in, the effects of which are felt cumulatively rather than immediately. Yet the narrative that has developed around Gates's words—the sermon of a postmodern preacher saving us from the sins of the contemporary art world—seems to preempt a more profound engagement with the content and analysis of the deeply wrought but equally constructive contradictions of the work. We are in trouble when a self-described trickster's voice is the beginning and end of critical authority on a work.

The Vera List Center for Art and Politics has endeavored to focus on the life and productive capabilities of *Dorchester Projects* as a site and a project both within and outside the discourse of Gates's own biography. More to the point, this is a book about *Dorchester Projects* as exemplary of the intersection of art and social justice, and about how those outside *Dorchester Projects*—visitors, scholars, writers, strangers—can access,

understand, and question it. To that end, we summarize some major themes that have emerged from our thoughts on the growing literature around the project in the last several years in order to help readers consider some entry points into Gates's practice that have often been glossed over.

Descriptions of *Dorchester Projects* tend to play a key role in setting the scene for Gates's rise to international recognition, even fame, in the art world. The relationship between *Dorchester Projects* and Gates's commercial endeavors—in the art and real estate worlds—is often framed as a symptom of creative problem solving rather than a key move in shifting market ecologies by using the logic of gentrification against itself. Gates's insistence on commitment to place (Chicago, the South Side, the block) only functions within an engagement with commercial galleries, biennials, museums, real estate development, and international banking. The tension between what would otherwise appear to be mutually exclusive—even antagonistic—forces is in fact the glue that holds *Dorchester Projects* together. The belief and the hope that one can turn an exploitative system against itself is the crux of Gates's redemptive practice.

Criticism of Gates's work often remains ambiguous about how to measure or define success—how and when is it useful to consider the work of art an aesthetic object? As a tool towards social justice? Many writers insist on setting objective standards for the success or failure of *Dorchester Projects*, only to ultimately shuffle aside their calls for a clear theory of change, impact assessment, money trails, or deep, anthropological and sociological study of *Dorchester Projects* in favor of equivocal and evocative descriptions. This ambiguity corresponds to the way in which Gates himself has been able to wriggle between the ways of working as an artist, developer, preacher, performer, and self-identified hustler.

Writers clearly find Dorchester Projects to be broadly relevant to the strategies, struggles, and repercussions of both the recent American real estate crisis and ongoing tensions in U.S. race relations, which are in turn knotted together with the highly racialized process of subprime lending and foreclosures. *Dorchester Projects* has become a shorthand art reference for such discussions, easy to mention but far more complicated to consider in depth. The messy entanglement of class and race, just like the intermingling of belief, skepticism, and speculation that drives Gates's practice, has yet to be fully pulled apart and explored—if indeed these lines can ever be untangled from each other in the

American cultural context. Very rarely does the existing literature on Gates and *Dorchester Projects* trace its resonance with urban policies (Mabel O. Wilson's essay in the pages of this book is a launching point for an emergent discourse on the subject). How would focused analysis of past and current discourse on race, space, and architecture not only argue for a more nuanced relationship between the three, but also support better formal and aesthetic readings of the work?

Finally, Gates's work operates within a framework we would like to call a pragmatic utopia. Through a practice based simultaneously on mutual benefit and co-exploitation of polarized social, economic, and ethnic groups, Gates has produced a new, highly contingent discourse of hope. *Dorchester Projects* is an always already compromised utopia, but one in which we want—perhaps even need—to believe in while at the same time acknowledging its fraught existence in a fraught world.

It would be a futile effort to present a comprehensive bibliography on Theater Gates's practice in a print publication: between January and May of 2015 alone, at least 11 new major citations have appeared. The following bibliography represents a fraction of the literature on Gates's *Dorchester Projects*, with an emphasis on significant newspaper, magazine, and scholarly articles published between 2012 and 2015. Together they map various attempts to make sense of a complex practice, and its resonance with contemporary art and social conditions.

Tim Adams, "Chicago artist Theater Gates: 'I'm hoping Swiss bankers will bail out my flooded South Side bank in the name of art,'" *The Guardian*, May 3, 2015, http://www .theguardian.com/artanddesign/2015/ may/03/theaster-gates-artist-chicago-dorchester-projects.

Ben Austen, "Chicago's Opportunity Artist." *New York Times*, December 20, 2013, http://www.nytimes .com/2013/12/22/magazine/chicagos-opportunity-artist.html?_r=1.

John Colapinto, "The Real Estate Artist," *The New Yorker*, January 20, 2014, http://www.newyorker .com/magazine/2014/01/20/ the-real-estate-artist.

Huey Copeland, "Dark Mirrors: Theater Gates and *Ebony*," *Artforum* (October 2013), pp. 222–29.

Kelly Crow, "The Artist Next Door," *The Wall Street Journal*, October 25, 2012, http://online.wsj.com/article/ SB1000142405297020442590457807264026 95163394.html.

Shannon Jackson, "Life Politics/ Life Aesthetics: Environmental Performance in *red, black & GREEN: a blues*," in *Performance and the Politics of Space*, ed. Erika Fischer-Lichte and Benjamin Wihstutz

(New York: Routledge, 2013), pp. 276–96.

Tom McDonough, "Theaster Gates," *BOMB* 130 (Winter 2013), http:// bombmagazine.org/article/2000073/ theaster-gates.

Hesse McGraw, "Theaster Gates: Radical Reform with Everyday Tools," *Afterall: A Journal of Art, Context and Enquiry*, no. 30 (Summer 2012), pp. 86–99.

Michele Robecchi, "The New Revolutionary," *Mousse Contemporary Art Magazine* 32 (February–March 2012), http:// moussemagazine.it/articolo. mm?id=907.

Marina Vishmidt, "'Mimesis of the Hardened and Alienated': Social Practice as a Business Model," *e-flux* 43 (March 2013), http://www.e-flux .com/journal/"mimesis-of-the-hardened-and-alienated"-social-practice-as-business-model/.

Vera List Center Prize for Art and Politics

The Vera List Center Prize for Art and Politics was launched in 2012 to celebrate the twentieth anniversary of the founding of the Vera List Center for Art and Politics. It honors an artist or group of artists who has taken great risks to advance social justice in profound and visionary ways. International in scope, the biennial prize is awarded for a particular project's long-term impact, boldness, and artistic excellence.

The prize initiative unfolds across various platforms and over an extended period of time. It serves as a catalyst for activities that illuminate the important role of the arts in society, and strengthen teaching and learning at The New School in art and design, social science, philosophy, and civic engagement. More than a single moment of recognition, it represents a long-term commitment to the question of how the arts advance social justice, how we speak of, evaluate, and teach such work.

An exhibition of the winning project, a conference, various classes, and an online and print publication featuring select nominated projects complement a cash award and short-term New York City residency for the honoree. In the spirit of the center's twenty-year history, the prize provides the opportunity for an ongoing public conversation on art and social justice as a global issue that engages audiences in New York City, nationally and around the world.

The inaugural Vera List Center Prize for Art and Politics was bestowed on Theaster Gates on September 18, 2013. It was accompanied by an artist lecture, a conference, and the exhibition Theaster Gates: A Way of Working, curated by Carin Kuoni and Chelsea Haines, in collaboration with Theaster Gates. The exhibition was presented from September 18 through October 5, 2013, in the Arnold and Sheila Aronson Galleries of the Sheila C. Johnson Design Center at Parsons School of Design.

Theaster Gates's project of historical reclamation, interrogation of archival legacies, and social construction of memory and cultural agency has it all tied together. Dorchester Projects is extraordinary. The installation layers a meditation on the present by connecting it to the haunted remains of the American past, making links with narratives of race consciousnesses, the Civil Rights Movements, but ultimately probing how the African American experience is enlivened by ongoing processes of testimony. Entering that installation is like entering a haunted space.
 —Okwui Enwezor, Jury Chair

Inaugural Prize Nominators Council
Negar Azimi
Omar Berrada
Zoe Butt
CAMP
Sofía Hernández Chong Cuy
T.J. Demos
Galit Eilat
Bassam El Baroni
Shiming Gao
Susanna Gyulamiryan
Shannon Jackson
Koyo Kouoh
Ana Longoni
H.G. Masters
José Roca
Gregory Sholette
Bisi Silva
Pooja Sood
Chen Tamir
What, How & for Whom/WHW

Inaugural Prize Jury
Okwui Enwezor, Chair
Carin Kuoni
Lydia Matthews
Susan Meiselas
Dorothy Q. Thomas

Prize Founding Supporters
James-Keith Brown and Eric Diefenbach
Elizabeth Hilpman and Byron Tucker
Jane Lombard
Joshua Mack

Nominated Projects

AI WEIWEI
weiweicam.com, 2012
Beijing, China
aiweiwei.com

SHAHIDUL ALAM
My Journey As a Witness, 2011
Dhaka, Bangladesh
shahidulalam.com

KAREN ANDREASSIAN
Ontological Walkscapes,
2008–2010
Yerevan, Armenia
ontologicalwalkscapes.format.am

AMY BALKIN
Public Smog, 2004–present
Los Angeles, United States,
and Kassel, Germany
publicsmog.org

BIBLIOTHÈQUES SANS FRONTIÈRES
The Haiti Project, 2010–present
Port-au-Prince, Haiti
bibliosansfrontieres.org

GIUSEPPE CAMPUZANO
Museo Travesti del Perú, 2004–
2013
Lima, Peru

CHTO DELAT
*CHTO DELAT/WHAT IS TO BE
DONE?*, 2003–present
Saint Petersburg, Russia
chtodelat.org

DABATEATR
*DABATEATR Citoyen/Citizen
Theater Now*, 2004–present
Rabat, Morocco
dabateatr.com

ETCÉTERA
1997–present
Buenos Aires, Argentina
facebook.com/grupoetcetera

THEASTER GATES
Dorchester Projects,
2008–present
Chicago, United States
theastergates.com

GUGULECTIVE
2006–present
Capetown, South Africa
facebook.com/gugulective.
gugulective

HANS HAACKE
*Der Bevölkerung/To the
Population*, 2000
Berlin, Germany
derbevoelkerung.de

SANDI HILAL and
ALESSANDRO PETTI
Campus in Camps
2012–present
Bethlehem, Palestine
campusincamps.ps

SANJA IVEKOVIĆ
Women's House, 1998–present
Zagreb, Croatia

AMAR KANWAR
The Sovereign Forest, 2011–present
Odisha, India
amarkanwar.com

FAUSTIN LINYEKULA
more more more ... future, 2009
Kisangani, Democratic Republic
of Congo
kabako.org

INTERFERENCE ARCHIVE
2011–present
Brooklyn, United States
interferencearchive.org

MOSIREEN
2011–2014
Cairo, Egypt
mosireen.org

MARINA NAPRUSHKINA
Office for Anti-Propaganda,
2007–present
Frankfurt, Germany
office-antipropaganda.com

TENZING RIGDOL
Our Land, Our People, 2011
Dharamshala, India

ISSA SAMB
Laboratoire Agit'art, 1974–present
Dakar, Senegal

CHRISTOPH SCHÄFER
Park Fiction, 1995–present
Hamburg, Germany
christophschaefer.net

TAKE TO THE SEA
2008–present
Cairo, Egypt

Vera List Center for Art and Politics

The Vera List Center for Art and Politics is an idea incubator and a public forum for art, culture, and politics. It was established at The New School in 1992–a time of rousing debates about freedom of speech, identity politics, and society's investment in the arts. A pioneer in the field, the center serves a critical mission: to foster a vibrant and diverse community of artists, scholars, and policy makers who take creative, intellectual, and political risks to bring about positive change.

We champion the arts as expressions of the political moments from which they emerge, and consider the intersection between art and politics the space where new forms of civic engagement must be developed. We are the only university-based institution committed exclusively to leading public research of this kind. Through public programs and classes, awards and fellowships, publications and exhibitions that probe some of the pressing issues of our time, we curate and support new roles for the arts and artists in advancing social justice.

Vera List Center Advisory Committee

The Advisory Committee of the Vera List Center is an integral part of The New School community. Members of the committee advise the chair and counsel the director of the center, develop expertise on ways to support the academic enterprise, offer insight and guidance on programs, provide significant financial support, and serve as links to the communities in which they live and work.

The publication of this book is made possible in part through the generous support of Vera List Center Prize for Art and Politics Founding Supporters, Lambent Foundation and The Malka Fund.

Book Contributors

AI WEIWEI is an artist. Born in 1957, he currently resides and works in Beijing, China. From architecture to installations, social media to documentaries, Ai uses a wide range of media as expressions to set up new possibilities and conditions for his audience to examine society and its values.

SHAHIDUL ALAM is a Bangladeshi photographer, writer, and social activist as well as the initiator of the Drik Picture Library, founded in 1989 and based in Dhaka, Bangladesh.

KAREN ANDREASSIAN is an Armenian artist whose documentary work records the political and geological landscapes of Armenia and the social transformation it faces in post-Soviet times.

NEGAR AZIMI is a writer and Senior Editor of *Bidoun*, an award-winning arts and culture magazine. In 2014–2015 she was a fellow at the Cullman Center for Scholars and Writers at the New York Public Library.

AMY BALKIN is an American artist whose projects propose a reconstituted commons, considering legal borders and systems, environmental justice, and the sharing of common-pool resources in the context of climate change.

HORACE D. BALLARD, JR. is a doctoral candidate at Brown University in the programs of Public Humanities, History of Art, and American Studies and a lecturer at the Museum of Art, Rhode Island School of Design (RISD).

OMAR BERRADA is a writer, translator, and critic who currently directs Dar al-Ma'mûn, a library and artists residency near Marrakesh.

BIBLIOTHÈQUES SANS FRONTIÈRES was founded in 2007 in France at the initiative of Patrick Weil. It is one of the leading NGOs working in access to information and knowledge and culture-based development, supporting libraries around the world.

CAMP is a collaborative studio founded in Bombay in 2007 by Shaina Anand and Ashok Sukumaran. It combines film, video, installation, software, open-access archives, and public programming with broad interests in technology, film, and theory. CAMP likes to work on long-term, complex projects that nest in their contexts. From their home base in Chuim village, Bombay, CAMP are co-initiators of the online footage archive, the new cinema archive, and the Wharfage project on the Indian Ocean.

GIUSEPPE CAMPUZANO (1969–2013) was a philosopher, performer, activist, and the founder of the *Museo Travesti del Perú*, which addresses issues of sexual rights, participation, and inclusion.

KATAYOUN CHAMANY is Associate Professor of Biology at Eugene Lang College of Liberal Arts at The New School.

CHTO DELAT is a collective founded in 2003 in St. Petersburg, Russia, by a group of artists, critics, philosophers, and writers, with the goal of merging political theory, art, and activism.

ROMI N. CRAWFORD, Ph.D., is Associate Professor in the Visual and Critical Studies and Liberal Arts Departments at the School of the Art Institute of Chicago. Her research revolves around ideas of race and ethnicity and their relation to American art, literature, and film.

DABATEATR is a Morocco-based company founded in 2004 by Jaouad Essounani that consists of performing art makers from Morocco and all over the world who work as a freelance collective.

T. J. DEMOS is Professor of History of Art and Visual Culture and Director of the Center for Creative Ecologies at University of California, Santa Cruz.

JOCELYN EDENS is the Kress Curatorial Fellow at Hampshire College in Amherst, Massachusetts, where she works with the Institute for Curatorial Practice and digital platforms for curating.

GALIT EILAT is an independent curator, editor, and writer. She was Founding Director of the Israeli Center for Digital Art in Holon and Co-founder and Chief Editor of *Maarav*. Among many exhibitions, she co-curated the Polish Pavilion at the 54th Venice Biennale and the 52nd October Salon at the Museum of Yugoslav History, Belgrade, Serbia. She served as a Research Curator at the Van Abbemuseum between 2010 and 2013 and as President of the Akademie der Künste der Welt from 2012 to 2013. Recently she co-curated the 31st São Paulo Biennial.

ETCÉTERA is an interdisciplinary art collective, founded in 1997 in Buenos Aires, with the objective to create a movement that interacts with political and social issues. In 2005 they were part of the foundation of the INTERNATIONAL ERRORIST movement, an international organization that claims error as a philosophy of life.

JENIFER EVANS is an artist and writer based in Egypt who co-runs Nile Sunset Annex and is culture editor at *Mada Masr*.

JULIA FOULKES is Professor of History at The New School where she investigates interdisciplinary questions about the arts, urban studies, and history in her research and teaching.

THEASTER GATES is a Chicago-based artist and urban planner whose work includes space development, object making, performance, and critical engagement with many publics. He is the recipient of the inaugural Vera List Center Prize for Art and Politics.

ANDREA GEYER is New York-based artist who uses both fiction and documentary strategies in her image and text based works. She investigates historically evolved concepts such as national identity, gender and class in the context of the ongoing re-adjustment of cultural meanings and social memories in current politics. She is a 2006–2007 Vera List Center Fellow.

GUGULECTIVE is a contemporary art collective founded in 2006 in Gugulethu, a township near Cape Town, South Africa, who believe in art as an instrument for social change.

SUSANNA GYULAMIRYAN is an Armenian critic, curator, and Director of the Art and Cultural Studies Laboratoryin Yerevan, Armenia.

HANS HAACKE is a German-American artist, living in New York since 1965. He works in many media, including sculpture, installations, painting, photography and text, which explores physical, biological, and social systems.

CHELSEA HAINES is a curator and writer based in New York where she is a doctoral student in Art History at The Graduate Center, City University of New York.

RICHARD HARPER is Assistant Professor at the School of Jazz at The New School where his areas of expertise include voice, vocal training, piano, and trombone.

SANDI HILAL and ALESSANDRO PETTI direct *Campus in Camps*, an experimental educational program based in Dheisheh refugee camp in Bethlehem, Palestine, that aims at communal learning and production of knowledge grounded in lived experience.

INTERFERENCE ARCHIVE explores the relationship between cultural production and social movements through public exhibitions, a study and social center, talks, screenings, publications, workshops, and an online presence. The archive is located in Brooklyn, organized by over 30 volunteers, and is largely funded through a broad base of over 125 supporting members.

SANJA IVEKOVIĆ is a Croatian photographer, sculptor, and installation artist who is known for her social and political commitment to enhancing the role of women in society through her work.

SHANNON JACKSON is the Associate Vice Chancellor of the Arts and Design at the University of California, Berkeley, where she is also the Cyrus and Michelle Hadidi Chair of Rhetoric and Performance Studies and the Director of the Arts Research Center.

AMAR KANWAR is a filmmaker and artist living in New Delhi. His films and installations address the political, economic, and cultural structures of contemporary life in South Asia. His work is exhibited across art, film and community spaces.

THOMAS KEENAN is Associate Professor of Comparative Literature and Director of the Human Rights Program at Bard College, Annandale-On-Hudson, New York. He is the author of *Fables of Responsibility* (1997) and *Mengele's Skull* (2012, with Eyal Weizman).

KOYO KOUOH is the founding artistic director of RAW Material Company, a center for art, knowledge and society in Dakar and the curator of FORUM, the education program at 1:54 Contemporary African Art Fair in London and New York.

CARIN KUONI is Director/Curator of the Vera List Center for Art and Politics. In her curatorial and critical work, she focuses on how contemporary artistic practices reflect but also inform social, political, and cultural conditions.

MARK LARRIMORE is Associate Professor in Religious Studies at The New School where his areas of interest include modern manifestations of religion and the politics of their study.

FAUSTIN LINYEKULA is a Congolese dancer and choreographer who addresses Democratic Republic of the Congo's legacy of decades of war, fear, and the collapse of the economy for himself, his family, and his friends. He founded in 2001 the Studios Kabako, a space for training, production, and touring for young Congolese artists in the field of dance, theatre, music, and film.

ANA LONGONI is a writer and researcher based in Buenos Aires, Argentina, and specializes in the articulations between art and politics in Latin America since the twentieth century.

H.G. MASTERS is a writer and editor focusing on artists from Asia and is Editor-at-Large for *ArtAsiaPacific* magazine and is editor of the annual *ArtAsiaPacific Almanac.*

LYDIA MATTHEWS is Professor of Visual Culture, Art, Media and Technology at Parsons, The New School. Her work addresses how artists, artisans, and designers foster democratic and intimate community interactions in the public sphere.

KEVIN MCQUEEN is an impact investing consultant and a lecturer at the Milano School of International Affairs, Management, and Urban Policy at The New School for Public Engagement, where he teaches finance.

MOSIREEN was a non-profit media collective in Downtown Cairo born out of the explosion of citizen media and cultural activism in Egypt during the revolution. Over four years hundreds of videos were produced, which were viewed millions of times; a public space was opened and maintained; an educational syllabus was designed and taught; and the largest known archive of video of the revolution was collected.

MARINA NAPRUSHKINA is a Belarusian artist and activist based in Berlin whose work focuses on the political propaganda machine of the Republic of Belarus as well as on the mechanisms of political propaganda in general.

JASMINE RAULT is Assistant Professor of Culture and Media Studies in Eugene Lang College at The New School. Her research revolves around feminist and queer affects, architectures, activism and cultural economies. Her first book is *Eileen Gray and the Design of Sapphic Modernity: Staying In* (2011) and her forthcoming book is on the *Arts of Activism in the Queer Americas.*

JOÃO RIBAS is Deputy Director and Senior Curator of the Serralves Museum of Contemporary Art in Porto, Portugal. He was previously curator at the MIT List Visual Arts Center (2009–13) and at The Drawing Center in New York (2007–09) and his writing has appeared in numerous publications and journals.

TENZING RIGDOL is a contemporary Tibetan artist whose work captures ongoing issues of human conflicts and ranges from painting and drawing to video installation and performance art with strong political undertones.

ISSA SAMB is a Senegalese artist and co-founder of the interdisciplinary Laboratoire Agit'Art, which aims to transform the nature of artistic practice from a formalist, object-bound sensibility to practices based on experimentation.

CHRISTOPH SCHÄFER is a Hamburg-based artist who focuses on urban life and the production of public spaces since the 1990s.

GREGORY SHOLETTE is a New York-based activist and author of *Dark Matter: Art in the Age of Enterprise Culture* (2011). He is active with Gulf Labor Coalition and was a co-founder of the collectives Political Art Documentation/Distribution (PAD/D: 1980–1988), and REPOhistory (1989–2000).

BISI SILVA is a contemporary art curator and the founder and Artistic Director of the Centre for Contemporary Art in Lagos, Nigeria, which opened in 2007.

SHARON SLIWINSKI is Associate Professor in the Faculty of Media and Information Studies at the Western University in Ontario, Canada.

KATHRYN SMITH is an interdisciplinary visual and forensic artist, and senior lecturer at Stellenbosch University, South Africa. Her interests include risk and experimentation in art; socially responsive practices; and the ethics and aesthetics of investigation. She is based at Liverpool John Moores University, England, from 2015 to 2018.

POOJA SOOD is Director of KHOJ International Artists' Association, an autonomous, artists-led registered society based in New Delhi that is aimed aimed at promoting intercultural understanding through experimentation and exchange.

RADHIKA SUBRAMANIAM is Director/Chief Curator of the Sheila C. Johnson Design Center and Assistant Professor in the School of Art and Design History and Theory at Parsons School of Design at The New School.

TAKE TO THE SEA is an artist collective founded by Lina Attalah, Laura Cugusi, and Nida Ghouse.

It began working in Cairo in 2008 as a research project focusing on "irregular" migration from Egypt to Italy via the Mediterranean Sea.

CHEN TAMIR serves as the Curator at the Center for Contemporary Art in Tel Aviv and as Curatorial Associate at Artis.

WHAT, HOW & FOR WHOM/WHW is a curatorial collective formed in 1999 and based in Zagreb and Berlin. WHW organizes a range of production, exhibition and publishing projects and directs Gallery Nova in Zagreb.

MABEL O. WILSON is Associate Professor at the Graduate School of Architecture, Planning and Preservation at Columbia University.

Index

Image Credits

Cover: photo by James W. Toftness, courtesy
Theaster Gates; pp. 21–22: courtesy Magnum
Photos; pp. 25, 28: courtesy National Archives and
Records Administration (NARA); p. 49: photo by Ai
Weiwei, courtesy MIT Press; pp. 54, 56–57: courtesy
Shahidul Alam/Drik/Majority World; pp. 60, 62–63:
courtesy Karen Andreassian; pp. 67–69: courtesy
Amy Balkin; pp. 73–75: courtesy Videaux and
Bibliothèques Sans Frontières; pp. 79–81: photos
by Claudia Alva, courtesy the estate of Giuseppe
Campuzano; p. 89: courtesy Chto Delat; pp. 94–95:
courtesy DABATEATR; pp. 101–03: courtesy
Etcétera; pp. 106, 108: courtesy Gugulective; pp.
112, 114–15: photos by Stefan Müller, courtesy Hans
Haacke and Artist Rights Society (ARS); p. 119: photo
by Vincenzo Castella, courtesy Campus in Camps;
pp. 120–21: courtesy Campus in Camps; pp. 125–27:
photos by Irina Arellano, courtesy Interference
Archive; pp. 130, 132–33: courtesy Sanja Iveković;
pp. 136, 139: courtesy Amar Kanwar; p. 138 (top):
photo by Jonty Wilde, courtesy Amar Kanwar; p. 138
(bottom): photo by Stephan Wyckoff, courtesy Amar
Kanwar; pp. 142, 144, 145 (top): photos by Virginie
Dupray, courtesy Faustin Linyekula; p. 145 (bottom):
photo by Andreas Etter, courtesy Faustin Linyekula;
pp. 149–52: courtesy Mosireen; pp. 154, 156–57:
photos by Kristof Vrancken, courtesy Marina
Naprushkina; pp. 160, 162: courtesy Tenzing Rigdol
and Rossi & Rossi; pp. 165–67: courtesy Issa Samb;
pp. 170, 172–73: photos by Margit Czenki, courtesy
Christoph Schäfer; pp. 176, 178–79: courtesy Take
to the Sea; pp. 186–91, 193 (top), 197: photos by Sara
Pooley, courtesy Theaster Gates; p. 192, 194–95:
photos by James W. Toftness, courtesy Theaster
Gates; pp. 193 (bottom), 196: photos by Andre
Wagner, courtesy Theaster Gates; p. 201: photo by
Naomi Miller; pp. 207, 210–13: photos by Marc Tatti;
pp. 208–09: courtesy Theaster Gates; pp. 254–71:
photos by Andrea Geyer.